ie

Guide to
IMPRESSIONIST
PARIS

Photographs
Darryl Evans

To the memory of my father, Monte Robson, and to my mother, Claire Robson

FOREWORD

A commonly held misconception is that the followers of the Impressionist painting style concentrated on recording a fleeting moment of time only in a country landscape setting. When an educated art appreciator is asked to recall an "Impressionist" painting, he will frequently visualize numerous landscape canvases complete with shimmering water and multicolored flickering light. Monet and Renoir at Bougival, Pissarro at Pontoise and Sisley at Moret-sur-Loing are indelibly etched in our collective mind's eyes as typical examples of this popular well-known painting style. As evidenced by Guide to Impressionist Paris, however, it is obvious that Impressionist painters did not restrict themselves to village scenes, and several chose to investigate the "modern" city of Paris as a prime painting motif. Drawing inspiration from the 17th-century Dutch masters, these young French artists reexplored an older painting tradition: Impressionism made popular again the depiction of contemporary people in an urban setting. Not every Impressionist ventured to the countryside but, without exception, they all immortalized France's capital city.

WHICH "IMPRESSIONISTS" HAVE BEEN INCLUDED?

When deciding who are "Impressionist" painters, art historians use a variety of criteria. Some consider Monet, Morisot, Pissarro, Renoir and Sisley to be the important core group, and other names are included or excluded depending on the historian's particular standards.

"Relaxed" guidelines have governed the specific selections made for Guide to Impressionist Paris. Included are the most commonly acknowledged precursors (i.e. Manet and Jongkind), any painter who elected to show in at least one of the eight independant "Impressionist" exhibitions held between 1874 and 1886, and painters who were too young to be included in these shows but who, nonetheless, had also been identified during their careers with the "new painting" style. The latter include, among others, Van Gogh who executed his first painting in 1882, and several Americans who came to Paris in the late 19th century, seeking aesthetic inspiration and technical expertise. Whether you scan the paintings in advance or wait for each to be magically presented as the tour unfolds, you cannot remain unaware of the considerable differences in painting styles that these "Impressionist" painters were exploring. History has proved some to have been more significant than others but do try to remember that they all contributed to this particularly vital era in the history of art.

HOW TO USE THIS BOOK

Guide to Impressionist Paris allows you to easily explore France's capital city while simultaneously stepping into the footsteps of many well-known Impressionist painters. Nine walking tours direct you to the exact locations that inspired these selected painters to create some of their most innovative and admired works of art.

In addition to enlightening you on the history of Impressionist cityscapes, the Guide can be used as a general tour book of Paris. Each chapter begins with an overview of the specific walk. Then, the narrow column is intended to be read next. It contains detailed directions and in-depth historical information on the specific painted site and area of the city you are exploring. Information regarding the artist and the painting is available in the broader column of text.

It is recommended, but not imperative, that you follow these walks in the order in which they have been organized; information regarding the individual artists is cumulative and builds on what has come before. Paris, however, is a city to be visually savored, and getting sidetracked or "lost" can be part of its charm. When looking for the exact painted scene, use the maps and the accompanying contemporary photographs to orient yourself. Although the face of Paris has changed in the last 100 years, most of the on-site locations still have recognizable physical features which attracted the Impressionists and continue to attract millions of visitors each year. More people visit France than any other country in the world; the city most often visited is its capital, Paris.

Pont Royal
to Pont des Arts

A short, leisurely stroll along the Seine's quays between Pont Royal and Pont des Arts is a tantalizing introduction to *Guide to Impressionist Paris*. You will become familiar with almost every major riverfront landmark in the heart of Paris and with many of the most famous Paris cityscape painters.

The tour starts at the Orsay Museum's front door. Built for the World Exposition of 1900, this former train station houses France's major collection of Impressionist and post-Impressionist paintings, and a visit is a delightful must. The tour ends at the Cour Carrée, the Louvre's back door. The first painting site features Pissarro; he painted more urban landscapes than any other major Impressionist. A convenient resting spot, complete with benches, Pont des Arts is located more than halfway along your excursion. It is this author-painter's opinion, one shared by numerous other artists, that the view of or from this bridge offers the most memorable of Paris. For those of you wanting a mental and visual challenge, it would be no mean feat to recognize

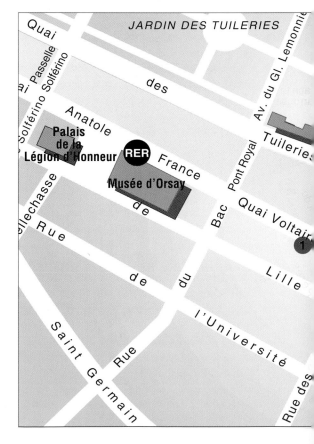

each building upstream, towards the Ile de la Cité, and downstream, towards the Eiffel Tower, from the Pont des Arts. Actual walking time is about one and a half hours but allow yourself more. The quiet calm of the Seine's banks is sure to seduce you, as will the paintings by Monet, Signac and Renoir, to name just a few of the featured artists.

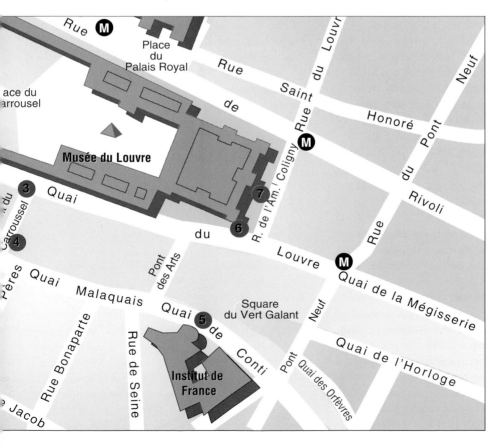

To start your first walk, position yourself with your back to the Orsay Museum's front door, and turn right; at the quay, turn right again and proceed forward. Across the river to your left are the Tuileries Gardens. Prominently silhouetted, diagonally across the river, are two large structures; both are attached to the Louvre on their right. The one bordering the Seine, the Pavillon de Flore, was originally constructed by Henri IV. To its left is the complementary Pavillon de Marsan, built by Louis XIV. As you proceed along the quay, stop before crossing Rue du Bac. On the other side of this street, the building on the corner dates from 1882-83. Its decorated facade of caryatids is noteworthy. Continue forward and pass, on your left, the Pont Royal; built during the reign of Louis XIV, it was the first bridge to span the Seine, unaided by an island. Stop in front of Hôtel du Quai Voltaire, located at number 19. This 18th-century building was converted into a hotel in 1857, and former guests include the first two featured painters, as well as Baudelaire, Wagner, Sibélius and Oscar Wilde. An adequate ground-level position from which to view your matched pairs is slightly further along the quay, in front of number 15. From the hotel window, look to the right, or, from street level, look straight ahead along the quay. Gracing the horizon line is the Le Vau-built, 17th-century dome of the former College of Mazarin. Wanting an intellectual center for gentlemen from four newly-acquired French provinces, Cardinal Mazarin provided money in his will for its establishment. Until 1790, when this institution was closed, it was also known as the College of Four Nations. Since 1805 the buildings have been home for the five French academies "established" during the aftermath of the French Revolution;

1. QUAI MALAQUAIS: MORNING SUN (1903)

CAMILLE PISSARRO

At the age of seventy-two, Pissarro, the only artist to show in all eight independent Impressionist exhibitions, took up residency at the Hôtel du Quai Voltaire. Possibly the last work he completed before his death, *Quai Malaquais: Morning Sun* (1903) is one of a series of paintings which together constitute the 180-degree view from his hotel window.

The tree-lined, shadow-filled, bending quay, the domed Institute of France, the slowly flowing Seine, and the arched Pont du Carrousel are motifs that set the stage for his study of a specific time of day in a specific season.

Pissarro's work allows the viewer's eye to roam leisurely; his choice of location and light conditions is also a study in repetitive gentle curves and tranquil hues. Using a classic Impressionist working method, Pissarro observes and records how the largest unobstructed area of light, and thus color, relate to smaller areas. The cool, autumn morning sunlight produces diffused, pink-blue air and drifting puffy clouds. This light then touches wisps of orange-yellow leaves, which cast a combined color of peach-orange onto the quay. The shadow of pinks, purples and blues is created when the concert of light "hits" the unseen buildings and mixes with the peachy road. Shapes and lines appear as he works from large to small and continues to focus his attention on these differing light relationships.

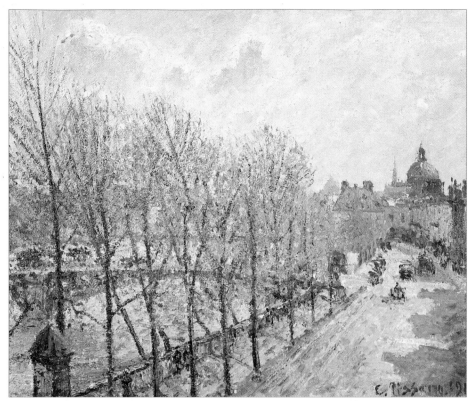

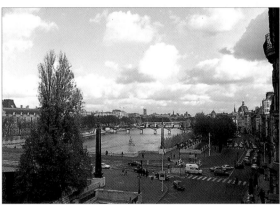

Despite the contrast of the shadows on the fully-lit quay in the foreground, the repetition of hues and soft curves results in a calm ambiance. There is no disharmony between the city dweller and city life. Noise from the busy bridge has been muffled, and Parisians are enjoying themselves, quietly talking or strolling along the left side of the quay. Pissarro is observing the wholeness that comes when a man lives in harmony with his environment. The consummate painter of rural France now observes in the city the country mood he so often recorded in the past.

together they form the Institute of France. In actuality, however, all five owe, directly or indirectly, their existence to the Royal Academy established under monarchial rule during the 17th century. The academy most feared, or revered, by artists during the latter half of the 19th century was the Academy of Fine Arts. When choosing paintings for the government-sponsored Salon Exhibition, this august group felt it was necessary to protect the field of art from "revolutionary" or non-academic influences. Their exclusive, rigid attitude eventually led to the proliferation of independent salons and the public's exposure to what we now consider to be some of the finest art produced in the late 19th century. Although, early in his career, the first featured painter exhibited in the Salons of 1859, 1864 and 1865, he did not continue employing the painting techniques deemed acceptable by the Academy of Fine Arts. It is a curious fact, however, that late in his life he depicted the Academy's home.

2. THE LOUVRE AND THE PONT ROYAL

(1897)

CHILDE HASSAM

To locate the next site, proceed to the right along Quai Voltaire. Painters Vernet, Delacroix and Corot all lived at number 13 at different times. This quay is lined with antique shops and art galleries. At the traffic light, cross the busy quay and move to your left. Stand at the corner of Pont du Carrousel to make your second painting comparison. Look across the Seine toward the Pavillon de Flore and Pont Royal; both are important motifs in the next painter's cityscape.

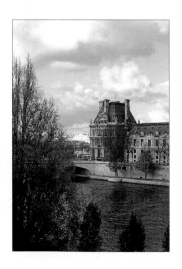

Hassam, an illustrator-turned-painter, is often recognized as the most important American painter to be linked with French Impressionist sensibilities. An extended stay in Paris, from late 1886 to the summer of 1889, had a profound impact on his use of color (see tour 3), and another sojourn, in 1897, aided him in his continuing development of Impressionist techniques. This second time, wanting to experiment with brushwork and an even lighter, more heightened palette, he painted along the quays and in the streets and gardens of Paris. From his hotel window on Quai Voltaire, six years before Pissarro depicted the expansive vista, Hassam did at least two paintings facing left, and one facing right. *The Louvre and the Pont Royal* (1897) is typical of his output. To attain the continuously dissolving, shimmering effect of bright sunlight, Hassam applies short, fragmented dashes and elongated strokes of soft yet dazzling color. Abstract patches of combined yellows and blues emerge as he rapidly moves his brush around the canvas; haphazard strokes create a lyrical rhythm. Indicative of his basic interest in depicting a modern, animated city is Hassam's choice of a moment when people are ambling across the bridge, and smoke-billowing boats are moving along the active river. Mindful of portraying the architectural splendor of Paris, he prominently features the Pavillon de Flore; in the distance appear the buildings on Rue de Rivoli. Shortly after returning from Paris, Hassam, along

with nine others, resigned from the conservative
Society of American Artists. Their work was received
with mixed reviews the following year, 1898, when
shown at Durand-Ruel's New York gallery. Some
thought Hassam's work to be "strange" and
"incomprehensible," but he continued to be the
foremost proponent of the new French painting
technique among his contemporaries.

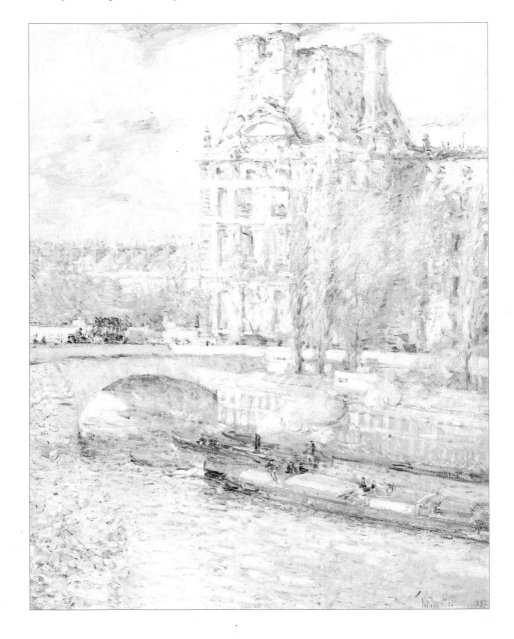

3. PONT DES ARTS (1928)

PAUL SIGNAC

To locate the site of the next matched pair, proceed onto the bridge past the pedestaled woman representing the Seine, on your left. Ahead are the five arches leading to Place du Carrousel, hence the bridge's name. To the right of the Place, but not viewable from your present position, is the Pei-designed, transparent pyramid; it has marked the main entrance to the Grand Louvre since 1985. To position yourself for the next on-site painting comparison, proceed right, cross the bridge and position yourself in the corner, facing the metal Pont des Arts and the stone Pont-Neuf behind it; woman of Industry is to your back. Ahead, in the middle of the Seine, are the steeples and rooftops of the buildings on the Ile de la Cité, the island once known as Lutetia. The original

S ignac, an *en plein air*, neo-Impressionist, showed for the first time in the final Impressionist exhibition of 1886. In a 1894 diary entry, however, Signac wrote, "It seems crazy to paint everything you see before you," and we know that his oil paintings were thereafter executed exclusively in his studio (often based upon "sketches" done outdoors). *Pont des Arts* (1928), a motif he methodically repeated several times during his career, is representative of his mature, oil painting technique. His position indoors allowed for a more thoroughly contemplated work, and the light which he described as "unpredictable" ceased to distract him. His desired end result was a formal, synthesized study of tensions and contrasts. The linear composition of this

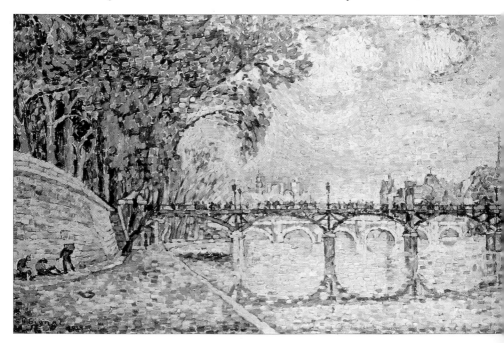

cityscape forces the viewer to compare the solidity and stability of the angular, metal bridge with the curve of the overhanging trees. Warm green, yellow and orange contrast with cool blue and purple in the foreground, and a similar tension is subtly repeated in the depiction of the Ile de la Cité and the Pont-Neuf in the background. Although the pointillist dots have all but disappeared, brushstrokes of energetic dashes further add to the vibrancy of Signac's cityscape. Neo-Impressionists believed that non-mixed, pure color could not be easily assimilated by the eye, and that putting colors side by side in the form of dots intensified the visual experience of the viewer.

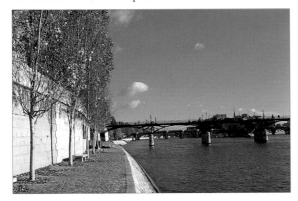

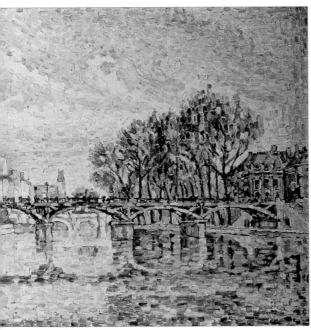

inhabitants, a Celtic tribe called the Parisii (later referred to as Gauls), settled there in the 3rd century BCE; they were conquered by the Romans, who by that time had established themselves on the left bank, in 52 BCE. Later, marauding barbarians ravaged the left-bank community, and the Romans, now mixed with the Gauls, were forced in 276 to retreat to the island. They built a protective city wall around the island, which existed until the end of the 12th century when Philippe Auguste built a new wall to accommodate the city's expansion onto the right and left banks. Despite this expansion, rulers continued to live on this central, well-protected location; it was, and still is, the heart of the city.

Motifs in the painting to be compared include the tall thin steeple of Sainte-Chapelle, built in the 13th century when Louis IX was reconstructing the royal palace. It is one of the oldest remaining structures of the Ile de la Cité. To its right are the double towers of Notre-Dame cathedral, started in 1163; its steeple dates from the 19th century. Left of Sainte-Chapelle are the pointed towers of the Conciergerie, first built as a royal residence by Philippe the Fair during the 13th century, and now part of the Palais de Justice (law court complex). The rounded dome, also on the left, is the 19th-century Tribunal of Commerce. The featured painter also included the 20th-century additions to the Palais de Justice, which you see on the right side of the Ile de la Cité.

Your present position, though not the exact location chosen by this painter, is a convenient spot, more than adequate for an on-site comparison (later, on this tour, you will have the opportunity to stand at a more accurate location).

4. PONT DES ARTS (1868)

PIERRE AUGUSTE RENOIR

The next painting site is only moments away, near the left-bank end of Pont du Carrousel. Recross the bridge almost in its entirety, and face toward the Pont des Arts, the Institute of France and the riverbank quay. Pont des Arts is, and has been, the most popular pedestrian bridge in the capital city. On its opening day in 1804, 65,000 Parisians paid a 5-centimes toll to stroll its length, or simply relax on one of its many benches (it remained a toll bridge until 1848). The name was chosen appropriately as it linked the Palais du Louvre, also known as the Palais des Arts, to the left bank. From 1805, when the Institute of France moved from the Louvre to the location of the old Mazarin College, scholars, routinely, could be seen upon it, traversing the Seine.

During the late 1860's, Renoir (and Monet) started to explore the city of Paris as a painting motif. *Pont des Arts* (1868) is typical of Renoir's early style. Recognizable buildings, in this case, the Institute of France on the right, and the twin roofs of Châtelet, Hôtel de Ville and Saint-Gervais on the left, are the backdrop for the activity in and around the water. Often interested in portraying pleasurable leisure activities, Renoir painted figures strolling or casually standing on the quay or bridge. Reflected light and the weather conditions, two subjects to be explored by Impressionist painters during the next decade, occupy his attention at this early stage. Impressed by the bright, sunlit area on the quay, Renoir skillfully contrasts it with the odd-shaped edge of the shadowed area; a multitude of reflecting colors is woven into the blue of the water. Although Renoir is known to have said, "I believe I have done nothing but continue what others have done better before me," his signatory, soft, hushed yet accurate brushstroke is already evident in this early urban landscape painting.

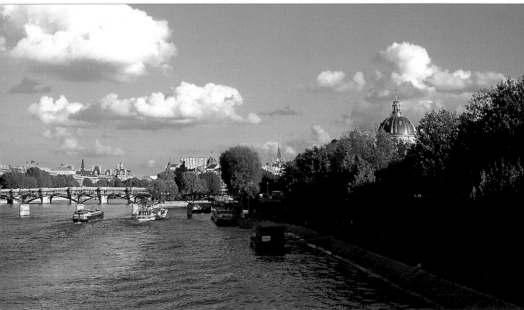

To view the next site, turn right, go past the sculpture of the Ville de Paris on your left, leave the bridge, and turn left onto the quay. Continue along Quai Malaquais (the name changes at Rue des Saints-Pères) and note number 17, the back buildings of the School of Fine Arts. (The facade overlooking the garden is an unaltered, François Mansart design dating from the middle of the 17th century.) Just before 7 Quai Malaquais, descend to the water's edge via the steps, turn right, and travel along the bank. The quay, radically modernized in the 20th century, retains, nonetheless, its 19th-century ambiance. People here stroll along the banks of the Seine, and freight-carrying barges can still be seen floating along the river. Noise from the well-traveled street above seems almost nonexistent.

Proceed under the metal Pont des Arts and look left toward Pont-Neuf. Buildings on the south bank of the Ile de la Cité are now clearly visible. Notice the two brick and stone facades which together mark the entry point into the hidden Place Dauphine beyond; they are original and date from the 17th century. Bordering the quay, behind the Place Dauphine, are the buildings of the Palais de Justice (including the silhouetted tower marking its end point). They were constructed during the law complex's second major alteration, at the beginning of the 20th century.

As you approach the bridge, the steeple of the 13th-century Sainte-Chapelle suddenly appears. Before continuing

5. THE LOCK AT THE PARIS MINT

ALBERT LEBOURG

Lebourg's painting is an illustrious example of the changes in creative priorities accompanying the Impressionist movement. No longer bound by classical standards, he is free to offer the eye a gauze of color without distinct lines, and a painting that appears incomplete. His challenge, when painting *The Lock at the Paris Mint*, is to depict the enveloping ambiance of a winter mist in a recognizable context. Sensitive to the transitory nature of weather, Lebourg paints quickly. He constructs solidity with nuances of color, and uses the same fluid touch for figures, bridge and buildings. If his rendering of an arch of the Pont-Neuf is not exact, or a window on the Quai des Orfèvres appears slightly diagonal, Lebourg, as an Impressionist painter, knows it is not vital to the success of his landscape. A painting is created from life, and is not a photographic reproduction.

Despite Lebourg's participation in the fourth and fifth Impressionist exhibitions (1879 and 1880, respectively) and his long career of fidelity to classic Impressionist techniques, his work has never attained the critical acclaim awarded to his contemporaries. In an arena where originality and innovation are a mark of "genius," Lebourg's never-ending fascination with, and repetitive recordings of, winter light can account for his relative obscurity by the middle of the 20th century.

Often painting in series, Lebourg had a particular affinity with ephemeral winter light.

further, stop for a moment to consider the fact that, even taking into account a remodeled quay, the growth of trees, boats blocking the view, and the successive building of the Palais de Justice on the southern quay, the next featured painter's exact position is ambiguous. If you try lining up the arches of the Pont-Neuf, the steeple of Sainte-Chapelle and the end building of Place Dauphine with those depicted in the painting, then your conclusion must be that this artist modified the positions of what he saw.

The locks, needed to control the water level between the island and the Seine's left-bank arm, ceased to exist in the 1930's, but none of the other older structures have been moved or substantially altered. (The Mint, only noted in the painter's cityscape title, is on the quay at street level above to your right.)

Move forward and stop where you think the painting comparison should be made.

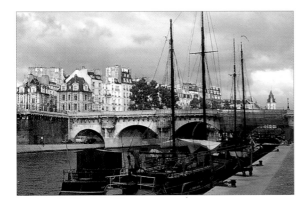

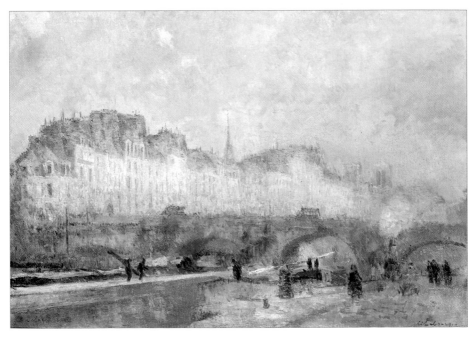

6. QUAI DU LOUVRE

(1866-67)

CLAUDE MONET

Continue forward on the quay, climb the steps just beyond the riverfront fire station, and stop momentarily at street level. The building on the other side of Quai de Conti is the Mint; classical in design, it dates from 1777. Turn right and continue forward. The small square, set back from the street on your left, has buildings dating from the 17th and 18th centuries; the sculpture of Condorcet, politician, philosopher and mathematics scholar, was erected in 1991. At the Pont des Arts, look left for an impressive, unobstructed view of the Institute of France. Le Vau, its architect, while also working on the Louvre, created a complementary design for the Institute. The Cour Carrée of the Louvre, at the opposite end of the bridge, lines up with the Institute.

Before proceeding to your next painting comparison site, turn right and walk halfway across Pont des Arts. A bench is a perfect place to stop, relax, and quiz yourself on those bridges and buildings you have already seen, or to familiarize yourself with those Paris landmarks which are sure to appear in other paintings.

To continue, complete your journey across the bridge. If you want to discover Signac's position when he painted the already compared depiction of Pont-Neuf and Pont des Arts, turn left onto Quai du Louvre, and descend to the water's edge. If you decide to forego the experience and wish to continue to the next painting comparison site, cross Quai du Louvre, turn right and proceed to the first street, Rue de l'Amiral-de-Coligny; make a half-turn to face the

When Monet received permission to paint inside the Louvre as a "landscape" painter, he was inspired by the panoramic view from the Colonnade balcony. The immediacy of the city people moving or resting along the sun-brightened quay sets the scene for one of his earliest urban landscapes. *Quai du Louvre* (1866-1867) is similar in style to Renoir's painting (seen earlier on this tour) of the same period. On the horizon, the Panthéon is flanked by the Sorbonne on the right, and the Saint-Etienne-du-Mont and Clovis tower on the left. The sculpture of Henri IV is nestled amongst sunlit and shadowed trees, and a red structure along the opposite quay casts reflected color onto the blue-green water. Monet flattens the picture plane without compromising proper perspective, and, even at this early stage in his development, there is a notable absence of lines. But Monet, like Renoir, depicts moving people as he has been trained to see them, and not as blurred licks of

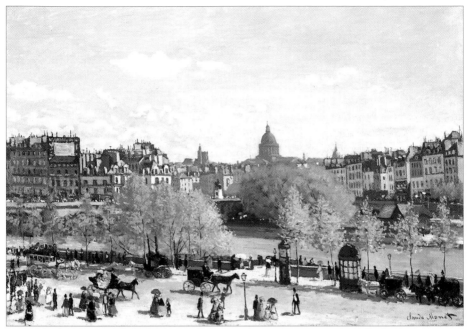

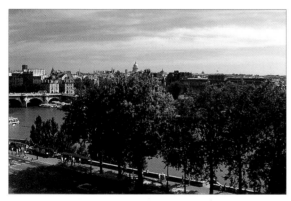

color which later would come to represent more accurately his vision. Still influenced by traditional methods of viewing the world and picture-making, he has not yet reached the stage where he depicts the fleeting moment or the first "impression" of his sensory perceptions.

True to the early goals of the Impressionist painters, however, Monet has not embellished or idealized the scene, and his portrayal of Paris reflects the unhurried manner of urban living at that time. When we view this same scene more than 125 years later, despite the noise of modern Paris, the same feeling of calm and contentedness can prevail.

river. Before you is the impressive dome of the Panthéon, designed by Soufflot and built between 1758 and 1789. The Louvre balcony, behind and above you, is the actual location of the featured artist. In 1793, the Louvre was established as a public museum, and its gigantic collection became a source of cultural enlightenment for Parisians and painters alike. Latour, Manet and Degas, all Paris residents, frequented the picture galleries, and the latter two became acquainted there in 1859. Latour introduced Berthe Morisot to Manet in 1868 while she was diligently copying a Rubens. As the story goes, Renoir, too, lauded the Louvre collection, and spent hours studying and copying the French 18th-century painters Boucher, Fragonard and Watteau. One day he coerced his friend and fellow painter, Monet, to go along. A few days later, Monet, too, applied for permission as a copier, but his application stated that he wanted to paint from the galleries upstairs as a "landscape" painter.

To view the only painting of this walk which lacks a bridge or quay, continue left on Rue de l'Amiral-de-Coligny, and position yourself in front of Saint-Germain-l'Auxerrois. The present church is located on a former 8th-century sanctuary, and from the 14th century it served as the royal parish church. Essentially Gothic (13th century), its architectural splendour has been enhanced by six centuries of alterations. Since 1926, on the first Sunday of Lent, it is a tradition among artists to come to pray for those who will not make it through the following year. Next door, is the Mairie of the first arrondissement. The building, designed by Hittorff under Haussmann, is of a style complementary to that of the neighboring church. The artist's position was on the balcony behind and above your present position. The Louvre Colonnade dates from Louis XIV. During the first half of his reign, he was interested in enlarging and embellishing the royal palace. He lost interest, however, and left for Versailles not long after the facade of columns had been completed.

At the conclusion of your first walk, it is recommended that you visit Saint-Germain-l'Auxerrois; several artists are buried there. Next door is the Saint-Germain-l'Auxerrois pastry shop, which has been doing business for over a hundred years; its interior is worth seeing. You are also conveniently near the entrance to the Louvre; walk through the Cour Carrée, the former courtyard of the 16th-century Louvre Palace built by François I, to find Pei's pyramid entrance. For those of you wanting to continue making on-site painting comparisons, the next walk starts only moments east of your present location. Travel along Quai du Louvre to its conclusion at the Pont-Neuf.

7. SAINT-GERMAIN-L'AUXERROIS (1867)

CLAUDE MONET

Monet executed *Saint-Germain-l'Auxerrois* (1867) during his urban landscape campaign at the Louvre. His interest in sunlight and shadows is again evident, and people, trees and buildings are all treated with the same direct, painterly brushstrokes. His study, which includes the complicated rose window, is detailed yet not stiff. In this painting, as opposed to the one just seen, Monet's view is focused on a contained area. Although he has cut off the picture plane arbitrarily on the left side – a device used by the Dutch cityscape painters in the 17th century to indicate a "slice of life" motif – buildings and trees define and control our eye.

Cars have replaced carriages, yet people still relax in this area of greenery near the Louvre's backdoor.

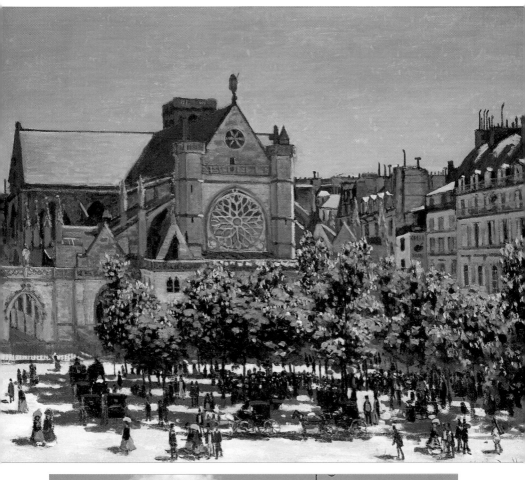

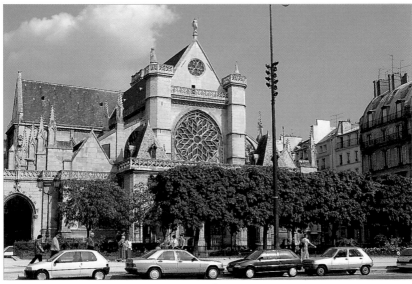

Pont-Neuf
to Pont Louis-Philippe,
via Pont Sully

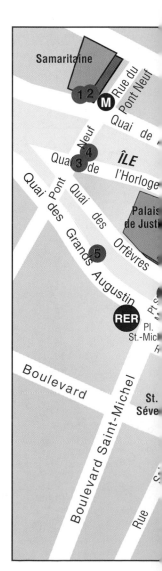

The bridges and quays of the two islands in the center of Paris offer an almost overwhelming variety of stimuli for your eyes, ears, minds and hearts. Your first stop, the right-bank arm of the Pont-Neuf, is a chaotic frenzy of buses, cars and rushing people. Your last stop, on Pont Louis-Philippe, is near the main street of Ile Saint-Louis, and only moments from a peaceful, tree-lined river dock for the BatoBus (a river ferry which costs 60 francs for the day, and allows you to explore seven stops along the Seine at your leisure). The sudden transitions from noisy to quiet, experienced on this walk, are typical of the rhythm of modern Parisian life.

Originally, this section of Paris was composed of six islands; today there are two. Ten bridges connect these islands to the right or left banks of the mainland; two more link both banks, and each one crosses an island at its tip. The Pont-Neuf connects the right and left banks at the Seine's widest section near the tip of Ile de la Cité. The longest bridge is Pont Sully which crosses the eastern tip of Ile Saint-Louis. Seeing the bridges and quays of the two islands through the eyes of the featured painters complements tour 1, and completes your overview of two motifs, bridges and quays, which were often depicted in Paris cityscapes. Give yourself ample time to enjoy this tour. From the second Lépine site, you can join the Parisians sunbathing, picnicking, or simply relaxing in an outdoor sculpture garden, and, after the Prendergast site, you can stop for a meal or drink at one of several floating restaurants next to Notre-Dame.

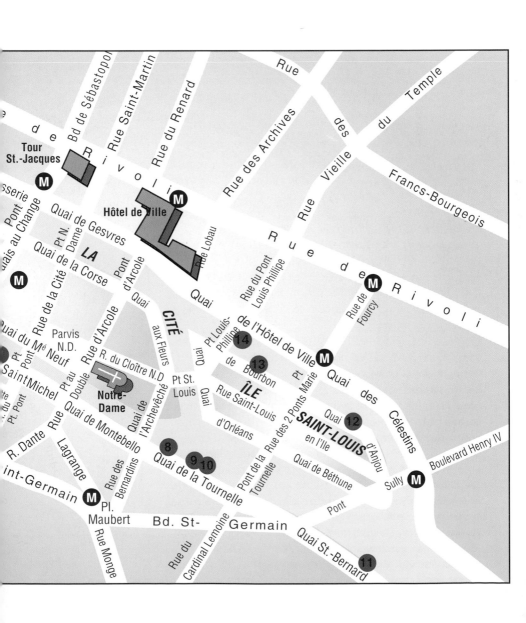

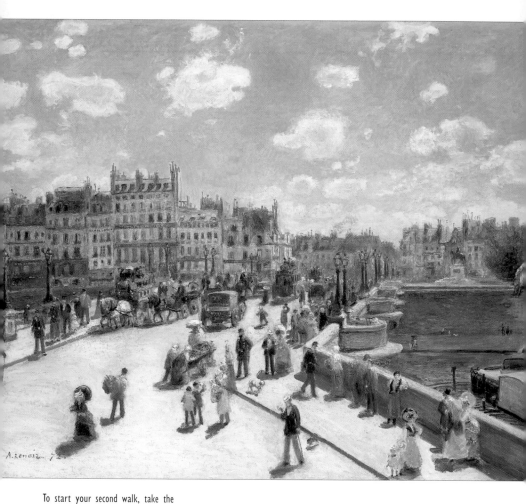

To start your second walk, take the
metro to Pont-Neuf (La Courneuve-Villejuif
line). Follow the signs to Pont-Neuf and
the Musée de la Monnaie. At street level,
move to the right and spot the
equestrian sculpture of Henri IV, halfway
across the river Seine. When he became
King of France in 1589, the foundation
stone of the Pont-Neuf had already been
laid by Henri III. The new King revised
the plans to create the large protruding
platform near the bridge's midpoint,
alcoves for peddlers, and sidewalks for
strollers; Henri envisioned the Pont-Neuf
becoming the center of the commercial

1. THE PONT-NEUF

(1872)

PIERRE AUGUSTE RENOIR

Both Renoir and Monet executed paintings of the centrally-located, immensely popular Pont-Neuf from the window of a second-floor, right-bank café. Both capture the fleeting, temporal condition of light in a specific atmospheric condition. Both study the surrounding reflecting colors. Both snatch at the moment when people are moving across the bridge, and both "impressions" of a contemporary scene are detailed enough for us to recognize, even today, the sculpture of Henri IV on the bridge, the buildings on Ile de la Cité, Quai Conti and Quai des Grands-Augustins, and Rue Dauphine beyond. Without altering the existing diagonal, vertical and horizontal lines, both paintings invite the viewer to enter and participate in the scene taking place upon the bridge. Art historians are divided as to whom was inspired by whom, but more important to consider are the differences in style between these two artists, recognizable as early as 1872.

In 1869, they painted, side by side, the floating restaurant at Bougival, La Grenouillère, and it is difficult to tell the difference between the Renoir and Monet depictions. Of course, to the discerning eye, even then, Renoir's brushwork is more feathery, Monet favoring wider strokes, and Renoir's figures are a little more detailed. However, it is when they both paint the Pont-Neuf that their individual creative directions are more obvious.

and social life in the capital city. The bridge's popularity was sealed on opening day in 1607 when Henri IV galloped aross with fellow merry-making Parisians. As he had hoped, at all hours of the day and night (until the Revolution almost 200 years later), swarms of lighthearted townspeople mixed with peddlers, street musicians, and charlatans selling "medicinal" tonics. Nude bathers at the tip of the island, to your right, wanting to tantalize or shock, could be seen from the bridge during the warm days of spring and summer, and, purportedly, a young Molière decided to become a playwright after his grandfather exposed him to the outdoor theater on the bridge. Also new on Paris' first bridge to be constructed without houses — and not at the former location of an older crossing point — was a technically advanced, hydraulic pump. Called the Samaritaine, after the women of Samaria who gave water to Jesus in the desert, it was located on the right-bank arm of the bridge. Low in structure, it did not interrupt the view afforded to and from the bridge.

The best position from which to make your first comparison is located inside the Samaritaine department store behind you. Cross the busy Quai du Louvre, enter Samaritaine, building 2. Take the elevator to "Espace Enfant niveau 2," and proceed to the window next to the reception counter (*accueil*), in the southeast corner. Although the building postdates the two featured painters, the panoramic view of the river and city below has changed little since 1872. Other expansive views of Paris can be seen from the Samaritaine's rooftop terrace and fifth-floor bar and restaurant area.

Renoir's *The Pont-Neuf* (1872), painted on a sun-drenched day, sparkles with the glow of blues, greys and golden hues which are interspersed with dabs of pure reds and yellows. Though his figures are modeled loosely with color, we still discern the age and social class of the pedestrians. Renoir's interest in the human figure would continue to manifest itself (note tours 6 and 8), and he would eventually become known for his application of Impressionist techniques and sensibilities to the human form.

Monet's painting, *The Pont-Neuf* (1872), is less "complete" than Renoir's; odd shapes define the people, umbrellas and horse-drawn wagons. Intent on capturing the rainy, dreary, grey Paris day, Monet creates a palette rich in muted hues of mauve and greyed blues.

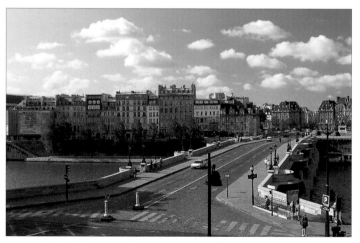

A touch of genius is his portrayal of the confusion of carriages on the bridge. The misty atmosphere enveloping the scene restricts his view of detail, and Monet doesn't paint what he doesn't see (note tour 6 to see his "evolved" figures in *Boulevard des Capucines*, painted only two years later, and tour 5, his first series of trains at *Gare Saint-Lazare*). Monet's mature work would culminate in pure studies of light and color, notably his garden paintings executed at Giverny. Often quoted is Cézanne's description of Monet: "He is only an eye, but what an eye!"

2. THE PONT-NEUF

(1872)

CLAUDE MONET

3. THE PONT-NEUF, THE STATUE OF HENRI IV: SUNNY WINTER MORNING (1900)

CAMILLE PISSARRO

To continue, leave the department store, turn left, cross Rue du Pont-Neuf ahead, and turn right. Cross Quai de la Mégisserie, turn right and then left onto Pont-Neuf; stop at the first alcove. Ahead, to the left of the bridge on Ile de la Cité, your view includes Quai de l'Horloge, the north wing of the law courts and the restored facade of the old palace prison, the Conciergerie. The four towers, three cone-shaped and one square, date from the 13th and 14th centuries. The latter is the site of the oldest public clock in Paris, hence the quay's name. The westernmost tower, Tour Bonbec – thus named because it was used as a torture chamber under the Reign of Terror – was made higher during the 19th century. Believing that "perfection" was God's realm only, medieval architects often employed asymmetrical designs which, when given the opportunity, 19th-century architects redesigned symmetrically. The domed Tribunal of Commerce is a 19th-century invention, as are the law courts. The rebuilt bridge, Pont au Change, spanning the Seine next to the clock tower, also dates from the 19th century. Named after the moneylenders installed there as from the 12th century, it was first constructed in the middle of the 9th century, but has been rebuilt numerous times.

To proceed to your next painting site, continue in a forward direction, stop just past Quai de l'Horloge, and stand in front of the first twinned building. The featured artist, painting from an upstairs apartment behind you, concentrated his attention on and divided his depictions of this panoramic view into three specific directions. The featured cityscape is

I n November 1900, Pissarro moved into an apartment at 28 Place Dauphine. Over a three-year period he completed over forty-two paintings, which proved to be his most productive effort at any one location. His works could be classified into sub-series based on weather conditions, time of day or season, but, when looking at the titles and paintings, it is apparent that he divided his large output according to stable, physical points of view. Returning to the working method established in his first expressively painted series (see tour 6), Pissarro doesn't rotate his head to depict increments of the same scene (see tours 1 and 3). Instead he concentrates on the same view, either to the left, right or straight ahead, and varies the time of day and weather conditions. (When looking out his northwest windows to his left, he saw the Institute of France, the statue of Henri IV, a portion of the river, and part of the protruding terrace of Pont-Neuf. To the right, he could see the Louvre, Pont des Arts, the river, and, again, a portion of the raised terrace of the bridge.) *The Pont-Neuf, the Statue of Henri IV: Sunny Winter Morning* (1900) is his northwest panoramic view (straight ahead). It is important to realize that Pissarro was above all

concentrating on technique. Recognizable buildings are simplified, and, despite a limited palette, he records, as the title indicates, the sunny, winter morning light. From the title, we can surmise that Pissarro is also making a political comment. The Dreyfus affair was still dividing the country, and Pissarro, a passionate supporter of human rights, is gently reminding the French people of the tolerance of the former King.

straight ahead, and spans both banks of the Seine.

(Possibly a more advantageous perspective from which to make your comparison would be a more forward position on the protuding area of the bridge, but that view would eliminate the King's sculpture which is in the featured painting.)

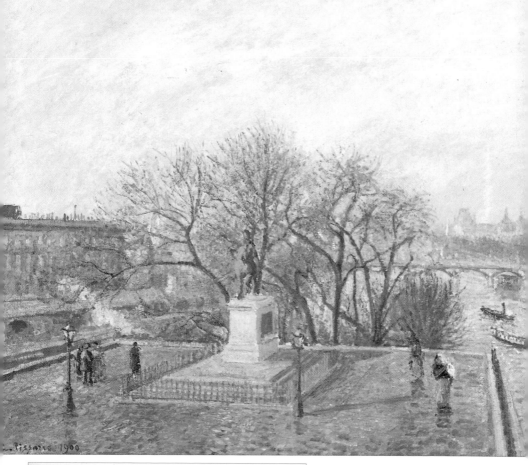

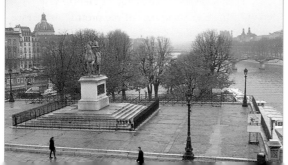

4. THE PONT-NEUF, RAINY AFTERNOON

(1901)

CAMILLE PISSARRO

To locate another work by this same painter, move to the right and position yourself on Quai de l'Horloge. Face toward the Samaritaine department store, and note the alcoves of the right-bank extension of Pont-Neuf.

To continue your walk, turn around and move forward on the bridge, toward the left bank. Immediately on your left, with the sculpture of Henri IV on your right, is a narrow road leading into the secluded, always quiet Place Dauphine; enter the Place here. Included in Henri IV's plans for the Pont-Neuf was the construction of a "royal" Place, which would be geometric in shape, with buildings uniform in design, and a fitting location for an equestrian sculpture of a King. It is unknown why the buildings here were never uniform, as had been planned, but it is possibly the result of Henri IV's assassination in 1610, which ended his indirect supervision of the project. There still exist, however, several original stone and brick houses which are complementary to those already seen at the entrance to the Place.

The original, triangular shape was altered in the 19th century. The back wall was needlessly destroyed to enhance the entrance to the Palais de Justice; most people, however, enter from the parallel street, Boulevard du Palais.

In the 17th and 18th centuries, Place Dauphine was used for outdoor art exhibitions which rivaled the Salon's indoor shows.

The never-ending activity along Pont-Neuf and the right-bank quay also attracted Pissarro's attention. From two different northern windows, he painted what some consider to be a separate series. In ambiance and technique, his *The Pont-Neuf, Rainy Afternoon* (1901) combines elements from Renoir's earlier Pont-Neuf rendering, but Pissarro's own interpretation of throngs of moving people, together with his mature application of Impressionist sensibilities regarding light, color and paint-handling, creates a fresh, original depiction. The composition and the energetic brushwork persuade the viewer's eye to dart about while discovering the richness of pure Impressionism. A grey, rainy afternoon yields a sparkling light bouncing off the slick pavement, varnished wheel rims, and building facades. Curving thread-like touches of pure paint, mingled with mixed hues of horizontal brushstrokes, denote the fluidity of water and the solidity of buildings. Loosely detailed people, carriages and horses dissolve into a color-filled mass as their movement on the bridge continues toward the network of well-defined streets beyond. Pissarro's series or (sub-series) of Pont-Neuf speaks of a dichotomy that comes with modernization and economic prosperity. Busy Parisians, caught up in the business of living and working, only occasionally stop long enough to enjoy the beauty of the urban landscape in which they live.

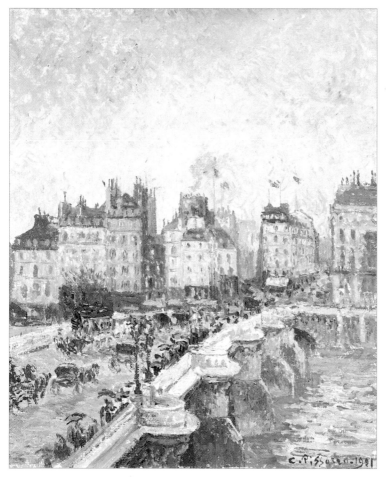

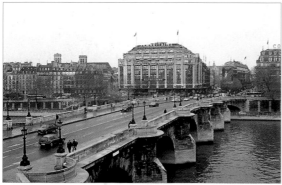

To arrive at the next painter's site, exit Place Dauphine at the right back corner, turn right onto Quai des Orfèvres and left onto the left-bank arm of Pont-Neuf. The quickest way to the quay by the water's edge, your next destination, is to turn left on Quai des Grands-Augustins and left again on the paved incline. Following your route, stop just before the bank curves. Look up to the right, and compare the buildings on the quay with those in the featured painting; from right to left, on the opposite bank of the Seine, are Notre-Dame, the Préfecture, and a section of the Law Court complex. The Law Court was built between 1907 and 1914, and the Préfecture, between 1870 and 1880. Only the right tower of Notre-Dame will be visible on your left, and the bookseller's metal boxes will block much of your view to the right. However, enough remains to make your next on-site comparison a noteworthy experience.

5. THE SEINE AND NOTRE-DAME-DE-PARIS (1864)

JOHAN BARTHOLD JONGKIND

Although Jongkind, a Dutchman, never showed with the Impressionists, never took part in their Paris café "discussions," and was very independent and often drunk, there is hardly an art historian who doesn't credit him with having had a tremendous influence on the young Impressionist painters. Inspired by the French landscapists in Barbizon and Honfleur, he began to record *en plein air* his spontaneous, sensory reactions to nature. This newfound passion for recording the immediacy of the changing light and the transparent atmosphere was so contagious that he provoked others to follow suit. Although it was Boudin who took Monet

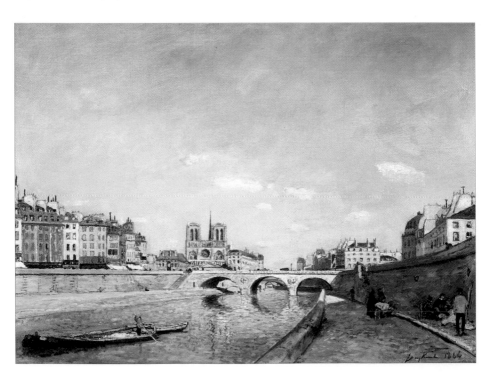

outdoors to paint for the first time, Monet credits Jongkind with "the education of my eye," and Boudin affirmed that it was "Jongkind who opened the door through which he walked and all the Impressionists followed." To paint *The Seine and Notre-Dame-de-Paris* (1864), Jongkind skillfully combines his Dutch-based academic roots with his French experiences of outdoor painting. Emulating his fellow countrymen of the 17th century, he depicts an engaging, contemporary city scene. Nothing is idealized, and there are no lofty messages; rather ordinary people are informally depicted going about their everyday life. The lowered horizon line, again borrowed from 17th-century Dutch painters, allows for an extensive sky study. Clouds form and drift and then melt overhead. Jongkind's vibrant palette, however, is a departure from his art school training. When he paints outdoors, a tapestry of multicolored brushwork becomes shimmering water and a bumpy cobblestoned quay. Jongkind, if alive today, would not be displeased with this site. Now, as then, the location allows for a candid depiction of contemporary city life.

As you stand by the river's edge, away from the activity of the traffic-filled street above, allow this artist's vision to come alive. Hopefully, you can ignore, or find humor in, the Préfecture's invasion of the location, and still appreciate the separate, and often hidden, world which exists down by the water's edge. People meander along, stop to chat, or simply sit and enjoy the quiet serenity of the area. Some of the buildings depicted have survived since the mid-19th century and, despite pollution, the color-filled reflections on the water's surface ebb and flow with the changing tides. Pont Saint-Michel, originally constructed in wood in 1364, was followed by the construction of other wooden bridges. In 1617, the first stone bridge was constructed here. The present one dates from 1857 when it was rebuilt under Haussmann; the "N," encircled by a wreath, stands for Napoléon.

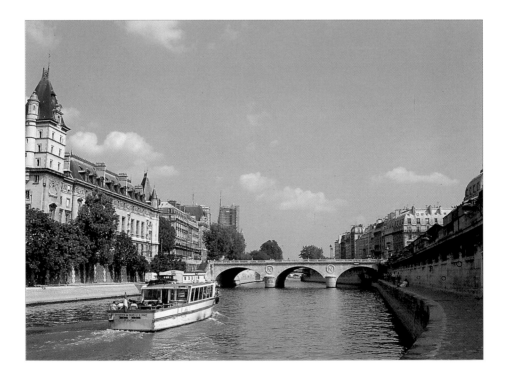

6. NOTRE-DAME, PARIS (1907)

MAURICE B. PRENDERGAST

To locate your next site, take the steps just before Pont Saint-Michel, ascend to street level, and survey ahead one of the oldest roads in Paris, Quai des Grands-Augustins. Although its name has changed numerous times, its original function, at the beginning of the 14th century, was to link the Royal Palace on the Ile de la Cité (to your right), via the bridge, Petit Pont (to your back), to the left-bank protective ramparts and the fortress-like Tour de Nesle (located ahead), both built by Philippe Auguste. The rampart and tower were located at the present-day east wing of the Institute of France. Bouquinistes, second-hand booksellers, have been here since 1619. One story purports that, at that time, Louis XIII wanted to allow his servants to make extra money, and offered them the privilege of selling used books on the quay. Irrespective of how they arrived, bouquinistes now crowd the quays between Pont Royal and Pont Sully (crossed later on this tour). To find the location of the next matched pair, move left to the quay and then left again onto Pont Saint-Michel. Ahead, and depicted by the next featured artists, are Notre-Dame, Petit-Pont and Quai Montebello.

Wishing to go to art school and gain inspiration, Prendergast, an American, came to Paris in 1891 and stayed until 1894. Already an illustrator and self-taught painter, he joined the Académies Julian and Colarossi. His first body of work consisted of watercolors and oils of women and children in Paris (see tour 7) and at the French seashore.

Although his second trip, in 1907, only lasted five months, Prendergast was able to complete three different bodies of work. *Notre-Dame, Paris* (1907) is representative of Prendergast's watercolors painted during this time; he is still working in a manner he discovered during his first, more extended visit to Paris, and during a trip to Italy in 1899.

In this Impressionist study, Prendergast works quickly to capture the moving figures on the bridge and the effect of the sunny yet cloudy day. Mindful of creating a passing moment, he depicts dresses which seem to swish and swing as the women walk, and bits of blue sky which appear only briefly as the clouds move swiftly overhead.

Prendergast's training as an illustrator ensures his attention to composition. Trying a new approach for this depiction, he lowers the horizon line and extends the depth of field. Notre-Dame is used as a decorative background for the bustling activity in the foreground; in the fashion of the classic Impressionists, the painting could almost be considered a cloud study.

Prendergast has been acknowledged as being the foremost, American watercolorist to use an Impressionist style. The highlight of Prendergast's five-month stay was his visit to the fifth Salon d'Automne, which included a retrospective exhibition of Cézanne's work and a showing by the avant-garde Fauvist artists. His future work would be directly influenced by Cézanne's use of color and the "wild beasts." Thereafter, Prendergast no longer considered himself an Impressionist, and was instrumental in spreading the even newer French artistic techniques and philosophy to the American art world.

Construction of Paris' cathedral started in 1163 under Bishop Maurice de Sully. It was not completed until the 14th century. Easily missed from your position on Pont Saint-Michel is the steeple built by Viollet-le-Duc during the reign of Napoléon III.

Petit-Pont is the shortest bridge in Paris and also the oldest. Originally dating from Roman times, Petit-Pont was rebuilt in stone by Bishop Sully 23 years after the construction of Notre-Dame had started. The present bridge dates from 1853, but it had been repaired or rebuilt at least eleven times before then. Fires and floods oftened proved to be the source of devastation. In 1788, the double rows of houses standing on the bridge were demolished by royal edict issued two years earlier. The aesthetic beauty, created by a houseless and fire-free Pont-Neuf, had not gone unnoticed. The houses on Pont Saint-Michel, which used to stand where you are standing, were also destroyed in 1807.

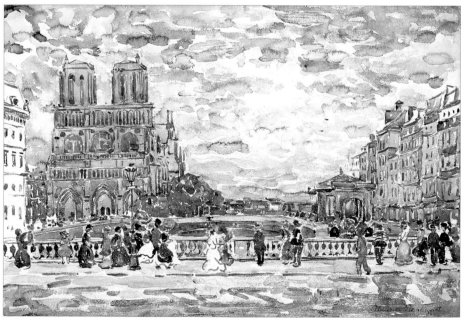

To leave the bridge, turn right, cross left at the light, and continue forward on Quai Saint-Michel; the water will be to your left. Look to the right to identify 19 Quai Saint-Michel, and stop. This building is the location of several artists' former studios, dating from as early as 1895; the most desirable ones had views of Notre-Dame, the bridges and the river from their upper-story windows. Matisse, though not an Impressionist, is the most well-known. The next featured artist also had a studio with quay-facing windows from which he depicted Paris in a landscape setting. As an elevated view is impossible here, the best street-level position from which to make your painting comparison is between the metal containers of the bouquinistes, in front of number 13. Before looking toward Notre-Dame, glance to the right to see Rue Xavier Privas, and to the left to see Rue du Chat-qui-Pêche. Both are typical of the streets which led to and bordered the Seine here before Quai Saint-Michel was built in 1812.

7. THE QUAI SAINT-MICHEL AND NOTRE-DAME (1901)

MAXIMILIEN LUCE

Political as well as artistic concerns inspired Luce to paint his depiction of Notre-Dame, the Petit-Pont and the activity along the quay. A respect for Seurat as a friend and as a theorist led Luce to adopt as early as 1887 the contemporary artist's divisionist theories. *The Quai Saint-Michel and Notre-Dame* (1901), one of a series started in 1899, exemplifies Luce's own investigation and interpretation of the neo-Impressionist style. Unconfined by the scientific constraints which controlled Seurat's palette, Luce juxtaposed a rich variety of color combinations on his canvas. Rose next to deep blues and purples in the shadow areas, and the addition of red without green in the sparkling face of Notre-Dame, result in a dynamic contrast of color and light. As significant as Luce's exploration of artistic technique is his choice of subject. The symbol of Paris, Notre-Dame, is no more important than the people who occupy the city. A man of anarchistic political views, Luce is purposefully drawn to depict both women and men who are burdened while slowly making their way along the quay.

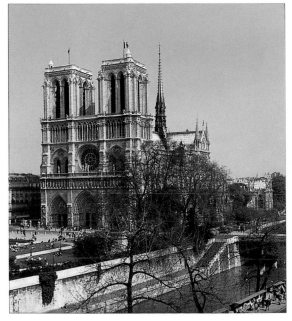

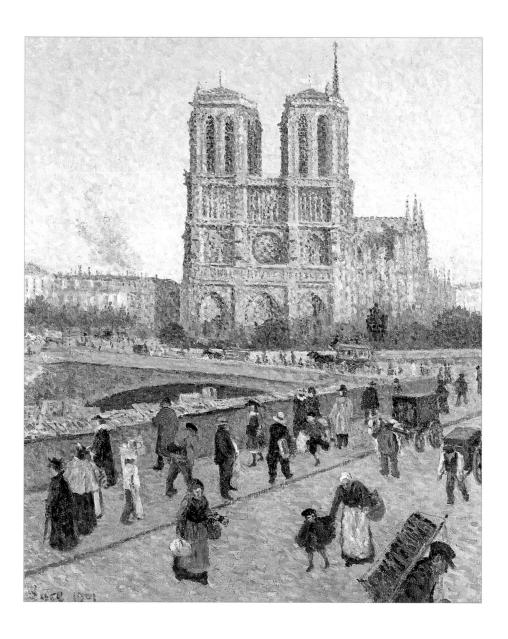

Recommended before searching out your next painting comparison sites is a visit to both Notre-Dame and the archaeological crypt located underneath the expansive area in front of the cathedral. During the excavation for an underground car parking area in 1965, building foundations of Gallo-Roman and medieval buildings were discovered there. Proceed forward to the Petit-Pont and stop. Look to your right to note the straight, ancient Roman road, Rue Saint-Jacques. Turn left onto the Petit-Pont, proceed forward and, at its conclusion, turn right. The entrance to the crypt is straight ahead to your left.

You are standing on the modern parvis of Notre-Dame. During medieval times, miracle plays, were performed in the old parvis in front of Notre-Dame. This then tiny area represented *paradis*; eventually the word evolved and shortened to *parvis*. Its enormous size dates from the 19th century. Haussmann's controversial decision to level the narrow, winding streets of the slums surrounding Notre-Dame increased this area sixfold. Many thought medieval Paris need not be destroyed. Others also argued that the aesthetic and intimate manner of viewing only bits and pieces of Notre-Dame at any one time would be sadly and irrevocably altered. Of course, Haussmann won. Over 15,000 poor Parisians were displaced. After your recommended visit to Notre-Dame, turn left when you come out of the cathedral. Pass the neo-Gothic buildings designed by Viollet-le-Duc, and travel forward across Pont au Double. This bridge was built in 1625 primarily to connect two wings of the Hôtel-Dieu, which, by this time, had extended to the left bank; a third wing of the hospital was built on the bridge. Those wanting to traverse from the left bank to the parvis of Notre-Dame were charged a

8. PONT DE LA TOURNELLE, PARIS (1862)

STANISLAS LEPINE

Lépine had a penchant for searching out quiet, urban river locations at a time when modernization was transforming the banks of the Seine. Although he included the river activity, often complete with boats and people, his canvases read as idealized, poetic depictions. Figures, seemingly stopped in time, are minuscule compared to nature's majestic creations; Lépine did not adopt the Impressionists' desire to depict animated, fleeting moments.

Lépine's creative expertise does, however, overlap their desire to study atmosphere and light as it actually exists, and to record, firsthand, these visual perceptions. The childhood summers spent contemplating the volatile weather on the Normandy coast, coupled with his inclination toward artistic pursuits, paved the way for Lépine's extraordinary talent for depicting Paris' well-known but not overly loved grey sky.

Pont de la Tournelle, Paris (1862) is typical of Lépine's urban water depictions. Delicate brushstrokes of carefully mixed paint render each nuance of iridescent silver grey. Shifting diagonal lines draw attention to the buildings on the Ile Saint-Louis, yet Lépine's study compels the viewer to regard shimmering water and illuminous sky as being more important. Almost unnoticed are the people on the right.

Stylistically, Lépine's oeuvre parallels the early Impressionists' work. His age falls roughly between that of Monet, Renoir and Sisley, yet he never participated in group painting expeditions nor in group discussions with his contemporaries. When Durand-Ruel mounted his first major show in 1886 in

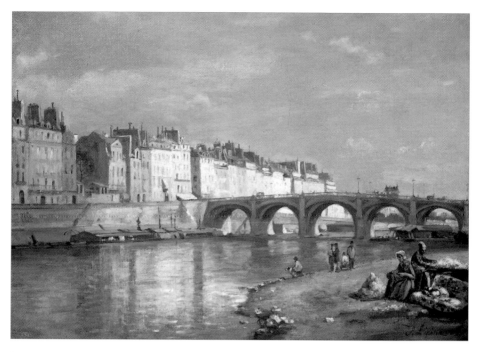

New York, "Works in Oil and Pastels by the
Impressionists of Paris," Lépine was included.
Lépine considers Corot, his friend and teacher, to be
his most important source of inspiration, although
traces of the influence of both Jongkind and Boudin
can still be detected in his works. Like Boudin, he
showed in the fledgling Impressionists' first group
exhibition. However, Corot's disapproval of any
independent activities precluded, probably prevented,
his further participation.

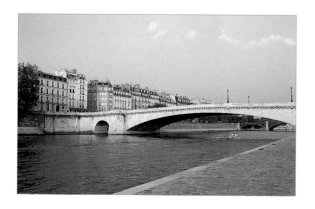

double tournois; the bridge derived its
name from this toll. When a fire
destroyed the hospital wing in 1871, a
new wing was never rebuilt; the toll was
abolished in 1789. The present bridge
dates from 1847. To the right, across
Quai Montebello is one of the oldest
churches in Paris, Saint-Julien-le-Pauvre.
The present building was constructed
between 1170 and 1240. To its right is
Shakespeare and Company, the historic
English bookstore. To proceed directly to
the next painting comparison site, turn
left from Pont au Double, descend again
to the water's edge via the steps,
continue along the remodeled quay until
you have passed under Pont de
l'Archevêché; stop near the 20th-century
brick building, and look left to make the
next on-site comparison.

A source of inspiration to the featured
painter were the uniform facades on the
Ile Saint-Louis and the stone version of
the Pont de la Tournelle, dating from
1656 when the island was first developed.

9. NOTRE-DAME VIEWED FROM THE QUAI DE LA TOURNELLE

(1852)

JOHAN BARTHOLD JONGKIND

Before proceeding to your next destination, scan the entire lengths of both Ile Saint-Louis and Pont de la Tournelle. The island was developed by Jean-Christophe Marie, with the permission of Louis XIII, between 1627 and 1664. Twenty of the finest architects were hired to build elegant houses with inner courtyards and vistas of the river. Access to the left bank was needed and, as land was being divided on the island, Pont de la Tournelle was constructed. Built of wood several times during the 17th century, it was finally built of stone in 1656. The present-day bridge dates from 1928, as does the modern needle-like sculpture of Paris' patron saint, Sainte Geneviève.

After venturing to Paris in 1847, Jongkind was the first cityscape painter in the capital city to permanently abandon an indoor studio. Intrigued with the notion of painting outdoors, he set up his easel where you are now standing. The result, an example of one of his first Paris cityscapes, *Notre-Dame Viewed from the Quai de la Tournelle* (1852), goes beyond both French and Dutch influences and, remarkably, predates the Impressionist paintings of Monet, Pissarro, Renoir and Sisley by more than ten years.

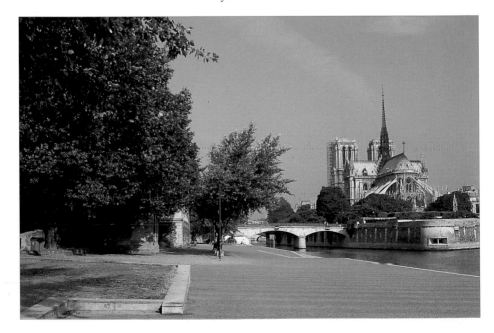

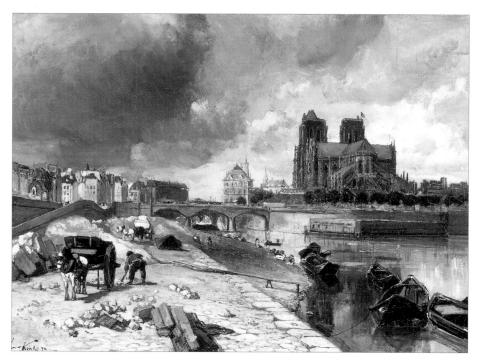

As an storm threatens, Jongkind rapidly executes a direct observation of shifting weather conditions, the grandeur of Notre-Dame seen from the riverside, and a solitary worker struggling with his shovel on the quay. To heighten his perception of the harmony of color and light, he uses a limited palette of blues, greys and earth tones. A smattering of red adds drama to the impending event. Although his sensory "impression" is the major subject, Jongkind, mindful of his art school education, renders physical motifs accurately, and his work has a finished quality. After observation of this location through Jongkind's eyes it comes as no surprise to learn that, thirty years after the painting was completed, Edmond de Goncourt wrote about this artist, "Any landscape which is of value today descends from his work, borrowing his skies, atmosphere and earth."

Two different artists, separated by over half a century, cast their painters' eyes on your next painting comparison site. One was a brash precursor of Impressionism and the other was a seasoned veteran. To compare both works to each other and then to the site, proceed forward and turn around after passing the tiny brick building. Before you is the often-written-about, spectacular view of Notre-Dame's bold, flying buttresses. Only one painter features the steeple built by Viollet-le-Duc in 1879, but both feature Pont de l'Archevêché constructed in 1828. Not featured in either painting is Pont Saint-Louis, painted green, to your right. It connects the two islands and has been rebuilt a number of times. First built in 1627, the present bridge dates from 1970.

10. THE QUAI OF THE TOURNELLE AND NOTRE-DAME OF PARIS (1909)

ALBERT LEBOURG

R ouen-born Lebourg's interest in architecture evolved into a love of painting, and a chance encounter led him to Algiers in 1874 where he taught drawing. While working there, in relative isolation from the art scene in Paris, he began to paint landscapes using the same motif under light conditions that changed during the day. In 1877, he returned to France, and settled for a time in the capital city.

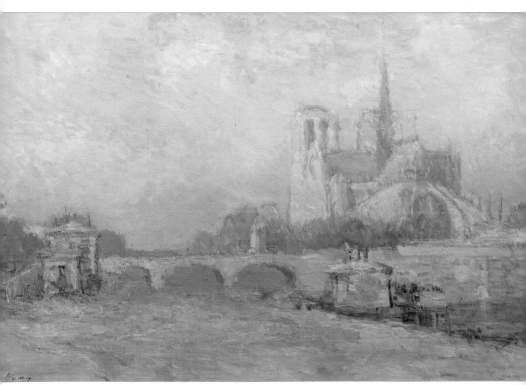

Lebourg discovered there that his creative investigations had independently paralleled those of the Impressionist painters. Lebourg's innate attraction to water as a painting motif led him eventually to specialize in river scenes. As quays were constructed and riverbanks changed, Lebourg eliminated from his paintings most hints of the modernization that was occurring. His "cityscapes" usually depicted a charm and beauty of earlier times.

The Quai of the Tournelle and Notre-Dame of Paris (1909) is typical of his consistent Impressionist style. Always mindful of light, structure and color, he represents the transitory quality of a cloud-filled winter sky. Loose, wispy brushstrokes denote Notre-Dame and the bridge as solid yet weightless, and interwoven complementary warm and cool colors create a surprisingly delicate effect.

Lebourg's narrow selection of motifs brought him Salon acceptance after 1883, but, at the end of his life, he affirmed his roots and dedication to Impressionism by asserting, "I am an Impressionist in that I am impressed by the present moment."

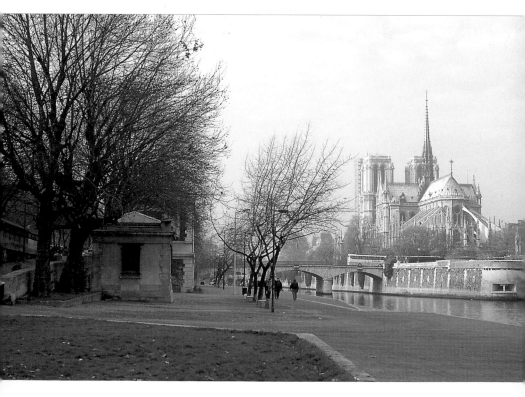

To continue to your next destination, turn around, mount the road by Pont de la Tournelle and, at street level, look right. At number 15, across Quai de la Tournelle, is the world-famous restaurant, La Tour d'Argent. Established in 1582, it is as fashionable today as it was then; the quay itself has existed in various forms since 1340.

During the 17th century, the area to your left was the most thriving, active port of Paris. It had, by that time, replaced the Place de Grève near the Hôtel de Ville in commercial importance. To visually understand the variety of people living here and the activities going on, see Quai and Pont de la Tournelle (vers 1645) by Mathan, at the Carnavalet Museum. The depiction, done by a Dutchman, is one of the earliest cityscapes of Paris, and the style has proven to be a forerunner to the Impressionist movement.

To proceed to your next painting comparison site, continue forward, pass Pont Sully (the only bridge to link both right and left banks of the Seine to Ile Saint-Louis), and almost immediately turn left onto a dirt path leading down to the water beyond. Continue forward into the outdoor sculpture garden, and move along the water's edge until you can see the tip of the island and the dome of Saint-Paul-Saint-Louis, when you turn back to view them, on your left. The wooden pier, featured in the painting, which protected docked boats from the ice-filled Seine in the winter, no longer exists. Originally built in 1750, it was rebuilt several times but finally disappeared in 1932.

11. THE QUAI DES CÉLESTINS AND THE ESTACADE (1870)
STANISLAS LEPINE

The silvery, cool light peacefully settling on the distant dome of Saint-Paul-Saint-Louis and the multicolored reflections shimmering on the River Seine have not notably changed since Lépine viewed and painted this spot well over one hundred years ago. Although he fell in love with the narrow paths of Montmartre and, early in his painting career, had depicted its quiet village ambiance, Lépine spent the majority of his painting life creating urban water scenes both in the Ile-de-France and on the Normandy coast.

The Quai des Célestins and the Estacade (1870) is one of at least two paintings done at the same location. Painting from life, but not working in series, Lépine returned to a location, sometimes even years later, to restudy and recapture the never-ending nuances of a greyed light. It is a tribute to his expertise that Lépine, preferring the persisting overcast day, does miraculously leave the viewer with a nagging doubt. Will the sun suddenly emerge from behind the moving clouds, or will a sudden downpour drench him and his canvas? Grey is grey, but Lépine's grey is brimming with potential life and vitality. Although Lépine was accepted at the state-run Salon as early as 1859, and a version of this painting won a medal at the Salon of 1889, financial success eluded him.

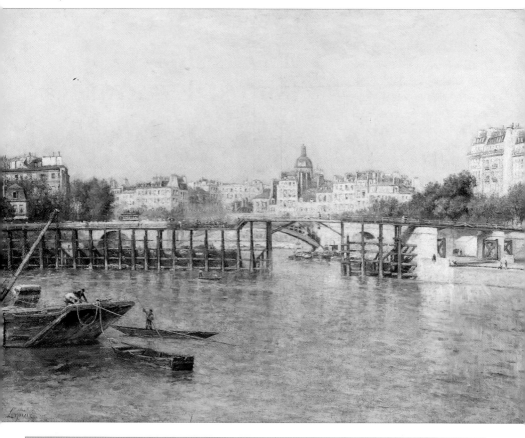

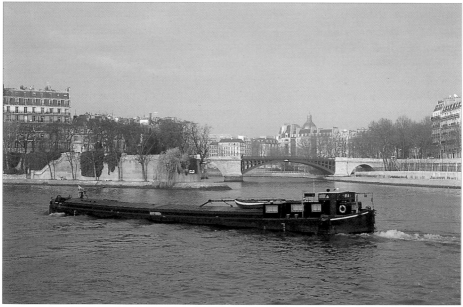

12. QUAI BOURBON, PARIS

LUIGI LOIR

Backtrack along the dirt path, at Pont Sully turn right onto the bridge, and cross to the left side with the traffic light. When crossing, notice the view of the Panthéon to your left and the column at the Place de la Bastille to your right. An example of Haussmann's obsession with perspective in his redesigning and expanding of Paris during the 19th century: Places with monuments or points of interest were, if possible, connected to other such locations. When a new bridge was needed to connect the right and left banks through Ile Saint-Louis, Haussmann insisted on an angle which differed from that of the other bridges crossing the Seine. As "his" Pont Sully would connect to "his" Boulevard Henri-IV and Place de la Bastille, established since 1803 on the right bank beyond, the new bridge and boulevard would be optically aligned with the Panthéon and the Bastille column. A change of pace in your walk here, as the island's 17th-century, hamlet-like atmosphere remains unspoiled. Turn right immediately, cross the main street of the island, Rue Saint-Louis-en-l'Ile, and continue along the curve to Quai d'Anjou. Cross to the river side in order to properly view the many elegant, 17th-century facades which still line the quay. In 1627, Christophe Marie obtained permission from Louis XIII to join and develop the two separate, small bodies of land that lay east of Ile de la Cité. By 1662, work had been completed on this upscale housing development (the first in Paris). Essentially designed for and bought by the aristocracy, many of the homes were masterpieces of architectural design; the most sumptuous faced the quays and thus had sought-after views of the river. Plaques on the exterior walls tell of many distinguished former

Removed from the hustle and bustle of the city, Quai Bourbon and Quai d'Anjou on Ile Saint-Louis are every bit as subdued today as in Loir's late 19th-century, mistitled representation, *Quai Bourbon, Paris*. Loir found particularly challenging the painting of outdoor Parisian life at night, infrequently portrayed by the Impressionist painters. His depiction, which includes both artificial and natural light, is made more technically difficult by his choice of a dense, foggy atmosphere. Representing glowing gas lamps, vehicle headlights and interior bulbs, odd-shaped, dazzling yellow specks pierce the soupy night air. Subtle changes of tone, applied with delicate brushwork, define the worker's apron; fuzzy images are used to represent trees, buildings and the bridge. Combining the naturalism of the Barbizon school with the "fleeting moment" technique of the Impressionists, Loir employs a palette of yellow-orange and green-beige, reminiscent of Corot's and Daubigny's oeuvres of the 1830's and 1840's, while soft, nondefined lines recall those which Monet, Renoir and Sisley perfected during the 1870's. Loir, a naturalized French citizen of Italian descent, was born in Austria. He studied fine art in Italy, and decorative art in Paris. He never exhibited with the Impressionists, but he began to show at the Salon in 1865. Loir is one of two painters in this book who do not conform with the standards for inclusion laid out in the introduction, but his painting is too "perfect" an example of an Impressionist cityscape to be ignored.

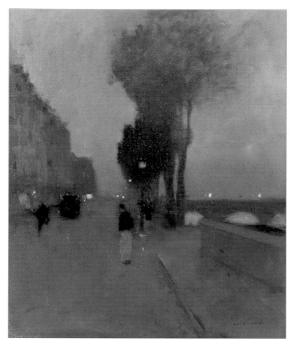

residents. Notably, Daumier, famous for political caricatures during the middle of the 19th century and also oils of washerwomen along this section of the Seine (seen at the Orsay museum), lived at number 9, and Daubigny, a forerunner to the Impressionists (also exhibited at the Orsay), lived at number 13. The latter address was also the studio of Guillaumin. During the 1880's, he and his friends, Pissarro and Cézanne, met here to continue discussions started when they all had been friends at the Académie Suisse in 1864. Interestingly, when these noteworthy artists lived on Ile Saint-Louis, the island had deteriorated, partially due to the migration of the displaced Parisians from the newly-restructured Notre-Dame quarter, into a virtual slum. Stop beyond number 17, near the intersection of rue Poulletier and Quai d'Anjou, to view your next featured site through the eyes of the painter. The street was named after one of the master builders who, along with Marie, developed this part of the island, and the bridge to your right is Pont Marie, named, of course, to honor Christophe Marie.

Pont Marie was opened in 1635 to allow access between the island and the right bank, but its history has been marked by a number of disasters. The houses once lining it were demolished in 1786, and the present bridge dates from 1850. Still empty are the niches, designed to house sculptures.

To continue, proceed along Quai d'Anjou and, just past Pont Marie, take the steps leading back to the water's edge. Look to the left in the direction of Pont Louis-Philippe and beyond. Continue forward on the remodeled quay until you can see the double roofs of Châtelet and the tower of Saint-Jacques peeking out near the decorative roof of the Hôtel de Ville.

Your position is more than adequate to view this once active section of the Seine depicted by the next featured painter. As late as the 1920's, floating wash-houses could be seen between Pont Louis-Philippe and the area beyond Pont Marie, to your right. Pont Louis-Philippe, first built of iron in 1833, was replaced in 1861 by this present-day, stone structure.

13. PONT LOUIS-PHILIPPE (1875)

ARMAND GUILLAUMIN

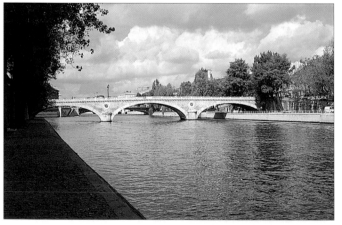

While living at 13 Quai d'Anjou, Guillaumin could step out his door and witness, firsthand, the continuous heavy river traffic. Boatmen trying to maneuver between clogged barges and burdened laundry women coming and going along the wooden planks were both a common daily sight. His job, working for the city of Paris in a department supervising the bridges and roads, also placed him in riverbank locations. With this consistency of daily, visual stimulation, it is no wonder that bridges and quays played an important role in his paintings of the 1870's and 1880's.

Although the importance of the Seine as a major artery for goods and services had been explored by several 17th- and 18th-century painters (see Carnavalet Museum, Paris), Guillaumin's *Pont Louis-Philippe* (1875) is distinctively modern in its execution. Following in the tradition of more well-known Impressionist artists, warm and cool tones are used to depict the areas of sunlight, shadow and water. The railroad had begun to symbolize, in both literature and painting, France's progress in the industrial age

(see tour 5); Guillaumin's painting, in the tradition of
Jongkind, reminds us that the Seine was still playing
a vital role in the city dweller's life. Contrary to
Lépine and Lebourg, Guillaumin creates an
impression of action and activity, both decidedly
classic impressionistic traits.

Guillaumin, while not adequately acknowledged in
20th-century, art history accounts of Impressionism,
was nonetheless a charter member when the first
independent exhibition was mounted. Of the thirty
participants he, along with Degas, Monet, Morisot,
Pissarro, Renoir and Sisley, were the only ones to be
identified as part of the "new school." Guillaumin
was also later included in the exclusive seventh show
of 1880, when only those current artists considered to
be "real" Impressionist painters were invited.

Despite two major catalogues of his work, art
historians are still unable to assign exact paintings to
exact titles listed in the independent exhibitions. The
featured painting could very well be the Pont Louis-
Philippe listed in the seventh exhibition. Others had
used these exhibitions as a forum to mount a
progression of work which included older paintings
so, in view of the limited number of exhibitors, why
not Guillaumin too?

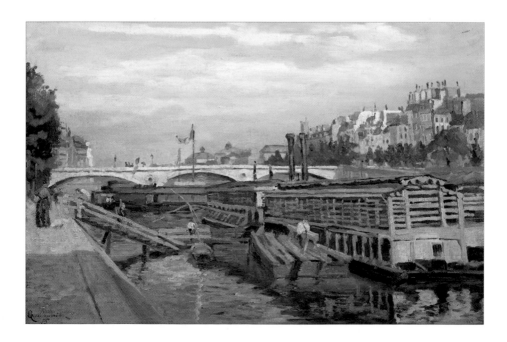

14. THE PONT MARIE

(1883)

ARMAND GUILLAUMIN

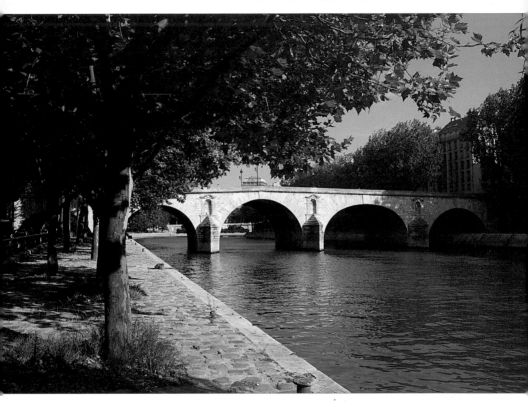

To arrive at your final painting comparison site, continue forward, mount the steps just before Pont Louis-Philippe, and cross the bridge to your right. At its right-bank end, turn back and face toward Ile Saint-Louis and Pont Marie. To your right is a wonderful view of the Panthéon.

As you have just seen, Guillaumin's early canvases have the short flicks of brushstrokes that "explain" the naturally reflected light of Ile-de-France, and his cityscapes are characterized by a delicate, harmonious quality despite their modern subjects. By the late 1870's, however, structure, form and the exploration of color have become as important as Impressionist-based sensibilities concerning light. *The Pont Marie* (1883) is a transitional painting. The pinks and blues from the sky do flicker on the Ile Saint-Louis building facades, trees and bridge, but the large area of yellow-orange sand, purposely placed in the middle of the canvas, is a decided change from the usual impressionistic composition and technique. A fleeting moment of

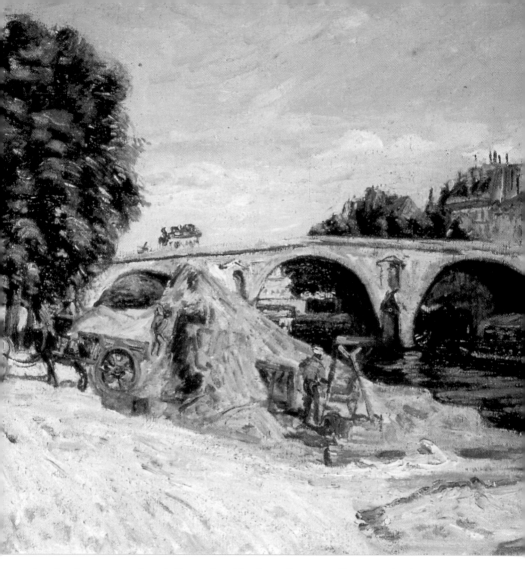

time has been arrested, and diagonal and horizontal lines almost divide his canvas into non-harmonious color areas.

Guillaumin predates other more well-known artists whose natural evolution would also take them into the arena of color. Van Gogh and Signac both had great admiration for Guillaumin, whose studio on Ile Saint-Louis became a gathering spot for them as well as for his old friends, Pissarro and Cézanne. At the age of fifty, Guillaumin, who had never had enough money to paint full-time, won a French lottery. The considerable sum of money he won allowed him to travel and paint for the rest of his life.

The metro station closest to your present location is Pont Marie (La Défense-Château de Vincennes line). Recommended at this time, however, is a further exploration of the two islands or a stroll toward the Hôtel de Ville to the curved pedestrian bridge located on your left. This bridge leads to another Batobus station, located at one end of a secluded park by the river's edge.

TOUR 3
From Palais Royal
to Place de l'Etoile

A variety of creative directions were explored by the artists who became known as Impressionists; no one artist could be said to represent every aspect of their philosophy. Tour 3 offers the unique opportunity to compare and contrast, on the same walking tour, many of the most distinguished painters to their painted sites and then to each other. If you ask yourself at each site, what the artist's most important message was and to whom, you'll discover the variety of themes and painting techniques which art historians now classify as tenets of the Impressionist movement. This walk allows you to see the bigger picture of the group, and to appreciate the finer distinctions between the individual artists.

Specifically, Pissarro's depictions could be considered "review" works, executed near the end of his life. At two different locations, he methodically re-explored every technical problem of recording changing light and changing weather conditions. By the end of the 19th century, the Impressionist movement had been recognized by art critiques, collectors and dealers as an important step in the history of art, and Pissarro, the only artist to participate in all eight of the Impressionist exhibitions, surely knew his work would be studied by art students, art historians, and the public after his death.

Degas, Manet and Monet were all breaking new ground in their attempts to record "impressions" of contemporary locations featuring contemporary people. Degas was enamored with the interior light of the popular Ambassadeurs, *café-concert* on the Champs-Elysées; his development of the new motif encouraged other painters to follow suit. Manet was exploring paint application and compositional concepts, while Monet was adapting landscape techniques acquired in the country, to a city environment. Still others featured on this tour include a beginner

who was breaking new, creative ground for himself, and seasoned veterans who were combining Impressionist techniques with a more academic approach in an attempt to win public approval. Every conventional guidebook of Paris, in some form or another, features a walk from the Louvre and Tuileries Gardens, to Place de la Concorde and Champs-Elysées beyond, and this unconventional guidebook is no different. This walk physically spans four centuries of rich French history.

Allow at least a half day; there are metro stops along your route, which can save steps but not time. It is even recommended to take the metro to your last painting comparison site near the Arc de Triomphe, and if you are so inclined, you then walk downhill along the avenue that is famous throughout the world, the Champs-Elysées.

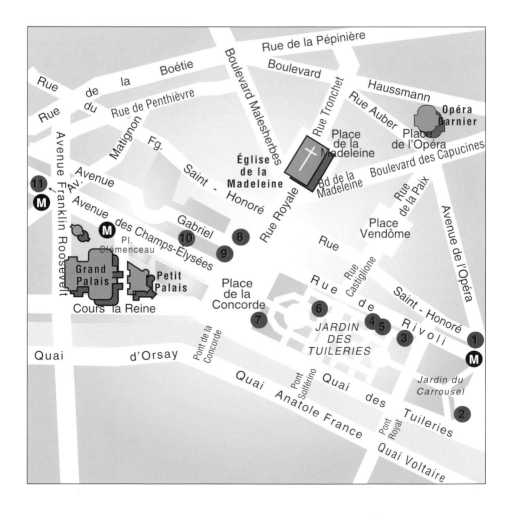

To start your next tour, exit the metro at Palais Royal-Louvre. If you are on the La Défense-Château Vincennes line, follow the *sortie* signs to Palais Royal. At street level, walk toward the "Conseil d'Etat" on Rue Saint-Honoré. Turn left on Rue Saint-Honoré, and situate yourself in front of the main entrance to the Hôtel du Louvre, on the corner of Rue Saint-Honoré and Rue Rohan. If you have arrived at the station Palais Royal-Louvre on the La Courneuve-Maire d'Ivry-Villejuif line, follow the *sortie* signs to Place Colette-Théâtre de la Comédie-Française; at street level, note the entrance to the Palais Royal, diagonally to your right, and cross to the left, Rue Saint-Honoré, to arrive in front of the main entrance to the Hôtel du Louvre. To orient yourself to this first site, place your back to the hotel entrance. The green-roofed Garnier Opera House is clearly visible at the end of the straight wide Avenue de l'Opéra; both are

1. PLACE DU THÉÂTRE-FRANÇAIS: SUN EFFECT (1898)

CAMILLE PISSARRO

Recurring eye problems and the unexpected loss of his son, Felix, did not deter Pissarro from undertaking yet another series of urban Paris landscapes. Undoubtedly following the advice he had given to his son Lucien when writing him about his brother's death, "we must work to heal our wounds," Pissarro painted fifteen canvases from an open window at the Hôtel du Louvre. Although three other works portray Rue Saint-Honoré to his left, here Pissarro concentrates more energy on absorbing, and then framing on canvas, the view straight ahead. As his eyes shift slightly from left to right, Pissarro's paintings become progressively more difficult to resolve; *Place du Théâtre-Français: Sun Effect* (1897)

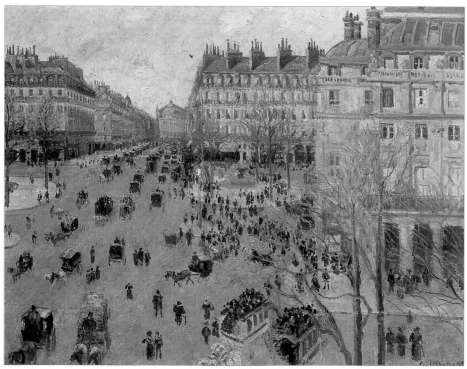

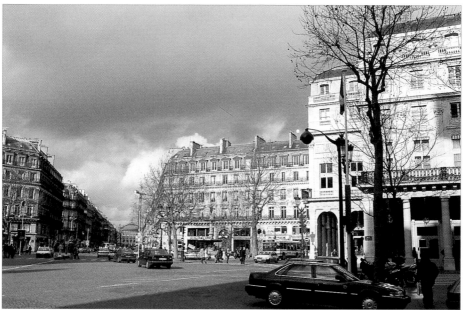

is a successful culmination of his efforts and perhaps one of the most dramatic works of his career. An unbalanced, off-centered composition is riddled with strongly opposed, pictorial motifs. Orderly traffic moving along the straight avenue disintegrates into chaos at the enlarged traffic junction, and two cut-off circular forms on the left disrupt the overall vertical orientation of the buildings. The opera building gently stops our eye in the background, yet the variety of intersecting streets and overlapping buildings in the foreground demands continuous visual motion. However, Pissarro's intrepretation of the golden warm light from an unseen sun brings harmony to his winter spectacle of modern Parisian life. Almost surprisingly, 100 years later, the objective reality of Pissarro's painted "impression" have not radically changed.

featured in your first painting comparison. To your right, across Place Colette, is the Théâtre de la Comédie-Française, also a motif in the painting to be compared. Avenue de l'Opéra was constructed in the mid-1860's and was the first to have gas lighting. The trees common to all Haussmann-designed avenues have since disappeared, but many of the buildings are still of his original design. The ground floor of each building was, and still is, reserved for shops, and the next floor, marked by little windows, was for the shop owners; today many businesses still occupy this space. Following are balconied second floors which originally housed the wealthiest residents. The third, fourth and floors were also apartments, but of lesser value as elevators did not exist when these buildings were constructed.
The top floor, under the roofs, were chambres de bonnes, small rooms for the servants of the residents below.
The first featured painter's position was from an elevated hotel window behind you; however your street-level position will not greatly affect your on-site comparison.

Cross Rue de Rohan at the light, immediately turn left, proceed forward, and stop at Rue de Rivoli. Across the busy street stretches in both directions the north facade of the Louvre. To the right is Pavillon de Marsan, now Museum of Decorative Arts; to the far left is the oldest remaining section of the former royal palace. Ahead are the arched passageways leading into and out of the Place du Carrousel, the large present-day courtyard of the Louvre Museum. To your right, Monet and Renoir both painted from an apartment at number 198, and Pissarro lived and painted at number 204.

When ready, cross Rue de Rivoli. Pass through the arches into the oversized, circular area, and continue forward on the sidewalk until the Arc de Triomphe du Carrousel is directly to your right. Built by Napoleon to celebrate his war victories in 1809, it was originally topped by horse sculptures stolen from Venice. They were returned in 1815, however, and those you see today are reproductions. The view up Avenue des Champs-Elysées, toward the Arc de Triomphe, is excellent from here. Behind you is the glass pyramid designed by Pei, which, since 1989, has been the main entrance to the Louvre Museum.

Place du Carrousel was fittingly named after a 1662 equestrian tournament; horses moved in a prescribed circular motion, hence the word carrousel.

At last, to arrive at the next painter's position, continue circling the Place along the curved sidewalk until it angles to meet a straight line, and turn back around to view the arch, the Pavillon de Marsan, and Rue de Rivoli beyond. Between the Pavillon de Marsan and the Pavillon de Flore (to your left) used to stand the Tuileries Palace, former royal residence of Catherine de Médicis. When it was burned down during the civil conflict following the Franco-Prussian War (1870-71), the new

2. PLACE DU CARROUSEL AND THE RUINS OF THE TUILERIES PALACE

(1882)

GIUSEPPE DE NITTIS

Unlike the most well-known Impressionist painters, De Nittis, an expatriate Italian, answered the call, after the Franco-Prussian War and the Commune of 1871, for artists to play an active role in Paris' recovery program. His response, *Place du Carrousel and the Ruins of the Tuileries Palace* (1882), is a contemporary landscape with a social message. Symbolically depicted in full sunlight are the rebuilt Pavillon de Marsan and newly cleaned Arc de Triomphe du Carrousel. Smoke emanating from the construction site in front of the gutted Tuileries Palace indicates that France is still actively moving forward, despite the defeat and destruction of the previous decade. Although in shadow, the well-dressed young woman and her chaperone reassure De Nittis' buying public that privilege and status are still very much in vogue; the underprivileged workers drudging through the square are appropriately contributing to the current economic prosperity, and pose no threat to the political stability of France's Third Republic.

Employing a blended technique of Impressionism and academic Realism, De Nittis renders some figures as flattened silhouettes while others are highly polished portraits. His placement of buildings follows the rules of academic perspective, yet his desire to capture a fleeting moment of moving people results in a large unorthodox, shadowed space emanating from the picture's center.

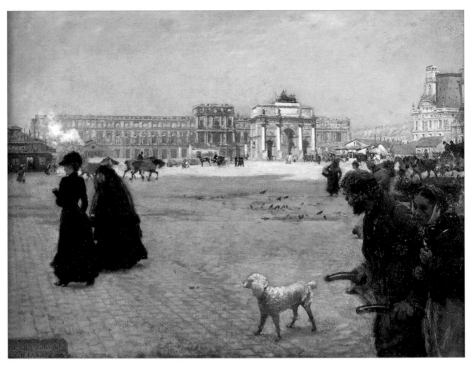

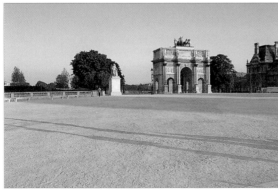

Republic was hesitant to restore such a blatant symbol of monarchial rule. With over 200 devastated public buildings to be rebuilt or repaired, and a five-millon-franc indemnity owed to the Germans, French leaders left the Tuileries a gutted shell until it was finally leveled in 1884. The two pavilions, however, were reconstructed during the early years of the new Republic.

De Nittis, not usually identified by art historians as being an Impressionist, did in fact exhibit at the first, ground-breaking independent exhibition. When making this on-site comparison, keep in mind that a variety of painting techniques were included in this controversial 1874 show; it was not only the core group of artists, called "Impressionists" by the critics, who were rebelling against the arbitrary and unpredictable jury system of the Salon exhibitions.

Controversy seemed to follow De Nittis. Invited by Degas to participate in the first Independent exhibition, his paintings were hung only after the opening day; Renoir thought his selections too academic. Despite his friendships with Caillebotte, Degas and Manet, these more innovative artist-collectors did not buy his work, and, although the Orsay Museum owns and hangs his paintings, his name is not mentioned in any of the museum catalogues. He only showed once with the Impressionists and died at age of thirty-eight.

To continue, proceed forward beyond the Arc de Triomphe du Carrousel. The gardens, replanted in the 1990's, date from 1909. For 20 years after the clearing away of the "demolished" Tuileries Palace, the area was a grassy patch with laid-out paths. Its name, Jardin du Carrousel, dates from this period, but it is now generically referred to as part of the Tuileries Garden. When you pass beyond the end pavilions of the Louvre to your right and left (between which stood Catherine's former palace), you are entering the location of the original garden built during the 16th century. Its history dates from the 15th century when tile kilns (*tuileries*, hence the name), shared the area with a refuse pit for butchers and tanners. Catherine de Médicis, who no longer wished to live in the royal residence after the "accidental" death of her husband, Henri III, decided to build her château (the Tuileries Palace) as an alternative home to the Louvre. She also bought land to create an Italian-style "backyard" garden, and hired Le Nôtre to design it. His garden, which included fountains, a grotto, a zoo, and a silkworm farm, attracted fashionable Parisian society. Strolling in the Queen Mother's garden became a fad, and, for the first time in French history, elegance was displayed outdoors. About 100 years later in 1664, Le Nôtre's grandson, also a gardener, was entrusted by Louis XIV and Colbert, his chief advisor, with the task of redesigning the garden. Le Nôtre, who was also the landscape architect for Versailles, created in the Tuileries what was to become the archetypical French, formal garden design. To achieve the desired effect of balance and symmetry, he included two terraces, a central alley, basins with fountains, geometric flowerbeds, and rows of trees. It bore no resemblance to his

3. VIEW OF THE TUILERIES (1876)
CLAUDE MONET

Monet's *View of the Tuileries* (1876) is one of four executed from collector Victor Choquet's apartment on Rue de Rivoli.
Dissatisfied with living in Argenteuil, Monet temporarily moved back to Paris, seeking greater artistic stimulation. With the exception of the round basin, water is not depicted in this cityscape, but the canvas is reminiscent of his sun-drenched, Argenteuil boating scenes of the same period. Typical of Monet's classic, Impressionist technique, warm and shadowed areas burst with reflected color; bluish white creates an overall shimmering effect. The flickering texture of foliage balances the solid form of the Pavillon de Flore, and he makes only slight reference to Paris' urbanization in the background. As already noted, Monet purposely excludes the gutted Tuileries Palace from his composition.
Few reproductions of this painting do it justice; it is well worth it to see the original at the Marmottan Museum in Paris.
Although the painting already was sold, he showed it at the third Impressionist Exhibition the following year; Monet was satisfied with the result of his labor.

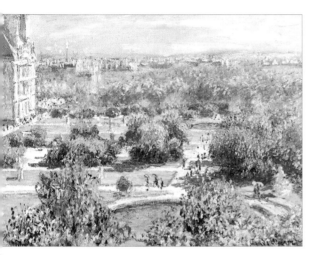

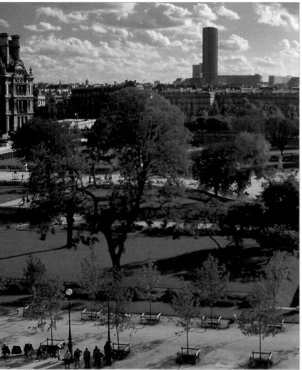

grandfather's design, but continued nonetheless to attract the upper class for another 100 years. The garden was refurbished in the 19th century, and its fashionability was re-established.

Another face-lift occurred late in the 20th century; the garden today mirrors Le Nôtre's original 1664, formal French, garden design.

Stop for a moment before descending the steps into the garden. To avoid frustration, as viewing painting sites can be confusing, familiarize yourself with the buildings and basins seen in the next three painting site comparisons. Orienting yourself in advance can make your comparison experience almost as rewarding as being in the upstairs apartments where the paintings were actually executed.

For example, in the first painting, Monet depicted the Pavillon de Flore (left) and the small pool on your right; he excluded the gutted palace. Your present position is just outside the scope of his painting. (Note that the basin featured in Monet's painting can barely be seen on the left edge of the corresponding photograph.)

To continue, travel along the dirt path, turn right at the first alley, and continue forward circling the round basin. Once past this pool, resume your forward direction on the path's continuation, and stop where the grass ends.

Ahead is the location of Monet's apartment on Rue de Rivoli; to see how he depicted his "impression" of trees, people, sculptures and buildings, turn around.

(Renoir also painted from this upstairs apartment The Tuileries (1874), a view quite similar to that in the Pissarro painting to be seen next, and Portrait of Madame Choquet (1875), which features the gardens in the background, out the window and to her side; neither are featured on this walk.)

Turn right and continue on the alley parallel to Rue de Rivoli. When the large basin is to your left, turn right and approach the outer wall of the garden. Pissarro's upstairs apartment is ahead on Rue de Rivoli. To make your next two painting comparisons, turn around. Pissarro's first featured painting includes the basin straight ahead. (This painting does not include the basin painted by Monet, but other works from Pissarro's series, which you can see in art books and public museums, shared Monet's motifs.)

4. THE TUILERIES BASIN, AFTERNOON, SUN (1900)

CAMILLE PISSARRO

Pissarro's tremendous output of works painted from his apartment on Rue de Rivoli constitutes his fourth series of Paris landscapes. Nearly thirty paintings depict a "city" of various combinations of trees, paths, sculptures, buildings and people, a city which exists within the larger city of Paris. As in his "Opera" series, seen at the beginning of this tour, Pissarro is again addressing the question of opposition and harmony. However, it is typical of this series that light is not the only unifying element; repeated, contrasted forms (both round and straight) flow and blend to create an overall harmony.

In *The Tuileries Basin, Afternoon, Sun* (1900), the round pool gently merges with rectangular paths, both of which mimic the exterior lines of the expanses of grass. Rounded, straggly tree branches gradually form uniform rows. The sense of unity is further reinforced when shapes outside the garden are mirrored inside. The double spires of Sainte-Clotilde, the curved dome of the Invalides, and the horizontal crane at the construction site of the new Orsay train station, all recall the vertical line of the spouting water, the curved oval of the basin and the formal symmetry of the garden.

A canvas which has been divided in half permits an overabundance of sky and thus light; Pissarro observes and paints the thickish air on a cloudy day. Nuances of reflected orange appear in bluish shadows, and overall unity of color is attained by an astute understanding of how light, color and atmosphere coordinate and combine to create a whole.

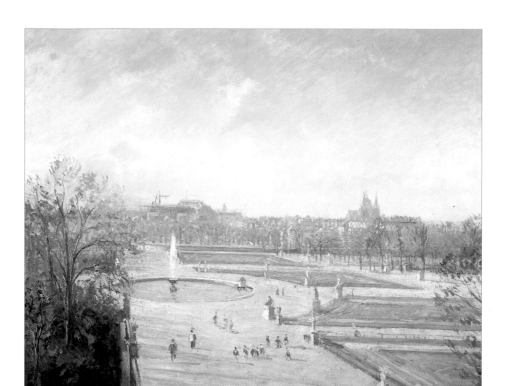

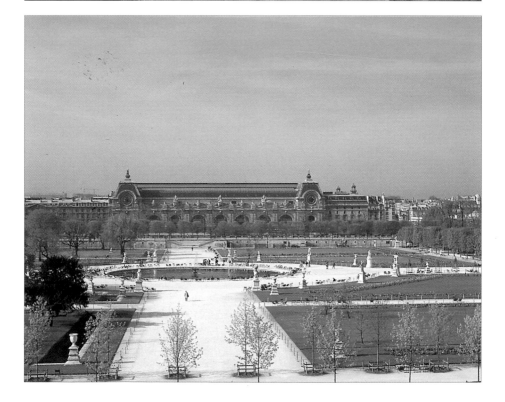

Pissarro's second painting features the Pavillon de Marsan. An underground road has all but destroyed the unpaved path featured in his painting.

After viewing these three paintings, stand here and mix in your consciousness five centuries of rich history which intimately affected upper-class Parisians; you are in the former garbage heap of the 15th century, the Italian park of the 16th century, and the formal garden originally from the 17th century.

5. PLACE DU CARROUSEL, THE TUILERIES GARDENS

(1900)

CAMILLE PISSARRO

From a different window of his apartment, Pissarro looked to the extreme left to paint *Place du Carrousel, the Tuileries Gardens* (1900). The Pavillon de Marsan cuts off the south side of the Louvre to create a closed, almost intimate corner of the garden. Pissarro does, however, make us aware of the city beyond, by including the distant top of the left-bank Institute of France, viewable between the double pavilions of the Louvre and the twin towers marking the entrance into Place du Carrousel.

Pissarro is defining a series of relationships, both contrasted and congruous. Green-leaved trees are intermingled with changing autumn ones; an ill-defined rectangular patch of greenery divides moving carriages from strolling or standing pedestrians. Bits of pure orange and red complement the areas of blue and green, and geometric shapes appear both in shadowy and sunlit areas.

It is an odd quirk of fate that, while re-exploring Impressionism, Pissarro re-explored the same vista his friends had painted more than 20 years before. Pissarro was certainly aware of the previous works of Monet and Renoir, but his choice of place to live and paint was, in fact, based on both his needs and those of his wife, Julie.

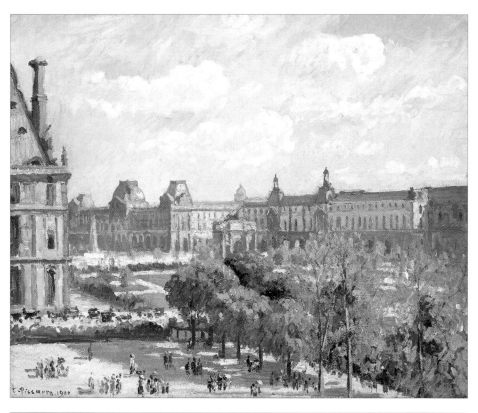

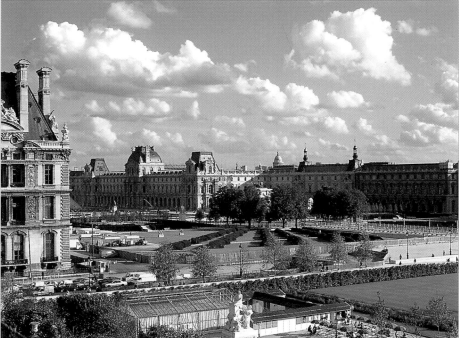

6. MUSIC IN THE TUILERIES (1862)

EDOUARD MANET

To continue, move forward to the large basin (featured in the Pissarro painting), turn right and continue along the main path of the garden. Your next painted location, as depicted by the artist, simply stated, no longer exists. The children's merry-go-round, however, just beyond your present position to the right, is an appropriate place to stop.

As you approach the area, imagine the 19th century, when the garden was the most popular airing spot of former aristocrats and upper-class bourgeoisie. Twice weekly, they flocked to the outdoor bandstand, located just outside the royal palace, to hear a concert. The next featured painter, himself an upper-class Parisian, felt very much at home during his afternoon walks in the Tuileries. Gone is the social elite of 19th-century Paris, but the courtly atmosphere still prevails.

Although Manet never exhibited with the Impressionists, his paintings influenced, and later were influenced by, the younger painters. *Music in the Tuileries* (1862) is an early, large cityscape. The composition of recognizable people in a crowded outdoor setting created quite a controversy the following year, when it was shown on the fashionable Boulevard des Italiens. Brushstrokes are forceful, trees are laid in with a palette knife, parts appear unfinished, faces are flat and left unmodeled, black and greys dominate the canvas, and Manet did use photographs for some of the portraits. Seen in profile

The next featured artist was situated
on the western *terrasse* of the Tuileries.
To position yourself correctly in order
to fully appreciate his painted motifs,
and also to orient yourself for the two
following artists, return to the central
alley, continue walking forward,
circle the octagonal basin to the left,
and climb the slope. When it merges
with the *terrasse*, continue forward
to the balustrade and stop; before you,
below and beyond, is an enormous area
of seemingly endless traffic activity.

behind the seated woman is Manet's close friend
Baudelaire, who accompanied him on frequent
sketching jaunts to the gardens; Manet himself is
featured, immaculately dressed in his standing
"uniform" of a formal, black suit, top hat and cane,
on the left.
Manet did in fact epitomize the modern, privileged
class of mid-century Paris, and he drew inspiration
from his own milieu for this particular exploration
of a contemporary urban scene. Manet's oeuvre
of Paris cityscapes does not, however, exclude other
social classes.

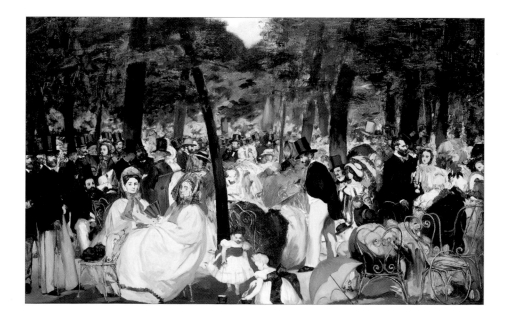

7. PLACE DE LA CONCORDE

STANISLAS LEPINE

Reflecting the political history of France, the "royal" square (geometric in shape with uniform buildings providing a suitable setting for a statue of a king) has changed names five times: Place Louis XV (1763), Place de la Révolution (1792), Place de la Concorde (1795), again Place Louis XV (1814), Place Louis XVI (1823), and finally back to Place de la Concorde (1830). Paralleling the art history of Paris cityscapes, the location has been a constant source of creative inspiration for painters.

Construction on the Place began in 1757, after architect Gabriel won a design competition. It was named to honor King Louis XV, reigning at that time.

By 1775 there existed the twin colonnaded buildings bordering the Place to your right. Straight ahead, in the middle of the Place was an equestrian sculpture of Louis XV, and eight massive, unadorned pedestals defined the octagonal shape. The area was surrounded by a dry, balustraded moat which in part followed the old city boundary, all dating from Louis XIII (now a side road for parked cars). Already existing was a drawbridge, dating from 1709 and ornamented with the winged horses by Coysevox in 1716; copies are viewable directly to your right, the originals are in the Louvre.

In 1792, the King's sculpture was removed, a guillotine was erected in the opposite corner diagonally to your right (near the present-day sculpture of the woman of Brest), and the name changed to Place de la Révolution. After the execution of Louis XVI, the guillotine was moved close to the entrance to the garden on your right, and more than 1,300 others met the same fate. When the slicing of heads came to an end, the name changed to Place de la Concorde, which symbolized an agreement or "accord" to stop the bloodletting and soothe the anguish

As evidenced by your on-site comparison, Lépine has altered the placement of the pedestaled women, the fountain, and the Marly horse. To realize why he did this will give you a better understanding of the work, rather atypical in his oeuvre. *Place de la Concorde* (undated) goes far beyond his usual study of picturesque locations, imbued with a middle-toned grey sky. When you view the intimate vignette of children with mothers at the end of the quiet garden, the title becomes thought-provoking, and indicates that Lépine's focus is to make a fresh comment on modern city life.

Even in Lépine's era, the well-known square brought to mind the idea of movement and noise. His inclusion of recognizable statues and the fountain

and turbulence of the preceding years. At that time, in 1795, the pedestaled twin Horses of Marly, seen straight ahead across the Place, were transferred from the destroyed château and summer residence of Louis XIV near Versailles. The Place's name remained unaltered during Napoléon's First Empire, but when monarchial rule was restored, the name symbolically reverted to that of Place Louis XV in 1814, and Place Louis XVI in 1823.

Finally, under Louis-Philippe (1830-48), the name stabilized as Place de la Concorde; many of the embellishments date from his era. The old drawbridge was removed; sculptures of women representing the major cities of France were placed on top of the massive, unadorned pedestals; two fountains, modeled after those in St. Peter's Square, Rome, were added; and a timely gift from the Viceroy of Egypt, the Obélisque de Louxor, provided Louis-Philippe with a politically non-controversial centerpiece. The 75-foot-tall, 3,300-year-old, granite monolith has dominated the middle of the square since 1836 and, as Louis-Philippe had hoped, it has never been destroyed during a politically-charged event.

The last renovation, which gave the Place its modern-day appearance, took place in 1852, when Haussman filled in the moat (now the small road and parking area you see below). Diagonally across the place to your left, a statue of La Fayette graces the Cours la Reine, a once popular carriage route created by Marie de Médicis.

With the historical motifs still in mind, move left along the terrasse, and stop when the pedestaled woman is directly on your right. Turn and take about ten paces back from the balustrade, then turn back around to face the Place.

further emphasizes its enormous size. Contrary to his customary, horizontally-oriented composition, strong vertical lines unify the intimate scene in the foreground and the chaotic public square behind. He moved the statues and fountain to ensure that neither location overpowers the other, and subsequently to change his visual and emotional message: quiet times are still possible in an action-filled modern city.

Before leaving this site, try imagining his painting with the square's structures in their actual locations. Although the trees have changed, visually demonstrate to yourself that any change of his carefully planned composition would alter his sought-after balance.

Highly recommended before searching for your next painting comparison site is a visit to the Musée de l'Orangerie, behind and to the left of your present position. It houses the notable Impressionist and post-Impressionist collection of Jean Walter and Paul Guillaume; oversized waterlily paintings by Monet can be seen in a circular room on the lower level. To continue, take the steps at the far left corner of the balustrade (just past the Musée de l'Orangerie) to street level, turn right and circle halfway around the large Place.

Don't miss the view from the grille marking the garden's entrance and exit; equally as visually impressive is the perspective in both directions from the middle of Rue Royale, which stretches

8. PLACE DE LA CONCORDE (ca 1895)

JEAN FRANÇOIS RAFFAËLLI

Raffaëlli's cityscape, *Place de la Concorde* (ca 1895), is a commendable example of his eclectic style. A salon painter, who was permitted, at Degas' insistence, to temporarily join forces with the Impressionists for their exhibitions of 1880 and 1881, Raffaëlli is noteworthy for successfully combining a well-developed drawing ability with a loose impressionistic line. Although a former student of Gérôme, a neoclassical painter, Raffaëlli found the Dutch "slice of life" cityscape more inspiring. His love of portraying animated people in a natural

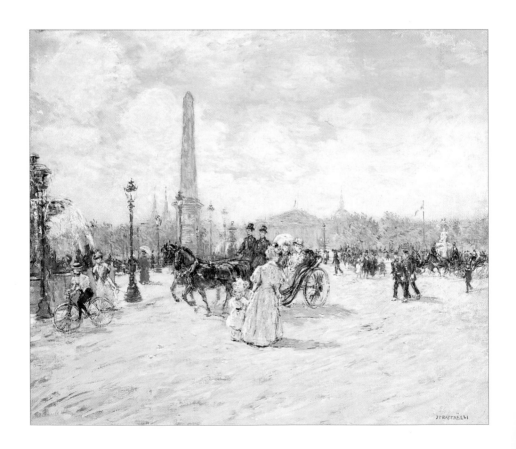

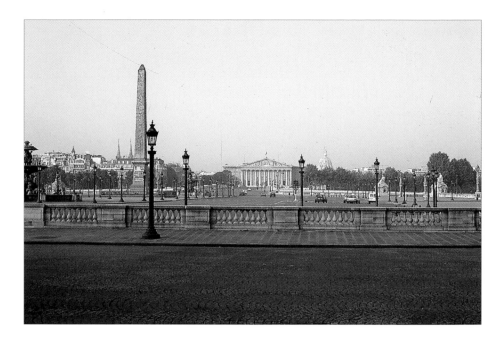

urban setting set the stage for his abandonment of classic subject matter.

With a confident yet delicate brush, Raffaëlli depicts a passing moment that has a "completed" look. The absence of Monet, Sisley, Renoir and Cézanne, due to internal conflicts, from the Independent exhibition of 1880 ensured Raffaëlli's success: his more refined, less fleeting impressions brought him immediate recognition. Some art historians note he was just "in the right place at the right time," when a less radical, impressionistic style was what the public and critics wanted and could accept. Before he died, Raffaëlli was awarded the Legion of Honor.

between the twin colonnaded buildings away from the Place.

Stop at the entrance of the Auto-Club de France, 6 Place de la Concorde, and face Paris' most confusing and largest open urban area.

To see the next artist's viewpoint, be sure the "river" fountain is on your left and the pedestaled lady of Rouen is on your right. Across the horizon line are the double spires of Sainte-Clotilde, the obelisk soaring 75 feet to its pinnacle, the classic facade of the Assemblée Nationale, and the golden dome of the Invalides.

9. PLACE DE LA CONCORDE (1875)

EDGAR DEGAS

To continue, move right past the Crillon Hotel, and cross to the middle circle of the Place (with the pedestaled women), via four sections of street. Turn around and, to position yourself for the next on-site comparison, keep the pedestaled woman of Rouen to your left, and that of Brest behind you to your right. Include in your view the women of Lille and Strasbourg and the arches on Rue de Rivoli.

Perhaps the most famous of the multitude of artists who depicted this area is "modern realist" Edgar Degas. *Place de la Concorde* (1875) is a portrait of both contemporary life and his friend and fellow artist, Viscount Lepic. The combination of themes permits Degas to explore an innovative, compositional style; highly organized, spatial relationships give the feeling of movement in time and space. Human figures, trees and buildings are boldly cropped at the picture's edge. Lepic's forward motion is mimicked by the horseman on the left, and, at first, we are not sure if the carriage next to it is attached or going in the opposite direction.

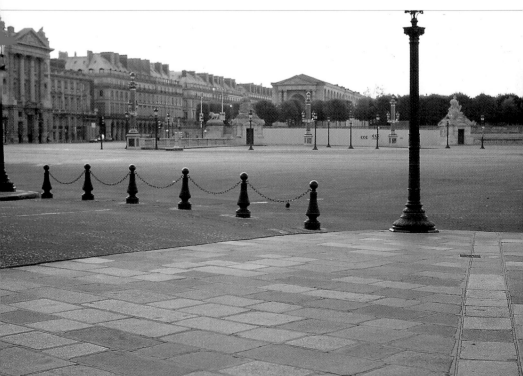

As you stand at this site, note especially how Degas applies his masterful, drafting ability. Brilliant at excluding superfluous details, he paints lines flowing from light to dark and wide to narrow, which appear to have minds of their own. Degas' style of modern realism, loose yet structured, influenced all of his painter contemporaries. Although he showed at seven of the eight independent Impressionist shows, he always denied being an Impressionist, and was quoted as saying, "There is nothing less spontaneous than my art."

It is perhaps interesting to contemplate the fact that Degas' cityscape, which is possibly his only one to feature viewable outdoor architecture in Paris, was done at a time when artists were being called upon to help heal France's wounds. It seems an odd coincidence that he – who abhorred political "rabble" – features a motif that is a reminder of the 1870-71 war, lost to the Prussians. Note the top hat on the right, as it masks the statue of the woman of Strasbourg behind. As France had lost this city to the German's in 1871, Parisians in 1875 would have certainly realized that the light-toned, puffy motif, seemingly connected to his hat, was part of the mourning drapery wrapped around her.

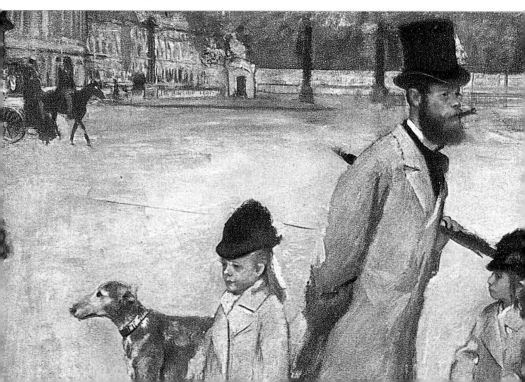

To continue, turn right and cross over to enter the "rural" section of Avenue des Champs-Elysées; the Marly horses are to your left. Stop when the first building on the right (in the grassy park area) is parallel to your position. You are now standing in the middle of what used to be marshy swamps and fields. As early as 1667, however, this area played an important role in the aesthetic development of the city; the potentially expansive vista was continually developed, preserved and expanded.

When it was still a marshy swamp, the gardener of Louis XIV, Le Nôtre, having already redesigned the Tuileries Gardens, constructed a central path here surrounded by double rows of trees. His express intention was to visually extend the garden's western end, but the Champs-Elysées, the name adopted in 1709, served no particular purpose. The main route into Paris passed to your right, along Rue du Faubourg Saint-Honoré, and there was already a path along the Seine to your left, built by Marie de Médicis in 1628 (Cours la Reine) for promenading in a carriage. Parisians wanting to enjoy an "outdoor" experience could walk on the sandy paths of the Grands Boulevards (see tour 6), on the Pont-Neuf (see tour 2) and in the redesigned Tuileries Garden itself.

The visual "treat" proved to be a success, and, in 1724, "gardener" Duke of Antin, having been elevated to the position of "Director of the Royal Gardens," extended the path and trees to the Chaillot mound, now the present position of the Arc de Triomphe. (It was extended to the bridge at Neuilly in 1772, and, two years later, 16 feet were taken off the top of the mound — the present-day Etoile — to improve the view.) Despite its aesthetic beginnings, the Champs-Elysées gradually became an area where local farmers sold

10.
THE AMBASSADEURS CAFÉ-CONCERT (1876)
EDGAR DEGAS

When Degas turned to the depictions of contemporary city themes, a night at the café-concert became food for his creative endeavors. Fascinated with the singers, the orchestra, the artificial light and the animated activity, he started, in 1876, a series of pastels, oils and prints of the popular nightspot, a subject he continued to explore until the 1880's. The most extraordinary as regards its variety of motifs is *Les Ambassadeurs Café-Concert* (1876). Joining the outdoor audience, Degas captures the chaotic, lively ambiance with bright colors and an unorthodox composition, with curves swinging to the right and verticals grounding the scene. The eye bounces from red to orange to yellow, and moves along the layered, flattened space from the elevated stage to the orchestra and then to the audience in the foreground. We must circle around the painting several times to take in and understand everything that is happening. It is a rather amusing portrayal, as no one is really listening to the singer, who is probably Thérésa (Emma Valadon). The group in the audience are talking amongst themselves, and the men in the orchestra are either playing or surveying the crowd. Degas, however, paid close attention to this singer; in the 1880's, he would describe her as having a voice "the most coarse, the most delicate, the most spiritually tender that there is." He did two versions of this *café-concert*, and showed them both

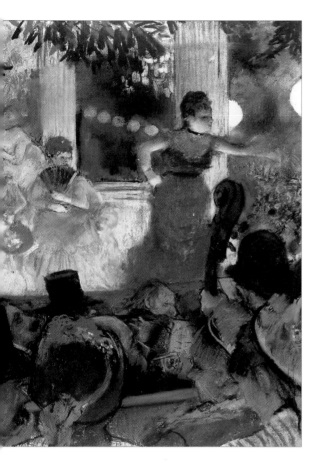

in the third Impressionist Exhibition. By the next year he had also turned his attention to Mademoiselle Bécat, another star attraction at the Ambassadeurs. Again, Degas' modern composition and portrayal of the singer include three separate light sources: the gas lights, the moon outside and the hanging interior chandelier. Degas' study of "atmosphere" in the Ambassadeurs results in a rather gaudy rendition of reflecting colors which does not resemble the sun-drenched light of the outdoor, Impressionist landscapes.

milk along the rural path; Parisians began to explore the still rural, yet tree-planted area. As early as the 1770's, informal outdoor drinking stands, called *guinguettes* had begun to be established; some of them also included areas for dancing.

In 1806, when Napoléon decided that this vista of the city provided the most dramatic backdrop for his immense monument celebrating French military victories, further transformations slowly began to take place.

In 1828, the city of Paris took over the upkeep of the avenue, and gas lighting, fountains and footpaths were installed. The 1830's and 1840's saw the creation of *musicos*, entertainment and drinking spots, complete with permanent structures which replaced the informal, rural ones of the previous century.

By 1870, *café-concert* was the name given to establishments which served wine and sometimes food, but predominantely provided entertainment in the form of singing, dancing and special acts. *Café-concerts*, located all over the city, were popular with the working class, but often were frequented by members of high society as well. Those on the popular Avenue des Champs-Elysées were a little more refined, and usually had outdoor terraces; hordes of people flocked there at night to be entertained.

On your right, the Espace Pierre Cardin, dating from 1931, is actually the former site of a 1770's outdoor refreshment stand, called a *buvette*, which then evolved into a *musico*. Finally, in 1841, Hittorff designed and built Les Ambassadeurs on this site. By the 1870's it was one of the most popular *café-concerts* on the avenue. Its interior was depicted by both Renoir and Degas.

To continue, cross Avenue des Champs-Elysées at the first crosswalk ahead. To your left is Ledoyen, a restaurant dating from 1791 and located on the site of a former 1770's' *guinguette*. In disrepair after the Russians camped on the Champs-Elysées as victors in 1814, a new building was designed and built by Hittorff in 1840. Although the restaurant has been remodeled throughout the 20th century, the basic lines remain true to the Hittorff design. When the Salon moved in 1855 from the Louvre to the Palais de l'Industrie on the popular avenue, the nearby garden of the Ledoyen — well-kept and worth seeing if you don't mind a detour — became a gathering spot for those connected with the yearly cultural event (the Palais de l'Industrie was destroyed to make way for the Grand and Petit Palais). Manet, preferring the Salon to the Impressionist exhibitions (he referred to the former as "the real battlefield"), surely would have been in attendance. Purportedly, Degas, Cézanne, Pissarro and Monet also frequented the well-known eating establishment.

To continue, proceed forward on Avenue des Champs-Elysées, past the statue of Clemenceau, with his scarf flying behind, on your left. Continue across Place Clemenceau (the metro station Clemenceau is directly ahead) and stop. To proceed directly to your last painting comparison site of this tour, and bypass the section of the avenue not seen in Impressionist paintings, take the metro at Clemenceau (La Défense-Vincennes line) and stop at Charles de Gaulle-Etoile. Sit in the most forward car, and follow the signs to Avenue Foch and Avenue de la Grande-Armée when you exit. Pass the main ticket area and follow the *sortie* to "Avenue de la Grande-Armée, côté des nos pairs." At street level, look

11. GRAND PRIX DAY
(1887)

CHILDE HASSAM

The yearly Grand Prix Day in Paris was a social, political, and fashion event. Instituted in 1863, the international horse race attracted the uppercrust of Parisian society. Decking themselves and their carriages in Sunday finery, they paraded back and forth and around Place de l'Etoile to see and be seen by their fellow elite. After this ritual, they proceeded to the Haussmann-restored, Longchamp racetrack. The event did not escape the notice of a young American painter, Childe Hassam.

Two paintings, done in different seasons and both entitled *Grand Prix Day* (1887 and 1887-88), share the same composition. A double line of carriages and a single row of trees invite the viewer to imagine the grand procession up to and around the giant Arc de Triomphe. Thes works were probably painted on Avenue Foch, despite a letter in which he said he had painted the "effect on Avenue de l'Armée... the top of a palace and part of an arch," and Hassam has clearly taken artistic license. None of Hittorff's uniform buildings have the number of windows which Hassam depicts, and the arch angle conforms to that seen from Avenue Foch. It is not known whether he just confused the name of the avenue, or did preliminary sketches at the site and, when completing the work in his studio, altered the angle of the arch and the number of windows. More importantly, however, this painting represents Hassam's first exploration into brightened sunlit color and the Impressionist view of reflected light. Painted during his first extended exposure to Impressionist techniques, these works were to

transform his development as an artist. Already adept at depicting scenes of urban life, and although known to have specialized in "grey day effects" (particularly those on rainy days), he painted his first cityscapes in Paris with bright, heightened, clear colors, and multihued reflections. Hassam's "student" painting has an advanced degree of control and structure. He entered the second painting in the 1888 Paris Salon, and was awarded a gold medal for his efforts. Hassam, whose work emanated a vitality and energy not usually displayed by American painters, continued to be linked with French Impressionism after this initial period.

toward the center of Paris' renowned circular traffic nightmare; dominating your view is the Arc de Triomphe. The gigantic arch, designed by Chalgrin, was conceived and commissioned by Napoléon Bonaparte in 1806 to honor France's military victories. Work began in 1806 but halted in 1814; it was not until 1836, under the direction of Louis-Philippe, that the enormous arch (50 meters by 48 meters) was finally completed.

To proceed to the location of your final on-site comparison for this tour, turn right to cross Avenue de la Grande-Armée (don't miss the view of the Arche de la Défense), and turn right onto Avenue Foch; it is the widest of the avenues circling Place de l'Etoile, and leads directly to the Bois de Boulogne and Longchamp racetrack. Continue forward to pass Rue de Presbourg on your right and, after the first traffic light, turn back around to see the featured painter's view.

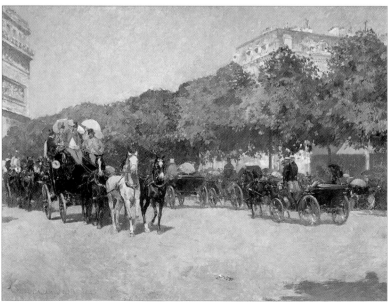

TOUR 4

Around Trocadéro

Tour 4 is a complete change of pace from the prior three walks. To describe it as "very short" or "rather brief" would underestimate the importance of this four-artist, three-stop tour which can be walked in a scant thirty minutes. Featured are artists who all died before their time (even when taking into consideration a shorter life expectancy during the 19th century); and they yet influenced those around them both while alive and after their deaths. All, with the possible exception of Berthe Morisot, are household names, even if you have only a brief knowledge of the history of Impressionism. Two were close friends and related by marriage, one gave up a prosperous career as a stockbroker to paint full-time, and, to complete the list, one was the chief theorist of the art movement which derived from and quickly followed Impressionism.

Neo-Impressionist theorist Seurat is featured at your second on-site stop and was the first major artist to depict the new Eiffel Tower; even though many of the painters featured on these tours were still alive when the gigantic new monument was built, none of the Impressionists or neo-Impressionists followed suit. (For the record, Rousseau, an independent artist who specialized in "primitive" depictions of wild animals lurking in patterned foliage, had featured the Eiffel Tower in his *Myself, Portrait: Landscape*, executed in 1890, but Seurat had done a sketch of the monument even before its completion.) Gauguin, the stockbroker turned painter, is featured at your last stop. He also chose a location not repeated by any of his colleagues. Although his technical style at the time reflected that of his Impressionist teacher, his cityscape location featuring the Seine at Pont Iéna is unique to him. Featured at your first stop, however, are the two friends who, although not sitting side by side, completed versions of Paris' skyline from almost the same position. Berthe Morisot, the

younger of the two, was undoubtedly inspired, when choosing her position on the Chaillot hill, by the older artist Manet. The exchange of ideas throughout their long friendship proved beneficial to both of them, and she later became part of his family by marrying the younger brother of her friend and fellow painter. The amount of time to allocate for this special mini-tour is impossible to estimate. Thus, it is highly recommended, before setting out, to consider the suggestions at the end of the tour when you plan your day.

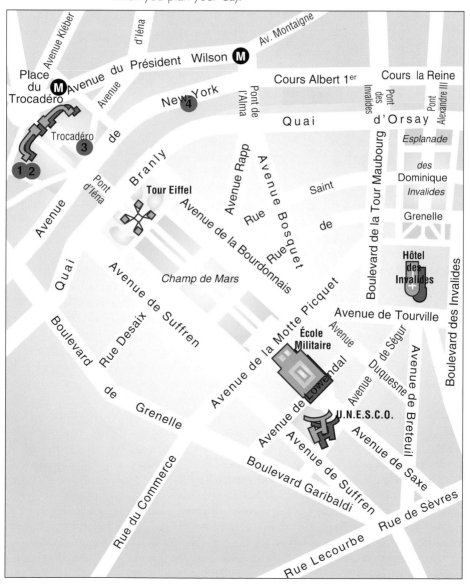

To arrive at your first destination on tour 4, take the metro to Trocadéro (lines Nation-Etoile or Pont de Sèvres-Mairie de Montreuil). The *sortie* for both lines ultimately leads you to the main area where tickets are sold. From there, follow the sign with the escalator symbol to "Palais de Chaillot, Tour Eiffel, côté Avenue du Président Wilson." (To avoid confusion when you reach street level, you should be on the same side as the Musée du Cinéma, the Musée des Monuments Français and the National Theater, all next to the Palais de Chaillot.)

Once you have successfully maneuvered to street level, immediately on your right, adorning the Haussmann-designed Place du Trocadéro, you will see an equestrian sculpture of World War I hero, Marshall Foch. An error on the part of the artist created a scandal when the bronze sculpture was first unveiled. The famous general, attired in military uniform, was without his hat! As is the case with all Haussmann-conceived Places, straight avenues radiate from the center of Place du Trocadéro.

Proceed in a forward direction, past the museums and National Theater already mentioned, and turn left into a large open area. You can't help but notice, looming directly ahead, the enormous monument created for the World Exposition of 1889, the Eiffel Tower. To your sides are the twinned buildings created for the World Exposition of 1937, the Palais de Chaillot. The two rows of golden sculptures date from the same event. Continue forward to the terrace, also dating from 1937, and stop at its most forward point. This particular panoramic view of Paris, which did not, of course, always include the 1889-built, iron tower, has been applauded in tour books as early as the 1860's.

1. THE WORLD EXPOSITION OF 1867

(1867)

EDOUARD MANET

Exceedingly "modern" in composition and personal expression, Manet's *The World Exposition of 1867* (1867) is an extraordinary example of his inventive approach to cityscape painting. Superfically, the title would indicate that he was "documenting" the important, international event symbolizing France's desire to be recognized as both a world power and a keen promoter of advanced, scientific technology. Identifiable on the Champs-de-Mars are the French lighthouse, on the left, and the enormous exhibition hall, just right of center. Significantly included in the upper, right-hand corner is the floating balloon from which Nadar, an avant-garde photographer, precariously drifted while taking experimental, aerial photographs. Not forgetting to also pay homage to the host city's historical past, Manet includes the double spires of Sainte-Clotilde, the double towers of Notre-Dame and the dome of the Invalides on the distant horizon line.

Despite the title, we know, from the condensed composition which virtually eliminates the importance of the river, quays and bridges, that the richly diverse Parisian population, featured in the foreground, is equally vital. Undoubtedly done from sketches and later painted in the solitude of his studio, a purposely confusing perspective of overlapping forms keeps returning the viewer's eye to the citizens of the city. Most are involved in idle conversation, and all seem only peripherally involved in the current activity across the river. With the exception of the gardener, social interaction or casual leisure activity

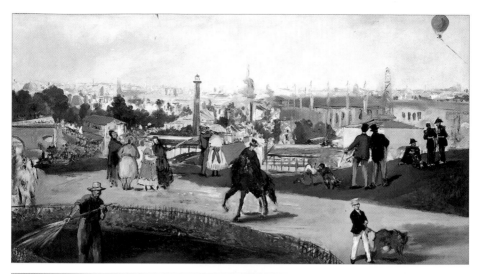

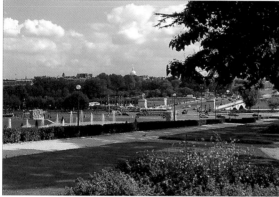

is dominating the day of every age group and social class of Manet's Paris.

It is curious that Manet, who previously drew upon his own experiences when depicting the urban city (see tour 3), makes no reference in this painting to his own concurrently-running, one-man show across from the fairgrounds on Place de l'Alma. By shifting his view slightly to the left, Manet could have included in this work the wooden building that was housing over fifty of his current paintings. The artist, whose works had until then been too often rejected by the Salon and/or ridiculed by art critics, had hoped to attract a wide, encouraging audience. When his solo show met with aggressive hostility, Manet, disillusioned, temporarily left Paris. His good friend, Proust, wrote of him, "Paris has never had a stroller in her streets on whom so little was lost..." Obviously the public on the Chaillot hill, only absorbed in its own pleasure, had not escaped the perceptive painter's notice.

When building Place du Trocadéro, just seen, Haussmann laid out a terraced garden on the sloping hill, and leveled the area where you are standing. Parisians and visitors alike were afforded this majestic view of the city. Even on a misty day they could always see three centuries of architectural splendor: the 17th-century golden dome of the Invalides, above the horizon line, the 19th-century Pont d'Iéna connecting both banks of the Seine, and, on the Champs de Mars, stood the 18th-century Ecole Militaire. Today, the latter is seen through the legs of the Eiffel Tower. Nonexistent, when Haussmann did his handiwork, were the curved buildings on both sides, behind you. They form the matching wings of the 1937-constructed Palais de Chaillot; the present-day fountain and gardens date from the same year.

This once rural hillside area overlooking the Seine started to assume some importance when Catherine de Médicis (see tour 3) decided she wanted a country home. In 1583, she had constructed here a rural retreat with terraces that extended to the river. During the early 17th century, the home changed hands several times, and, in the 18th century, it was converted into a convent. • • •

2. VIEW OF PARIS FROM THE TROCADÉRO

(1872)

BERTHE MORISOT

erthe Morisot's rendition of this site, *View of Paris from the Trocadéro* (1872), is illustrative of her talent as an Impressionist painter. Monuments on the skyline are recognizable yet not detailed, and a pale, early morning light unites with color to create a delicate harmony of opposed darks and lights. Broad curves and subtle diagonals keep the viewer's eye moving, but, as in Manet's work just seen, the foreground becomes the focus of attention. Contrary to the older painter, however, and against the vast panorama of Paris, Morisot records a quiet moment when the day is about to begin. Accompanying her on the outdoor painting jaunt and serving as willing models are her two sisters and niece.

This cityscape was probably, in part, inspired by an earlier watercolor sketch depicting one sister and the other sister's daughter. Executed from the back garden of the family's nearby home on Rue Moulins (now Rue Scheffer), a similar, unobstructed view of Paris is featured in this watercolor's background. A remarkable woman and a gifted painter, Morisot was accepted and respected by her fellow Impressionist painters. The only woman to be a founding member of the first Independent exhibition, she participated in all but one of the famous exhibitions, the year her daughter was born. Degas, Manet and Pissarro all acquired her paintings, and both Durand-Ruel and Georges Petit represented her works in group exhibitions. Though she had more than enough money after her father died in 1874,

• • • The convent was destroyed at the beginning of the 19th century, when Napoléon desired to construct a luxurious palace for his son, the King of Rome. Only the foundation of his proposed palace had been laid before he was exiled.

Move to the right side of the terrace and stop just before the steps leading into the garden. This location is the most convenient from which to make your first two on-site comparisons. The double spires of Sainte-Clotilde come into view on the left, and the changed angle of Pont d'Iéna is similar to that seen in the paintings. Although the bridge was widened for the World Expositions of 1900 and 1937, it retains the original design of 1806. Not viewable today, but observed by featured painters, is Pont de l'Alma to your left. Built by Haussmann in 1854, its design changed when it was rebuilt in 1972.

and despite being a wife, mother and of a class which required specific social obligations, Morisot pursued her career with a dedicated, quiet passion. She usually drew inspiration from her own personal world, that of women and children, and her emphasis on technical explorations prevented her work from becoming trite and sentimental. Ironically, although she painted what she saw around her and pushed Impressionist goals to an extreme, many of her mature paintings are admirable in their abstract quality. Brushstrokes of pure color defining only light, space and movement become unrecognizable forms. Even though her discoveries predate those, similar in nature, discovered by Monet while he was painting waterlilies at Giverny, Morisot's influence on 20th-century painters has rarely, if ever, been adequately acknowledged.

The first featured painting was executed not far from your present location. The second was done from a higher position to your right; this artist's position is the present-day corner of Rue Franklin and Place du Trocadéro. Importantly, both painters had unobstructed views of Haussmann's terraced hill, the Seine and the city below. The World Exposition of 1878 and building of the Palais du Trocadéro on the hill's crest, however, caused the obliteration of the second artist's original unhindered view. This impressive structure stood until the Palais de Chaillot replaced it in 1937. All that remains of the once monumental palace are the steps leading into the garden.

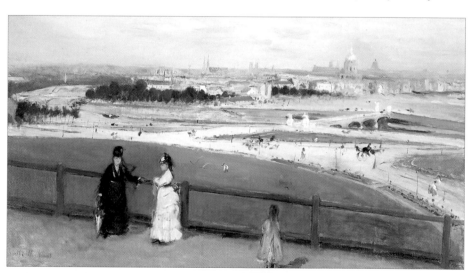

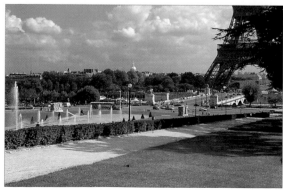

3. THE EIFFEL TOWER

(1889)

GEORGES SEURAT

To continue to your next painting comparison site, move to the extreme left side of the terrace and enter the garden via the steps, saved from the 1878 Palais du Trocadéro, leaving behind the youngsters on rollerblades and the sellers of postcards and souvenirs. Walk on the paved path to the bottom of the hill. Before crossing the first street, stop: be sure to not miss the relationship between the angle of the bridge and legs of the Eiffel Tower when making your next painting comparison.

Three years after creating a sensation at the eighth and final show of the Impressionist painters (officially known as "The Eighth Exhibition"), and two years before his premature death, Seurat most assuredly did not come to this spot on the Chaillot hill to paint his cityscape, *The Eiffel Tower* (1889). He was not known for outdoor painting, and, as a young art student, he avidly read the treatise by Eugène Chevreul on the optical effects of weaving differently dyed wools side by side, and understood James Clerk Maxwell's rotating disk of merging colors. Thus, wanting to recreate, with perfection, the luminosity and reflective character of light, he developed a scientific method of paint application which a number of other artists enthusiastically adopted. Small dots of contrasting colors, side by side, seem more alive, more "real" to the visual eye than mixed brushstrokes of the same hues.

Of course Seurat stood where you are standing now, and probably observed the monumental structure many times while it was being built. All of Paris was simultaneously revolted and fascinated by the modern structure. Seurat and his followers who adopted his pointillist technique, or a variation of it, were usually enthralled with the modernization of Paris which included the more industrial spots as well. It is no wonder the group's leader depicted the monstrous steel structure during its maiden year, bordered, in part, by leaves turning into autumn colors.

4. THE SEINE AT PONT D'IÉNA (1875)

PAUL GAUGUIN

To proceed to your final destination of this short walk, cross, ahead, both Avenue des Nations-Unies and the tiny one-way street which follows. Look right to notice the horse motifs gracing the end of Pont d'Iéna. Continue across Avenue de New-York (not marked with a sign), and turn left; the Seine is now on your right.

To arrive at the painting comparison site, walk along this active thoroughfare or take the steps leading to the river's edge. Both routes have their advantages: the busy avenue affords views of elegant houses decorated with intricate iron grill-work, but the river route, lined with private and public boats, is quieter.

If you are on Avenue de New-York, turn right at the first brick road; stop about halfway down. From the riverside route, go up the brick road and turn around. To make your on-site comparison, first imagine a snowy, winter day in Paris and a riverbank not abundant with boats. Then line up the Chaillot hill on the right, notice the horse sculptures on the bridge, and ignore the remodeled line of the quay.

To find the nearest metro: turn around on the brick driveway, turn right on Avenue de New-York and continue to the metro station, Alma-Marceau, at Place Alma on your left (there are steps from the water's edge near Pont de l'Alma for those of you preferring a quieter route). To visit the Museum of Modern Art-Palais de Tokyo, turn left on Avenue de New-York and take the *passage public* to cross the avenue. The museums at Place

Gauguin, most well-known for brilliantly colored paintings done in Pont-Aven, Martinique and Tahiti, was a beginning "Sunday" painter when he ventured, on a cold winter day, to the banks of the Seine. As evidenced by his result, *The Seine at Pont d'Iéna* (1875), he was absorbing Impressionist philosophy and technical applications.

The composition of parallel, curved quays, connected by the diagonal bridge and bordered on the right by the Chaillot hill, is reminiscent of similar river landscapes painted outside Paris by Monet, Sisley and Renoir during the early 1870's. His lowered horizon line, permitting the sky to dominate over half of the canvas, is, of course, reminiscent of Jongkind (see tour 2). Gauguin, conscious of the subtle, shimmering qualities of water and the potential aliveness of light, even on a dreary Paris day, was proving to be a talented, observant beginner. Executed only two years after his first known oil painting experience, this work has been favorably compared with the Impressionist snow scenes of Monet and Sisley. A stockbroker by profession, Gauguin only painted for pleasure until 1883. At that point, he abandoned his job to devote himself to a career as an artist. Remarkably, he was admitted to the 1876 Salon, but joined the ranks of the independents in 1879 and

participated in the group shows until the last one in 1886. Gaugin continued to paint with an Impressionist sensibility until 1888, when he rejected their philosophy that paintings were reflections of the outside world. He then embarked on discovering his own interior world of symbols and dreams where color could be used in both an expressive and spiritual manner. His mature works continue to inspire generations of 20th-century artists.

du Trocadéro are only moments from the Palais de Toyko on Avenue du Président Wilson.

Travel across the pedestrian bridge, Passerelle Debilly, to visit the Eiffel Tower and attractions of the left bank. Built for the World Exposition of 1900 to permit visitors easy access to both sides of the Seine, it serves the same function today.

From Place de Clichy
to Place Saint-Augustin

T our 5, a relatively short walk featuring only three
painters, is your first concentrated look at Paris' expansion and
subsequent restructuring during the 19th century. By the time
Napoléon III took control of the country in 1848, private
investors had already bought land with an eye toward future
development. When a new railroad opened between Paris and Le
Pecq in 1836, the tracks ran along an area already subdivided but
not yet developed. The investors quickly realized the possibilities
for financial gain, and Place de l'Europe, a small planted area
surrounded by radiating streets, suddenly increased in value.
Under Napoléon III's watchful eye and the singular control of his
appointed Prefect, Haussmann, this area, whose streets are named
after European capitals, became a model of urban development.
You'll walk through a former slum area that was demolished and
subsequently rebuilt, a former garden which became the bridge
under which the expanded train station's tracks could travel, and
an area that was exclusively planned and opened up by
Haussmann for the affluent class which had risen after the French
Revolution. This period marked the first time in the city's history

that housing, which purposefully and significantly separated the workers from the wealthy, was developed.

The featured painters' cityscapes, in one form or another, all recorded Paris' expansion and development in this area. Monet found fresh motifs, considered shocking by most, at the Saint-Lazare train station, and Caillebotte depicted the technologically-advanced iron bridge, built not far from his own newly-constructed family home.

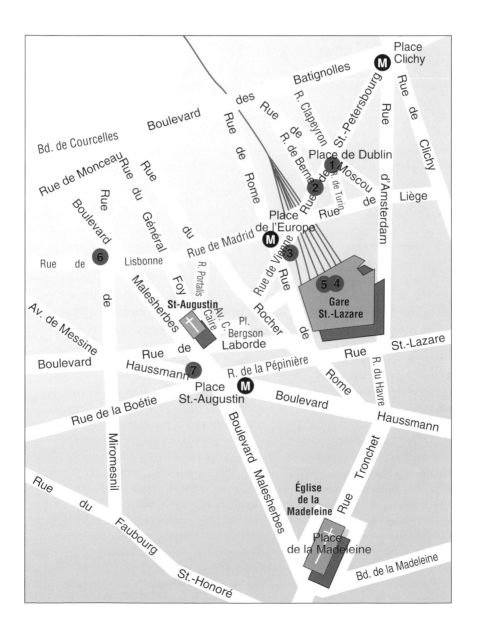

1. PARIS STREET: RAINY DAY (1877)

GUSTAVE CAILLEBOTTE

To start your next walk, take the metro to Place de Clichy (Châtillon-Saint-Denis line or Dauphine-Nation via Barbès line), exit by way of either the escalator or the stairs, and, at street level, immediately turn toward the center of the Place. The dominating sculpture facing Avenue de Clichy commemorates Marshall Moncey and his troops. In 1814, they defended the barricades which were erected here against foreign assault. To Marshall Moncey's left stands Wepler's restaurant; its interior appears in several works by Bonnard. Although nothing remains of the Café Guerbois, once at 9 Rue des Batignolles (later changed to Avenue de Clichy), the lively clashes of opinions and the discussions regarding aesthetics generated there had a significant effect on the history of art. Degas, Manet, Bazille, Monet, Renoir, Sisley and, to a lesser degree, Pissarro and Cézanne, all participated in these frequent gatherings. The combination of joint painting expeditions, visits to each others' studios, and the provocative encounters at the Café Guerbois during the 1860's fueled their individual creative energies, inevitably causing an explosion bigger than the sum of any of its parts. The new art movement, known as Impressionism, was the synergistic result. The equally important Nouvelle-Athènes in Place Pigalle (see tour 8) replaced the Café Guerbois in the 1870's.
To continue, circle the Place, behind

Generally considered by art historians to be Caillebotte's finest masterpiece, *Paris Street: Rainy Day* (1877) is, by its size alone (almost 7 feet by 10 feet), his most impressive composition. It is also the most complicated: the six buildings are related to each other and to the moving pedestrians at the intersection. His unique point of view and his slight alteration of the building's positions can only be fully appreciated on the site. It was noticed and commented upon during its showing at the third Impressionist Exhibition in 1877, and most critics did not understand his intentions. "What a strange idea he had, to paint a street corner on a rainy day with life-sized figures." It has taken over 100 years for Caillebotte's work to be appreciated and rightfully placed among the finest examples of the "new painting" movement.

Closely aligned with Degas' aesthetic, more "realistic" than "impressionistic" technique, Caillebotte's painting is above all a carefully contemplated study in composition. A mathematically devised surface pattern for both people and buildings competes, yet simultaneously harmonizes, with the depth of field created by the mammoth buildings. The light pole – the only non-modern motif in the painting – divides the canvas vertically in half, while the people's heads and building bases form the horizontal division. Caillebotte was not unaware of the other new painters' work, and his sensitive rendering of the weather (a blue-grey atmosphere embracing the limestone buildings, and falling rain glistening on the cobblestone streets) proves their influence on him was almost as important as Degas'.

However, his depiction is also a personal view of how a modernized Paris has affected the upper bourgeois class of which he is a member. Caillebotte chooses to render a location that did not exist, in this physical form, before Haussmann's redevelopment program began its second stage in the 1860's. New residential buildings dwarf the very people that they house, and the occupants, in their uniform dress, mimic the very buildings in which they live.

Interestingly, Caillebotte's painting method, organized, structured and well thought out, is the same method Haussmann used when restructuring Paris. Both have been vindicated in the 20th century.

Marshall Moncey turn onto Rue de Saint-Pétersbourg, opened by Haussmann, and travel downhill. You are entering the Saint-Lazare train station quarter, laid out in 1826 by private investors and altered by Haussmann as from 1858. Place de l'Europe (to be seen shortly) gets its name from all the streets around, named after European capital cities. At the second traffic light, turn left to cross the street and continue a few steps to the right. It isn't obvious, but you have arrived at Place de Dublin,

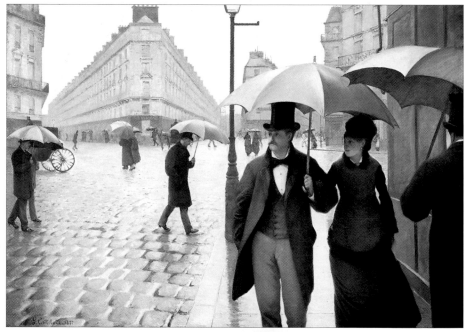

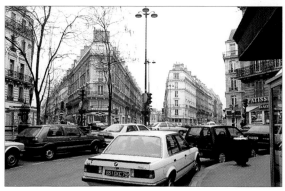

also created by Haussmann. Turn left at the corner, then immediately head across the street to your right. Next to the brasserie, situate yourself on Rue de Turin (opened in 1857). Turn around and face back toward Rue de Saint-Pétersbourg; the street to its left, in the center of your field of vision, is Rue Clapeyron, yet another Haussmann project. If you ignore the parked automobiles, this site has changed only slightly over the past 120 years.

2. RUE MOSNIER DECKED WITH FLAGS

(1878)

EDOUARD MANET

To continue, turn left, and proceed downhill on Rue de Saint-Pétersbourg. The first street on the right is Rue de Berne, formerly Rue Mosnier. Buildings first appeared on this street in 1848. The name didn't actually change until 1884.

To locate your next matched pair, face toward Rue de Berne with your back to the building between 4 and 6 Rue de Saint-Pétersbourg.

Before you leave the site, pay particular

One of three paintings that Manet executed from his studio at 4 Rue de Saint-Pétersbourg, *Rue Mosnier Decked With Flags* (1878) is one of two done on the same day. Inspired by the buildings hung with flags on June 30, 1878, Manet, an ardent Republican, chose spontaneously to immortalize the historic event. Having already painted outdoors with Monet in Argenteuil in 1874, Manet was technically prepared to create a superb impressionistic cityscape from his open studio window. Licks of paint define the fluttering flags, buildings only hint at detailed structure, and a dazzling sunlight envelops the scene. Despite these Impressionist qualities, Manet was still more interested in the "rules" of composition and how to model form than his Impressionist painter friends were. A classical perspective pulls the viewer's eye to the distant ill-defined background while a patch of blue coat rivets attention in the foreground. Shapes are defined by tonal changes as well as line and color contrasts.

This painting depicts the first time, since the Commune of 1871, that the national government had permitted its citizens to celebrate a public holiday out on the streets. The country's internal wounds had finally healed: the Republic was stable. Like the Impressionists, Manet uses reflecting color to depict this mood of warmth and harmony.

The importance of Manet's influence on the Impressionists, even in the 20th century, has been a source of disagreement amongst art historians. At best, he is thought to have had a vital, inspiring influence on the younger painters, some of whom were eight years his junior; at worst, his work is deplored as being derivative of these same artists' creative inspirations. Ironically, Monet also depicted this historic holiday from an elevated position. (Although not featured in this guidebook, Monet's paintings were done facing north on Rue Montorgueil, where it intersects with the Rue Mandar and Rue Greneta, as well as on Rue Saint-Denis where it crosses Rue de Turbigo.)

attention to the art deco, red brick post office on the left corner (it will block your view in the next comparison site). Also, notice the upper stories of the building opposite on Rue de Berne (this building will appear unobstructed). Noting them now will make it easier to identify the next matched pair.

To continue your tour, cross rue de Saint-Pétersbourg at the crosswalk (at Rue de Berne), and turn left to continue downhill. At its convergence with Place de l'Europe, turn right and stop. Take a moment to notice below the numerous railroad tracks of the Saint-Lazare train station. You are presently standing on the center section of Pont de l'Europe. The radiating streets and the Place itself were first laid out in 1826. When the area below was excavated for additional train tracks, between 1865 and 1868, the new steel bridge was considered to be the industrial jewel of the Second Empire. The present bridge dates from 1930, when the train station was also remodeled. The bridge's configuration of six radiating arms is true to the original design. The updated iron railing and stone pillars, however, will not correspond to those which will be seen in your next on-site painting comparison. Continue to circle in a counterclockwise direction, crossing Rue de Constantinople, Rue de Madrid and Rue de Vienne. Proceed right on this last street to the second bus stop (across the street on your right) and turn around. Be sure the building behind the red brick post office is viewable in the distance on your left.

3. THE EUROPE BRIDGE (1877)

GUSTAVE CAILLEBOTTE

The Europe Bridge (1877) is yet another of Caillebotte's bold depictions of modern Paris. His fascination with and celebration of the changes that have occurred in the city are evident in his paintings. The enormous, diagonally placed, slated iron railing of the newly completed bridge – the quintessential engineering marvel of his day – almost dominates the composition. Although both Manet and Monet also depicted portions of the bridge, neither of Caillebotte's contemporaries paint with such direct candidness the "ugly" girders which symbolized France's industrial and scientific progress. Hundreds of thousands used the train station daily, and perhaps in some small way, by making aesthetic a functional form, Caillebotte was the first Pop artist.

Your on-site comparison makes it obvious that Caillebotte has manipulated the perspective in order to exaggerate the depth of field. Similar to *Paris*

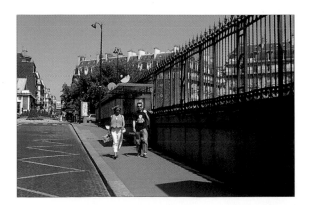

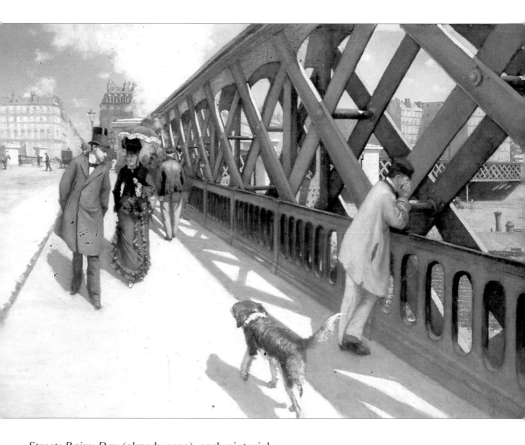

Street: Rainy Day (already seen), each pictorial element has been methodically arranged, but in this slightly earlier work his alterations pull your attention left of center, to the man in the top hat. It is, in fact, a self-portrait, and Caillebotte is featuring himself as a major focal point. His sideward glance, however, coupled with the altered perspective, reinforces the existence of another center of interest: the worker on the bridge. The worker is deeply intent on the train yard below; his posture suggests that watching the unseen trains come and go is his form of entertainment; he is completely oblivious to the elegant man and woman strolling behind him. We aren't sure what the man is observing but a *flâneur* (a person who walks to see and be seen) is, by definition, aware of everything around him. Surely we are to assume that Caillebotte's modern city includes the common worker and the architectural changes, as well as his own bourgeois contemporaries.

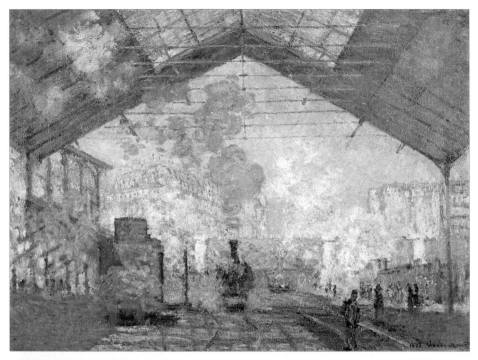

4. SAINT-LAZARE TRAIN STATION (1877)

CLAUDE MONET

Your next painting site takes you into the train station. From your present position on Rue de Vienne, turn around, continue downhill to Rue de Rome, turn left and proceed forward. At the bottom of the hill (you will have walked past several smaller entrances to the station), turn left to enter Saint-Lazare station at the Cour de Rome; take the escalator up one flight to the main level.
Follow the sign "Accès aux trains" into the platform area.
To make your on-site comparison, stand near platform 5.
Every Impressionist painter was familar with Saint-Lazare, as it was from this station that they departed for and arrived from the countryside. The extreme right platforms, 25-30, service Normandy (including Vernon and Giverny), and platforms 1-4, to your left, service Paris suburbs such as Argenteuil and Bougival.

Disappointment might be your first reaction when comparing Monet's painting of Saint-Lazare train station to the site today. The bridge has been remodeled, improvements along the tracks block the view, signs indicating departure and arrival times have been added, and the steam and smoke-billowing trains have disappeared. But if you really step inside Monet's shoes and look through his artist's eyes, the largest, most active train station of late 19th-century Paris has not changed in ambiance since his series of depictions in 1877-78. Active, colorful, modern, and vital are words used to describe this station in the 19th century, and they still apply today.
No other modern urban landscape series by any of the Impressionist painters is as ambitious, sensitively executed, and original in concept as Monet's depictions of Saint-Lazare train station. From several positions within the station, he paints the dense atmosphere of smoke and steam, while still portraying the iron and glass structure sheltering himself, station

workers, travelers and the trains themselves. Seven views, including *Saint-Lazare Train Station* (1877), were shown in the third Impressionist Exhibition of the same year. Monet is addressing the "polluted," color-filled atmosphere, the bustling activity, and the rich modernity of the site. A weaving of blue, violet and mauve becomes cotton-like clouds heaving from the solid, heavy locomotives. Haussmann-constructed buildings in the background bring Monet's study of a multicolored, dissolving light into an urban context. He applies the same concentration and perception of the atmosphere at the train station as he did along the banks of the Seine at Argenteuil.

Other painters, notably Manet and Caillebotte, also portrayed, in part, this urban symbol of France's entry into the industrial revolution, but Monet's series goes beyond both in scope and success.

5. THE EUROPE BRIDGE (1877)

CLAUDE MONET

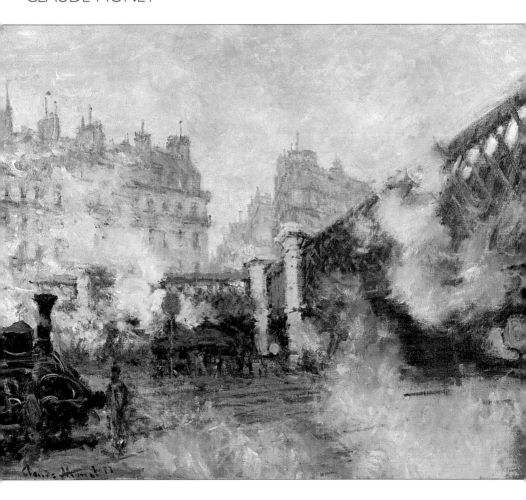

Your next destination takes you to 77
Rue de Miromesnil. There, Caillebotte's
father had built a luxurious townhouse
for himself and his family in 1867. In
1871 or 1872, the year Caillebotte
decided to study painting instead of
following a legal career, the corner room
on the second floor became his studio.
The site of a painting executed from the
window (the location from which
Caillebotte completed the cityscapes
already seen) is worth the effort of
a 15-minute walk.

Exit the station near platforms 1-4, turn
right and cross Rue de Rome. Make a
quick left, and then circle right onto Rue
du Rocher. This street marks the eastern
boundary of what was once a
particularly ill-reputed slum zone called
Petite-Pologne. Completely demolished and
then rebuilt by Haussmann during the
1860's, the area to the west (both north
and south) had a sobering effect on
Manet. Roaming here with Baudelaire,
who had proposed that artists depict
realistic contemporary life, Manet found
inspiration for many of his city scenes,
portraying the underprivileged in or near
this street. At the first small intersection,
continue forward and cross the street to
proceed onto Rue de Laborde, ahead and
a little to the left (rue du Rocher veers
slightly to the right at this point). The
metal dome of Saint-Augustin soon comes
into view. Circle Place Henri-Bergson
counterclockwise, and turn right on
Avenue César-Caire. Walk the short block
to the end of the avenue, cross to the
church side of the street, then
immediately turn right and cross the
street onto Rue du Général Foy. Opened
by Haussmann, it is straight and wide.
Some of the buildings on the right side
are the original ones from his era;
notice the dates on the facades. Turn
left on Rue de Lisbonne, continue

6. YOUNG MAN AT HIS WINDOW (1876)

GUSTAVE CAILLEBOTTE

When Caillebotte's controversial painting,
The Floor-scrapers (in the Orsay Museum),
was rejected by the 1875 Salon, he decided to join
ranks with those who had suffered the same fate.
Young Man at his Window (1876) was one of his
entries, along with the painting rejected by the Salon,
at his first showing with the independents. Although
critics referred to the newcomer at the second group
show as an "intransient," a pejorative term used
interchangably with "Impressionist," his drafting
abilities were generally praised.

Caillebotte's first painting of a theme he was to
continue in 1880 (see next tour) juxtaposes opposed
spheres of existence: one private, the other public.
Caillebotte depicted contrasting light sources to
symbolically divide the dimly lit, luxurious, interior
apartment from the exterior, sunny world of
Haussmann's redesigned Paris. The young man,
reportedly his brother René, is observing the world
beyond his apartment, but is not participating in it.

His attention is focused on the people in the newly-completed Boulevard Malesherbes, just beyond Rue de Miromesnil.

René unexpectedly died after the painting was completed. Possibly fearing the same early death, Caillebotte wrote in November his famous will, which provided money for a future Impressionist show, and gave his picture collection to the state of France. When he did die, in 1894, the collection was at first refused; later, thirty-eight of the original sixty-seven works were accepted.

forward to cross Boulevard Malesherbes and Rue de Miromesnil, and then stop immediately after having crossed the latter. While still on Rue de Lisbonne, make a quarter-turn right and face the extension of Boulevard Malesherbes, beyond Rue de Miromesnil. Remember that in the 1860's only the wealthy could afford to build in the then recently-opened area, west of the train station.

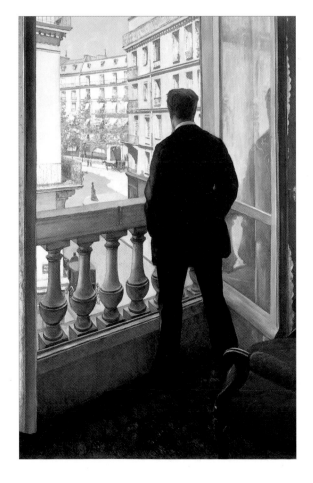

To locate your last painting comparison site of this tour, turn from your present position to your right, and travel downhill on Rue de Miromesnil. At the stop light, turn left onto Boulevard Haussmann, and, after passing the sculpture of Baron Haussmann, cross to the right side of the boulevard and continue in a forward direction. Upon reaching the massive intersection, yet another Haussmann innovation, stop on the first, tiny pedestrian island; use the crosswalk and stand at its tip to orient yourself. Before 1854, this was a simple two-street crossroads. What exists today is typical of Haussmann's restructuring of Paris: the large Place, or hub, is connected by wide boulevards to other squares or important monuments. His compulsion for perspective and balance led to the construction of Saint-Augustin, to your left, on an odd-shaped triangular lot which connects several boulevards and serves as a balancing point of interest. Its 60-meter dome is viewable from the Madeleine Church at the end of tree-lined Boulevard Malesherbes, ahead and to your right. It is also viewable from Avenue Friedland, the extension of Boulevard Haussmann behind you, which, in turn, connects to the Arc de Triomphe. Directly in front of you, tree-lined Boulevard Haussmann links Place Saint-Augustin to Place de l'Opéra and commercial areas beyond. To your left is the north-west extension of Boulevard Malesherbes which, appropriately, is connected to another square further north. Boulevard Malesherbes was originally authorized in 1808 under Napoléon, but was only finally constructed between 1854 and 1861 during Haussmann's building campaigns, under the reign of Napoléon III. Rue de la Pépinière, the street without trees, ahead and slightly to the left,

7. PLACE SAINT-AUGUSTIN, MISTY WEATHER (1878)

GUSTAVE CAILLEBOTTE

Without a doubt, Caillebotte crossed Boulevard Malesherbes, the Haussmann triumph, numerous times on his way to the Opera area before finally painting *Place Saint-Augustin, Misty Weather* (1878). At first glance, his painting is simply an Impressionist's view of Haussmann's modernized Paris. Loose, feather-like brushstrokes are employed to record Parisians in movement, and a silvery, foggy mist permeates the atmosphere. We imagine Caillebotte to be at the street-level site, portraying the massive, open space, the wide, tree-lined boulevard, and the tall monolithic buildings; all three architectural features mark Haussmann's city planning style.

Taking a second more concentrated look, we notice Caillebotte's repeating, triangular-shaped construction. He was possibly influenced by the unusual, triangular shape of the Baltard church, the height and placement of the trees, the casual line on the pavement, and the intensified contrast between the foreground, background, roof tops and sky, all of which systematically reinforce the fact that this work isn't as spontaneously constructed as it first appears to be.

Caillebotte's painting, most probably done from sketches or photographs in his nearby studio, portrays Paris as a livable city where trees, people, buildings, carriages, and lamps will continue to exist in a stable, unchanging harmony. Many of Caillebotte's cityscapes express this sentiment.

marks a loose southern boundary of the already mentioned slum area, Petite-Pologne. It connects to Rue du Rocher near the front of Saint-Lazare station. Many buildings in this area date from Haussmann's urban renewal days, when private buildings were specifically constructed to house the middle- and upper-class rich. A controversial issue at the time, this practice left many poorer Parisians without housing. As a result, they migrated to the "suburbs" of Montmartre and Clichy.

After your orientation, return to the outer circle; turn around with your back to the section of Boulevard Haussmann from which you have come, and face its extension beyond the mass of traffic.

Take the time now to circle Place Saint-Augustin, and view the interior of the church designed by Baltard in 1860 and completed in 1871.

The Grands Boulevards

Tour 6 is for a day when you want a full dose of unrelenting, modern city life. Despite the grandeur of wide tree-lined boulevards, the impeccably dressed windows of the luxury shops, and the sumptuous Garnier Opera House (its magical mixture of architectural styles made it the cultural gem of the 19th century), your route takes you into a noisy, high-paced, action-filled area of modern Paris. Commonly seen, as you travel between the numerous painting site locations, will be business people rushing to "power" lunches or appointments, office workers and salespeople hurrying to do errands during their midday break, and numerous visitors trying to absorb the never-ending variety of immediate sights. (On a yearly basis, Paris consistently attracts more visitors than any other city in the world.) The traffic congestion you will encounter, as you cross streets and boulevards, can be a source of amusement, as you observe what can only be described as the "novel" driving manners of the French, especially when they are immobilized in rush hour traffic. But, as you are jostled along with the motion of the crowd, remember that this area was once the "playground" for the most well-off Parisians who shopped, dined, and were entertained in this most fashionable section of the Grands Boulevards. This visually exciting tour boasts an abundance of painting comparison sites reflecting the dramatic changes which Haussmann and Napoléon III had implemented on the former Grands Boulevards; it starts quietly at Trinité Church, a Renoir-depicted site, then the pace accelerates markedly as you descend into the heart of the area. Next to compare is Caillebotte, the Impressionist arguably the most attentive to Haussmann's restructuring of the fashionable Grands Boulevards which culminated at Place de l'Opera and the ornate new Garnier Opera House. Degas, who painted inside the old opera house on Rue Le Peletier, and Mary Cassatt, who painted inside the new Garnier Opera House, are also featured along with several other Impressionists who were equally attracted to the original Grands Boulevards quarter of Paris. A surprise near the end of your walk features a picture painted expressly for an on-site painting comparison. For this tour, become the modern version of a 19th-century *flâneur*. Don your most elegant walking shoes, have

tolerance and patience, don't believe the guidebooks which say that the Grands Boulevards are no longer "grands," and allow ample time for this walk. The suggestions at the end of your tour could keep you occupied in this hub of action and attractions for the entire day. Cafés, shops, restaurants, movie theaters, the old Opera House, and other reminders of Paris' rich historical past in this area rival those seen on the Champs-Elysées.

While making your on-site comparisons, experience a slice of contemporary 20th-century, Parisian living which, though different from the 19th-century Impressionist version, still reflects aspects of their modernized Paris.

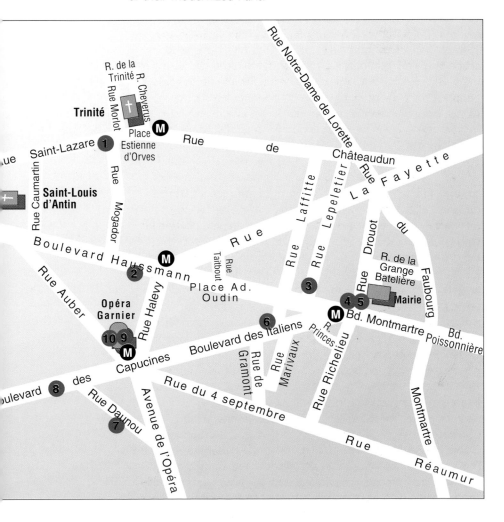

To start your next walk, exit the metro at Trinité-Estienne-d'Orves on the Mairie d'Issy-Porte de la Chapelle line, and take the escalator following the signs to Rue Saint-Lazare. At street level, make a U-turn, cross Rue de Châteaudun ahead and turn right. Trinité Church, the center of interest in this Haussmann-designed Place, was constructed in 1863-67; straight streets radiate from Place d'Estienne-d'Orves.

Cross Rue de la Chaussée-d'Antin, Rue de Mogador and stop at 77 Rue Saint-Lazare. Turn back to the right to make your on-site comparison. Gone is the awning protruding from the building on Rue Saint-Lazare, but the balconies are the same as depicted in the painting.

1. PLACE DE LA TRINITÉ (ca 1892)

PIERRE AUGUSTE RENOIR

Renoir's main area of expertise, on which he built his reputation, was the human figure. From 1867 and onward, however, he periodically explored both landscape and cityscape motifs. *Place de la Trinité* (ca 1892) is one of two paintings of this setting that Renoir did during the same year. He was actually returning to a location he had already painted twenty years before. But while the earlier cityscape focuses only on the Place, both of those done in 1892 include the church as a significant pictorial motif.

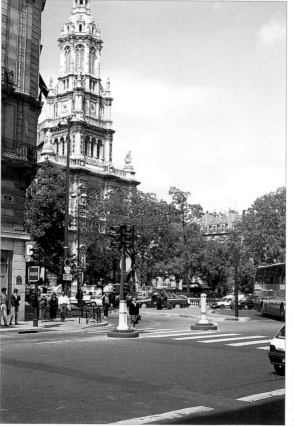

In the featured painting, Renoir demonstrates the composition and brushwork of a mature, secure painter. The buildings – painted with broad, sweeping brushstrokes – emanate a solid, stable feeling, and the wispy, fine strokes, representing the trees, allude to the ever-changing nature of trees as seasons change. Light strokes in the foreground render the square airy and open. Renoir saves the most vigorous brushwork for the sky, the source of the overall light. His composition and positioning of buildings is

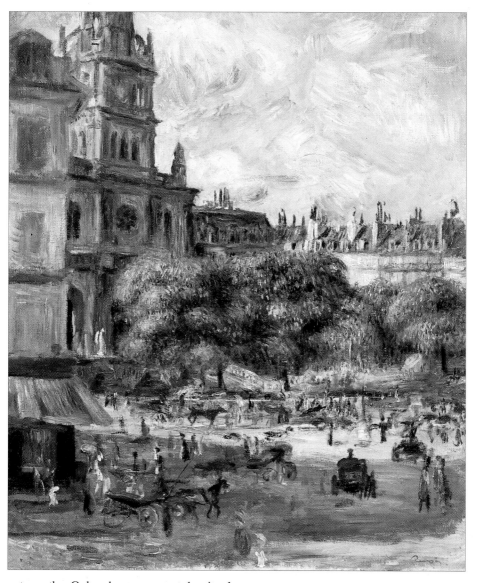

noteworthy. Only when you are at the site do you
realize how deceptive his depiction is. In the work, a
building on Rue Saint-Lazare partially obscures the
church facade, and, on the left, Renoir abruptly cuts
the steeple at the top of the painting. The rooftops and
chimney pots on the right, however, work to make the
space bigger.

Renoir is reaffirming an old Impressionist theme of
capturing a fleeting moment outdoors, and this
painting conveys his obvious ease when synthesizing
what he has learned since his early cityscapes.

Return to and proceed right on Rue de Mogador. Cross Boulevard Haussmann and Place Diaghilev.
Turn left and proceed on Boulevard Haussmann; stop almost immediately at number 29, the main entrance to the Société Générale building. Look diagonally left, across the busy boulevard, to see the site of the next painting comparison.
Following his mother's death in 1878, Caillebotte moved with his brother Martial from the house on Rue de Lisbonne to the more than spacious, upstairs apartment behind you.
Caillebotte did several cityscapes from the balcony you see from your present position.

2. A BALCONY (1880)

GUSTAVE CAILLEBOTTE

A *Balcony* (1880) depicts the view toward the right from Caillebotte's apartment above. The roofline at the corner of the building has changed but the general structure corresponds to that of the present-day building on Rue La Fayette. Keenly observant and interested in the changing face of Paris, he includes the still existing older buildings in the background, right of center; in 1880, Boulevard Haussmann only extended to the next street, Rue Taitbout.

This picture is similar in pictorial motifs to an earlier painting done in 1876 (see tour 5). Resuming the theme of private spaces opposing public ones, Caillebotte positions two men on the overhead balcony: one is attentively viewing the city below, while the other is involved in his own thoughts.

The position of the balcony and the abundance of leafy trees largely obscure the boulevard, but we are nonetheless very much aware of the city and the men's reactions to it.

Purportedly, Edvard Munch's *Rue Lafayette* (1891) was done from Caillebotte's balcony, or at least strongly inspired by the original work. At this time, though, it was still in his private collection. Caillebotte did show the painting in the seventh independent Impressionist Exhibition of 1882, but it is unlikely that Munch could have seen it publicly displayed.

On Boulevard Haussmann, continue in a forward direction. Pass Place Adrien-Oudin and Rue Taitbout. The ambiance of the boulevard changes as you leave behind the shopping section dating from the 19th century (and still a center of bustling action in our era), and enter the business section created when Boulevard Haussmann was extended in 1927. Prior to that date the streets extended, without a break, to Boulevard des Italiens to your right.

From the next street, Rue Lafitte, there is an unusual view of Sacré-Coeur (1876-91) and Notre-Dame-de-Lorette (1823-36), to the left. Not worth a detour, as all the buildings have since changed, are the birthplaces of Napoléon III (1808) and Monet (1840) at numbers 17 and 19, respectively. The galleries of Ambroise Vollard, an early supporter of Gauguin and Cézanne and sometime dealer of Renoir, were located at different times at numbers 39 and 41. Vollard opened business in 1895 with a major exhibition of Cézanne's oeuvre. Undaunted by bad press, he continued to show controversial and unknown artists; both Picasso (1901) and Matisse (1904) had their first Paris shows in his gallery.

Rue Le Peletier follows. Nothing remains of Durand-Ruel's former gallery at number 11. He was by far the most faithful dealer and supporter of the independent painters, and it was in his gallery that the group of artists, already known as Impressionists, had their second show in 1876.

Not far from your present position, at 6 Rue Le Peletier, was the private apartment that Caillebotte rented for the third Impressionist Exhibition one year later.

Perhaps this address is the most well-known for being the site of the Salle Peletier. Before destruction by a fire in

3. THE OPERA DANCE SCHOOL RUE LE PELETIER (1872)

EDGAR DEGAS

Degas, a lover of the opera and ballet, turned to his own life experiences when wanting to expand his pictorial horizons. When you look at Degas' depictions of ballet dancers, many done in series, his respect for their disciplined bodies is obvious. From lessons to rehearsals to final performances, he dedicated many years to recording their gestures, both in action and repose.

His first major work featuring dancers, *The Opera Dance School Rue Le Peletier* (1872), is unusual in that the interior of the building is as important as the young women. Degas uses a limited palette to unify the figures, the physical structures, and the interior light. Setting the mood for the formal lesson, the large, main room is topped with a gilded frieze, and classical columns frame the arched doorway. An open door introduces another room: it is left to our imagination to decide whether the depicted dancer is leaving or continuing to practice, unobserved by the director. Another figure on the right is partially silhouetted by yet another door, while her classmate reads announcements on the bulletin board. Clearly, the multiroomed dance school is not confined to cramped little quarters for its activities.

Degas' dancers, scattered about the large, main room, hold a variety of classical ballet positions or stand ready to assume one at a moment's notice. The straight-backed dancer on the chair is attentive even as she supposedly relaxes; her toes are pointed in anticipation. The director of the Opera Ballet, identified as Louis-François Mérante, is in firm control of this world of dedicated young women. Degas made an exhaustive analysis of ballerinas and corps dancers. Some critics, during his day, were inclined to simplify his artistic endeavors as mere depictions of ballet dancers. They were a featured theme in six of the seven Impressionist Exhibitions in which he participated, and Degas never tired of this multifaceted forum; through it he explored and elaborated on challenging compositions, new techniques and media (pastels, monoprints and sculptures), and refined rendering skills. In terms of the latter, pure color and line reduce every nuance of movement or stillness to its simplest pure form. Many of his works, including oils, pastels and sculptures, are viewable at the Orsay Museum. The collection spans work done at both Rue Le Peletier and the new Opera House, which opened in January 1875.

1873, it was Paris' most luxurious opera house, and its interior was depicted by both Renoir and Degas. The 1875 opening of the Garnier Opera House, seen later on this tour, provided the setting for later depictions of opera house interiors.

To continue, proceed to your left on Boulevard Haussmann, and stop in the small car parking area next to the metro entrance. This large intersection marks your introduction to the original Grands Boulevards (nouveaux cours), laid out and constructed by Louis XIV when there was no longer a threat of foreign invasion. Secure in his position as the King of France, he converted the protective, circular city walls of Charles V (dating from the 14th century), and those of Charles IX and Louis VIII (dating from the 16th century) into a wide, tree-lined road stretching from the Bastille to Place de la Concorde.

Ahead, Boulevard Haussmann becomes Boulevard Montmartre (dating from 1676) beyond the traffic light, and stretching behind you to your right is Boulevard des Italiens, opened in 1685. Until 1927, there were buildings where you are now standing; the even-numbered buildings from 2 to 14 Boulevard des Italiens were destroyed to make room for the enlarged intersection and the extension of Boulevard Haussmann behind you. With these alterations came the destruction of the next painter's domicile and studio. From his bird's-eye view there, he depicted Paris boulevards in both directions.

When making your on-site comparisons, either stay here or recross Boulevard Haussmann to your right, and move ahead toward Rue Drouot, the closest side street on your right. Imagine yourself at a hotel window, with an elevated view of the street-level commotion.

4. BOULEVARD MONTMARTRE: AFTERNOON, SUNSHINE (1897)
5. BOULEVARD DES ITALIENS: MORNING, SUNLIGHT (1897)
CAMILLE PISSARRO

Examples of Pissarro's series paintings have already been seen on tours 1, 2 and 3, but it is here, overlooking Boulevard Montmartre and Boulevard des Italiens, that the first commissioned, systematically organized cityscapes were executed. Having already completed and exhibited a small series of elevated views of the intersection in front of the Saint-Lazare train station, his dealer, Durand-Ruel, encouraged him to consciously paint new works in this serial manner. While renting a spacious room at the Grand Hôtel de Russie, 1 Rue Drouot, from February to April 1897, he rapidly completed sixteen canvases. Fourteen nearly identical views of Boulevard Montmartre and two views – described by Pissarro as "terribly difficult views" – of Boulevard des Italiens are the result of his first orderly effort at depicting specific light conditions at different times of the day. *Boulevard Montmartre: Afternoon, Sunshine* (1897), from this view to his left, and *Boulevard des Italiens: Morning, Sunlight* (1897), seen at his right, are both representative of his "sunlight" or "sunshine" output. Pissarro becomes aware of the endless combinations available, and his only known night painting also dates from this series. He undoubtedly painted on more than one canvas at a time. One can only guess at the technical and emotional discipline required to record the passing, changing light, and the variety of body positions of Parisians moving to and fro on the stretches of boulevard below.

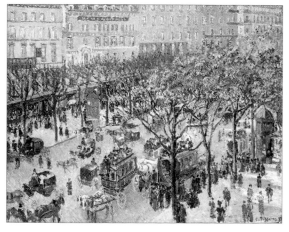

6. BOULEVARD DES ITALIENS (1880)

GUSTAVE CAILLEBOTTE

To continue, return to and cross Boulevard Montmartre, cross Rue Richelieu to your right, continue forward on Boulevard des Italiens, and locate yourself just past the first café on your left. Look across the Boulevard des Italiens and envision it in its former state. Imagine it in the beginning of the 18th century, with country gardens and woods stretching ahead of you. The lime quarries of Montmartre are visible and windmills dot the hills. Parisians are strolling along the wide, sandy road. By the 1750's, they are sitting on chairs beneath large-branched, shady trees, enjoying the pastoral ambiance. During this century, nobles were gradually building large estates, generally to the south, with entrances on side streets behind you, and a smattering of inns and carriage houses exist in this area. At the end of the 18th century and into the early 19th, land development accelerated dramatically. Land was subdivided, sold and developed; by the 1820's and 1830's, the boulevard activities of eating, drinking and being entertained had achieved international renown. The boulevards to your right, stretching to the Place de la Bastille, were for rowdy, outdoor theater, while the area to your left was reserved for the "beautiful people" of French society. By mid-century, the act of walking there had become an exacting scientific art of seeing and being seen, and Haussmann's decision, in 1858, to locate the new Opera House on Boulevard des Capucines further along, reinforced the image of elegance, culture and wealth surrounding this section of the Grands Boulevards. It is no wonder that the Impressionists chose to exhibit on the Boulevards des

There is no verified record as to where Caillebotte was standing when he composed, painted or simply took a photo for *Boulevard des Italiens* (1880), but, purportedly, he was in an apartment at 1 Rue Laffitte (also known as 20 Boulevard des Italiens). It is interesting to note that the bank building had only been constructed in 1878, and the grille facade had not even been completed when Caillebotte did his painting featuring this building and the crowds along the boulevard. Looking for the newest additions to the Paris he knows well, Caillebotte temporarily abandons the vantage point from his Boulevard Haussmann apartment for an elevated view of the older "grand" Boulevard des Italiens. This work is frequently compared with Monet's earlier Boulevard des Capucines (to be seen later on this tour); dark dabs of paint miraculously become moving people, elongated strokes merge to become distant trees, fuzzy lines become solid buildings, and a cloudy blue sky casts richly brightened and multicolored dapples of light and shadow throughout.

Caillebotte showed this painting during the seventh Impressionist Exhibition, held in 1882 at 25 Rue Saint-Honoré.

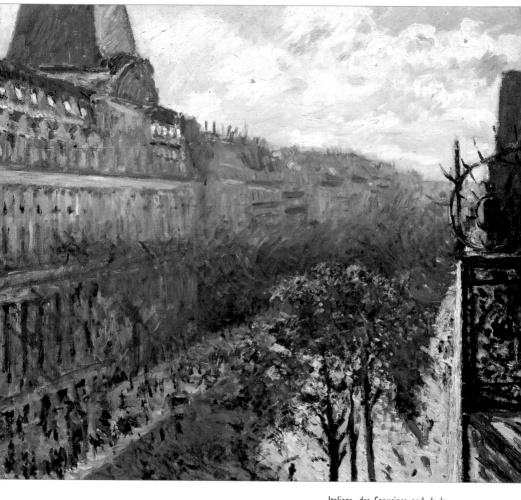

Italiens, des Capucines and de la
Madeleine to your left.

Behind your position and to the left is
the original location of the Théâtre des
Italiens, from which the boulevard took
its name. Pass the Passage des Princes,
originally opened in 1859 and now a
modern shopping complex. Turn left on
Rue Favart, then to the right across
Place Boïeldieu and return to Boulevard
des Italiens, Rue de Marivaux.

To arrive at your next painting
comparison site, cross Boulevard des
Italiens at Rue de Marivaux; turn around
and spot the Crédit Lyonnais bank across
the street to your right.

Before continuing, turn around and let your eyes do the walking at this historically important location. Look up, across Rue Laffitte, at the gold-decorated balcony and the unusual frieze of animals running in a thicket at 20 Boulevard des Italiens. An apartment in this building is the location of the final Independent Exhibition in 1886, where Signac and Seurat introduced the neo-Impressionist technique of pointillism to the public. Downstairs was the location of the economically-priced Café Hardy (1815) which was destroyed in 1839-40 to make way for the exorbitantly-priced Maison Dorée. The former was famous for its quickly-prepared lunch on a fork, and the latter became the most exclusive dining spot, reserved for only the most wealthy or celebrated, until the 1870's.

7. JULY 14TH, RUE DAUNOU (1910)

CHILDE HASSAM

During Hassam's final painting trip to France, he rediscovered a theme that he had initially explored in Montmartre more than twenty years before, and which he would continue to explore in New York less than six years later. This most highly acknowledged American Impressionist painter returned to the subject of flags. The centennial of Bastille Day and his concurrent investigations into the Impressionist use of color had prompted Hassam's earlier 1889 series. Joining the merrymakers on the street, he painted three different versions of the same event, versions which prominently featured the French tricolor in clear bright blue, white and red.

Returning to France in 1910, he found himself by chance, once again, amidst the joyous chaos of Bastille Day in Paris, and seized the opportunity to record the event a second time.

In contrast to his street-level, angular perspective in the Montmartre depictions, Hassam painted *July 14th, Rue Daunou* (1910) from his hotel balcony.

Combining his tonal studies of outdoor lighting from his early Boston days with his greatly matured knowledge of Impressionist principles, Hassam creates his own personal blend of American and French Impressionist sensibilities. Enveloped in a dreary light, moving cars and people alike disintegrate in the deep vista, and colorful flags hanging loosely from the buildings create a rich fabric of bright color. Hassam's brushstrokes are loose yet

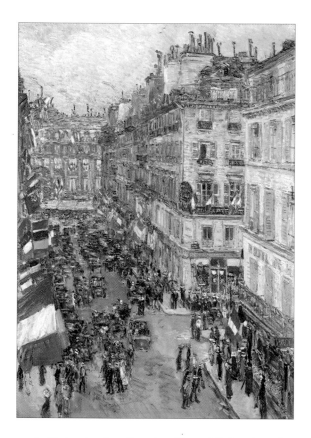

controlled as he describes the effect of light, air and movement, rather than the physical details of the scene on this windless day in Paris.

It is not known whether Hassam had been inspired by Monet's flag pictures, *Rue Montorgueil* (1889) and *Rue Saint-Denis* (1889), painted in June and exhibited at the Georges Petit gallery in early summer of the same year, but, certainly by 1910, Hassam was familar with the classic paintings.

Hassam's most celebrated flag series was inspired by America's efforts and eventual shared victory in World War I. Almost thirty works, characterized by clear splashes of color and expressive brushstrokes, depict the streets of New York City between 1916 and 1919.

To its left, at number 22 was Café Tortoni, Manet's favorite lunch and late-afternoon refreshment spot, where he joined similarly well-bred clients. At number 16 was the Café Riche, the potential rival of every café and restaurant in the area. Opened in 1791, it had the longest run on the boulevard before it closed in the 20th century. It was known for intellectual conversations regarding art and literature, and it was there that Caillebotte, Renoir and Monet periodically met their dealer, Durand-Ruel, during the 1880's and the 1890's Leave the cafés on Boulevard des Italiens and proceed along the Boulevard des Italiens until it turns into Boulevard des Capucines. Just before Place de l'Opéra, don't miss the column with Napoléon at the top, viewable to the left at Place Vendôme; the Opera House then comes into view on your right. Dominating your view to the right is the opera house designed by Garnier. Constructed between 1861 and 1875, it represents the crowning glory of Napoléon III's and Haussmann's collaborative efforts to modernize Paris. The sumptuous interior inspired a multitude of artists, most notably Renoir, Cassatt and Degas; the immense stage and foyer behind are the settings for many of Degas' works featuring ballet dancers.

To proceed to the next featured painting comparison site, circle the large Place de l'Opéra to the left, and continue forward on Boulevard des Capucine's extension on the other side. Proceed to the first street, Rue Daunou, turn left. Stop in front of number 9 (formerly the hotel in which the next featured artist stayed) in the second block. To recreate a view similar to his own, turn back around toward Boulevard des Capucines.

The next painting comparison site is only moments away. Backtrack to Boulevard des Capucines, turn left and continue forward to number 35. This former studio of photographer Nadar was the site of the historic first independent exhibition. Turn around and look back along the boulevard to view the location that the featured artist painted expressly for an on-site painting comparison.

8. BOULEVARD DES CAPUCINES (1873)

CLAUDE MONET

Monet's *Boulevard des Capucines* (1873) is symbolic of his creative foresight. The December before the first independent exhibition in May 1874, he purposely painted two versions of the boulevard below from Nadar's window. Monet wanted to give exhibition visitors the opportunity to compare site to painting. His depiction went on to become the archetypical perspective from which to view and record the new urban Paris of Haussmann's redevelopment campaigns. Other painters, already seen on this tour, assumed the same elevated viewpoint, and each certainly drew inspiration from Monet's original vision. To depict a wide boulevard, lined with trees and buildings and teeming with multitudes of people, Monet penetrates the properties of light, form and movement. Slashes and dabs of dark color, sparkling with light, form grand, solid buildings as well as moving people and carriages; middle-toned, wispy strokes, topped with dashes, become almost leafless trees. The pink balloons and man on the balcony arrest our eye for a moment as we take in the fugitive quality of time emanating from this picture.
The reviews of the Monet painting were mixed.

Amusingly, one critic wrote, "I never could find the correct optical point from which to look at his Boulevard des Capucines. I think I would have had to cross the street and look at the picture through the windows of the house opposite." Time has proved one critic's observation more accurate. Monet's painting was "a masterpiece" that went "a long way into the future."

Your last destination on this tour is the recently renovated interior of the Garnier Opera House. Proceed back to Place de l'Opéra and enter the Opera House to set the scene for your last on-site comparison.

9. FIRST OUTING (1876)

PIERRE AUGUSTE RENOIR

Renoir was not, by all accounts, a lover of opera music, and, when exposed to its performance, he was more impressed with the luxurious ambiance of the theater and dazzling interior light. Renoir saw there the possibility of a marriage between portraiture, for which he had a particular affinity, and the depiction of modern, contemporary life. As early as 1874, he had posed a Montmartre model and his brother, both in formal evening attire, in his studio, and had depicted them as upper-class theater-goers. Only a hint of the location is evident, a small portion of the railing and background drapery of the box seat, but the title, *The Loge*, indicates his desire to pinpoint the elegant setting so popular amongst the upper class. Satisfied with his success, he exposed the painting (not featured in this book) at the first Impressionist Exhibition.

Continuing the theme two years later, Renoir employs the same impressionistic technique to paint *First Outing* (1876). This time, however, he clearly depicts the seating arrangement at the then new Garnier Opera House. A partition separates a young girl, sitting with another female in a box seat, from the tiered, open balconies to the right. Not neglecting his never-fading fascination with light, he paints lineless patches of fused color to render her skin iridescent, and her supple clothes simultaneously opaque and translucent.

The young girl, seen in profile, is experiencing her first night out at an "adult" event. Renoir, not coming from the "class" who attended the opera regularly, probably experienced, during his first theater visit, many feelings similar to those of the young girl he is depicting. She is enthralled with the experience of the event, and even her flowers are leaning forward in the same position as she is, not quite relaxed back in her seat. She is oblivious to the blasé attitude of the

patrons, "more at ease" in the open balcony. Renoir notes that, for the initiated, theater- and opera-going was primarily a social event; correct protocol allowed for conversations and looking around during the performance. Renoir has adapted a day of fun in the countryside, an early Impressionist theme, to an evening of chatter and culture at the opera. This painting was not exhibited at the Impressionist show the following year.

At the conclusion of your walk, there are a multitude of other nearby places to visit.

For those of you wanting to experience the elegant ambiance of late 19th-century Paris, visit the Café de la Paix and the Grand Hôtel, both situated to the right as you leave the Opera House. These two cornerstones of fin de siècle Parisian society have been restored to their original luster, and both are now declared historic monuments.

For those of you wanting to go shopping, or to just enjoy the carnival-like atmosphere outside Galeries Lafayette and Printemps, circle behind the Opera.

For those interested in stocks and money, from Place de l'Opéra turn onto Rue du 4 Septembre to visit the Bourse; the French stock market is open to the public.

At number 41 Avenue de l'Opéra is the former site of the Café de Paris. In its day, it was one of the celebrated cafés of Paris. Part of it has been preserved and can be seen at the Carnavalet Museum. Across the street at number 28 is the location of the fourth Impressionist Exhibition.

Rue de la Paix and Place Vendôme are both fun for window-shopping; expensive jewelry, high fashion, the Ritz Hotel and the column topped by Napoléon (as Caesar) are the chief attractions here. An interesting tidbit... the destruction of the column during the Commune led to the ruin and exile of Courbet, the leading proponent of Realism, one of the art movements preceding Impressionism. He was implicated in its toppling, and was forced to pay for the re-erection in 1873-74.

Last but not least is the Opera House Museum and Library. Located at the left side-entrance on Rue Auber, it was

10. WOMAN IN A LOGE

(1879)

MARY S. CASSATT

Mary Cassatt, an American painter from a "good" Philadelphia family, also adopted the the new Opera House interior as a suitable setting for portrait painting. When Degas suggested she join the ranks of the "independents" for the group's fourth show in 1879, her entry included at least three works set in the radiantly-lit milieu. After repeated rejections by the Salon, Cassatt, a slightly younger contemporary of the Impressionists, had at last found a public forum for her paintings and pastels.

At the Opera and Woman in a Loge, both completed in 1879, illustrate Cassatt's range of creative interests and technical ability. The former work, not selected for her public painting debut, features a young matron, dressed in black, peering through opera glasses at either the performance or the other loge seats across the theater. Off to her side, in another box, a man is using his glasses to conspicuously peer at her. Like Renoir, she has depicted the seating arrangement of the opera house, and is likewise making a social comment on the behavior of the opera patrons.

One of her selected entries, Woman in a Loge, was, however, well received by both the public and the reviewers. In an unusual orchestration of motifs and hues, an auburn-haired woman, posed in a red, mirrored loge, is simultaneously seen from the front and back. Also seen in reflection are the filled theater seats and cut-glass chandelier. Cassatt's study of gas light mixing with the range of reds results in a bizarre, greenish skin tone with unflattering, lightened patches.

By 1881, when a modern type of realism, forged by Degas and Manet, was beginning to find acceptance among a select clientele, the respected Durand-Ruel started to carry her work. Cassatt was able to build an international reputation with numerous oils, pastels and prints of mothers and children, her chosen aesthetic arena. Of equal importance, Cassatt's social position permitted her to introduce the French Impressionist artists to American art patrons. This enhanced the French painters' ability to reach a wider, more accepting audience than they had previously known. For both reasons, Cassatt is one of the relatively few women painters who is consistently noted in art history.

formerly known as the "Pavillon de l'Empereur." The sloped entrance was wide enough for Napoléon III's carriage to be driven directly to the Emperor's box seat. The design of this entrance is probably the reason why the unknown Garnier won the competition to construct Napoléon III's cultural "jewel." A failed attempt on the Emperor's life while he was on his way to the Peletier Opera House in 1858 had made the secure entrance a highly appreciated design element.

TOUR 7
From Panthéon
to Luxembourg

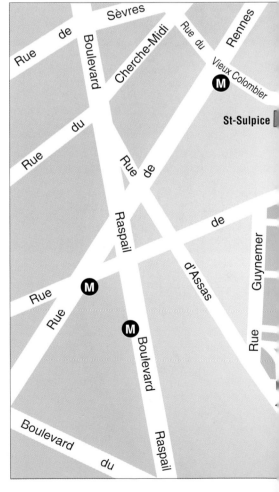

F ollow tour 7 on a day
when you want to escape the roar of
modern city life. A short walk from
the first two sites will place you at
your main destination, the
Luxembourg Gardens. Once inside, a
quiet calm permeates, and even the
children's play area on the west side
seems to have a reduced noise level.
In addition to painting site
comparisons (not exclusive of
Van Gogh, Lépine and Grant Wood),
several Illustrious Women of France
and a colorful myriad of flowers
await you. More than sixty sculptures
grace the fifty-seven acres, and
approximately twenty full-time
gardeners meticulously tend the
greenery. Flowers are planted
three times a year, and no year is like
the last. Many Parisians consider it
to be the most beautiful garden in
the capital city. On a sunny day, every
chair and bench is occupied by

pensive writers, avid readers, and sprawling sun-worshippers (it is prohibited to walk or sit on most of the lawns). The garden attracts joggers and numerous, hearty boules players, even during the winter months.

Allow yourself sufficient time to wander along the chestnut tree-lined "alleys" and meandering gravel paths. There is a café with both indoor and outdoor seating, and several kiosks sell candy, sandwiches and drinks. If you are so inclined, at the end of your tour, join the writers, artists, students, retirees, mothers and children who all frequent this popular left-bank garden.

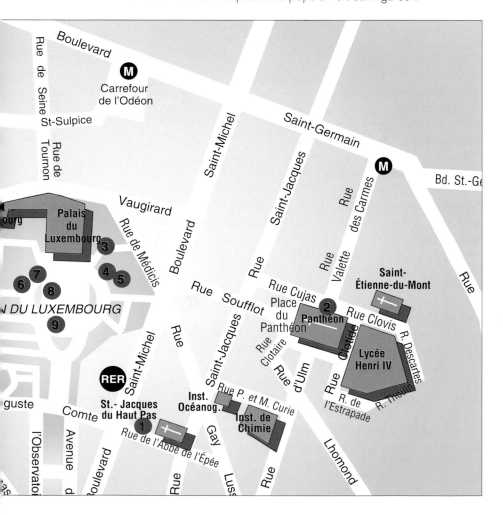

1. RUE DE L'ABBÉ-DE-L'EPÉE (1872)

JOHAN BARTHOLD JONGKIND

To start tour 7, either take the RER to Luxembourg station and exit Rue de l'Abbé-de-l'Epée, or take bus 38 and get off at Auguste-Comte.

To view your first site and painting comparison location, situate yourself near 18 Rue de l'Abbé-de-l'Epée with your back towards Boulevard Saint-Michel. Center in your viewpoint ahead the belltower of Saint-Jacques-du-Haut-Pas, a motif in the first featured painter's cityscape. The classically-designed Romanesque church, built between 1630 and 1685, replaced an earlier local parish chapel.

On your right, behind the stone wall, exists the National Institute for Deaf-Mutes (Institut National des Sourds-Muets). Founded by the Abbot of Epée in 1700, it was taken over by the state after the Revolution. The present building dates from 1823.

Boulevard Saint-Michel behind you was opened in 1855 as part of Haussmann's massive restructuring of Paris thoroughfares. The narrow street on which you are standing originally dates from 1576. A tiny alley that closed at night, it predominately serviced the parish church to your left and a military and religious outpost on your right, between Rue Saint-Jacques (ahead) and Rue Henri-Barbusse (behind). The military-religious complex had been established during the 12th century by Louis IX (Saint-Louis) to aid those making the pilgrimage to Saint-Jacques-de-Compostelle; at that time it was beyond Paris' city wall.

To continue, proceed in a forward direction to Rue Saint-Jacques. Possibly

Jongkind's *Rue de l'Abbé-de-l'Epée* (1872) technically echoes his river Seine paintings seen on tour 2. A composition of gentle curves balancing strong horizontals emphasizes the receding picture plane, and loose, flowing brushstrokes whisper across the canvas to produce the pervading iridescent light. The change of subject, from river and bank to narrow street, does not alter his facility to observe and then render his direct experience in paint.

A dramatic shift in Jongkind's creative consciousness marks his left-bank street scene. Noted as one of the first 19th-century painters to depict Paris in transition, often complete with workers, equipment and debris, Jongkind is deceptive, or selective if you prefer, in his choice of pictorial content in this painting . In 1872, the year Jongkind planted himself outdoors to record his experiential impression, workers were extending the tiny street in both directions. Inexplicably, he deletes both any hint of this disruption and any idea

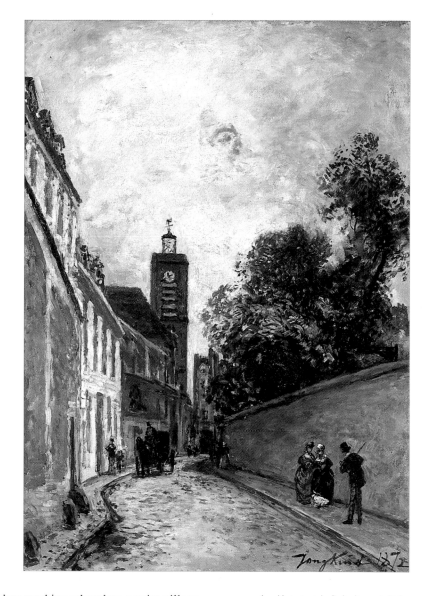

that Paris has anything other than a quiet village ambiance. Surrounded by noise and rubble, he doesn't "lie," but rather selects the one section of the street, unchanged by modernization.

Jongkind was, in fact, living on this tiny street when he executed this cityscape. Without documentation, we can only guess at his motivations for recording what seems to have been the charm of Paris during an earlier era.

He left the city the next year, and only rarely returned to paint France's capital.

the oldest street in Paris, it was built by the Romans and connected Lutetia to Orleans, to the south (Rue Saint-Jacques has already been noted on tour 2). To visit the courtyard of the school, which allows a better view of the trees depicted in the last painting and features a sculpture of the Abbot by a deaf and dumb artist, Felix Martin, turn right and enter the school's courtyard at number 254; ring the bell.

To continue without making the detour, turn left on Rue Saint-Jacques and continue in a forward direction. Cross Rue Gay-Lussac at the crosswalk to the left. Continue on Rue Saint-Jacques (for several blocks), turn right on Rue Soufflot, and continue up the slight hill. Directly ahead is the Panthéon; to its left, note the church, Saint-Etienne-du-Mont. The latter, a major motif in the next matched pair, took 150 years to complete. Built between 1492 and 1632, it has a transitional Gothic and Renaissance style. Saint-Etienne-du-Mont was formerly the parish church for the adjoining Abbey of Sainte-Geneviève; the abbey was located, in part, at the present-day location of the Panthéon. The Panthéon, designed by Soufflot, was constructed on the orders of Louis XV. In 1744, the King had promised to replace the run-down Sainte-Geneviève Abbey if he recovered from an illness he had been suffering from at the time; construction started in 1758 but was not completed until 1789. Stop when you are close enough to read the inscription in gold on the Panthéon's pediment. In 1791, during the aftermath of the Revolution, the church became a burial spot, or pantheon, for the great men of France. Hence, the words: "Aux Grands Hommes La Patrie Reconnaissante" ("To Great Men, the Country Acknowledges"). The dome is impressive, standing 272 feet high. To continue, use the crosswalk to traverse Rue Soufflot to the left, circle the large Place in a clockwise direction, keeping the Panthéon to your right. After the Faculty of Law, immediately recross Rue Soufflot to the right, and continue to your left, walking alongside the Panthéon. Stop outside the grille fence near the balustraded steps on your right. The changes made to the Place, first in the 19th century by Haussmann, and then again in the 20th century, make standing

2. SAINT-ETIENNE-DU-MONT (1920)

GRANT WOOD

All but forgotten by most art historians is Grant Wood's "Impressionist" period. His most famous painting, *American Gothic* (the stern, pitchfolk-holding farmer and his wife), bears no resemblance in style to his earlier works done both in Paris and Iowa. However, if you support the idea that an artist develops his own style as he learns from and imitates others, Wood's thickly painted, loose brushy style was a necessary stage in his own creative development. Typical of Wood's oeuvre during his first trip to France, *Saint-Etienne-du-Mont* (1920) is a small oil study done on composition board. The summer trip, almost mandatory for young American artists in the early 20th century, acquainted him firsthand with contemporary and classical European art. While painting *en plein air*, Wood adopts the loose, flowing brushstrokes of the formerly shocking Impressionist painters, yet fails to place emphasis on the fleeting nature of the light. Again imitating the Impressionists, he chooses a common, everyday scene but, unlike his predecessors, there is almost no movement. The woman holding her baby seems posed, and people in the background square, except for the solitary walker, do not appear to be animated. The strong horizontal and vertical lines give the painting a grounded, stable feeling.

Although Wood referred to his Paris paintings as "impressionistic" and this one does emulate the brushwork and color juxtapositions of their works, it is more an art student's interest in structure and form than an outdoor study of a fleeting moment in an animated urban environment.

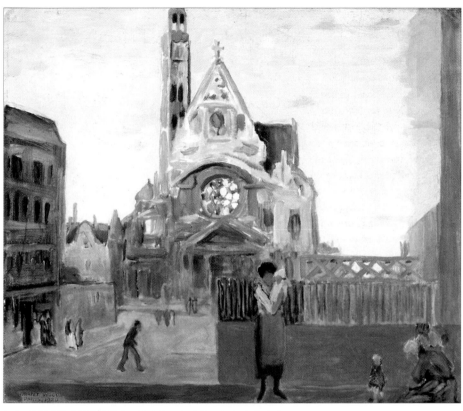

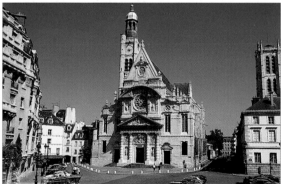

at your next painter's exact site an impossibility. Face Saint-Etienne-du Mont ahead for the best on-site perspective. It is recommended that you view the inside of both Saint-Etienne-du-Mont and the Panthéon before continuing your walk. The former has the only rood screen still existing in a Paris church; during the 15th and 16th centuries, its illustrations of the Epistles and the Gospels were used to educate the congregation. There is also a shrine to Sainte-Geneviève containing a remnant from her tomb. The view from the Panthéon's dome is worth the climb. On the circular ledge are outline drawings, including names, of the many monuments and buildings viewable from this elevated position. Tombs of Hugo, Voltaire, Rousseau, the architect Soufflot and others are in the crypt.

Exit the Panthéon, recross Rue Soufflot (again, by the Faculty of Law), turn left, and continue straight ahead.

Continue forward down the slight hill, cross Rue Saint-Jacques, and proceed downhill to a large intersection with a fountain. At this busy crossroads, make a quick jog to the right, and cross Boulevard Saint-Michel. While keeping the fountain at Place Edmond-Rostand to your left, travel forward. At the first crosswalk on the left, traverse Rue de Médicis and, immediately ahead, enter the left bank's most celebrated area of greenery, the Luxembourg Gardens. To proceed, travel forward along the dirt path directly in front of you. Spot to your right the monumental Médicis Fountain. Continue forward and stop at the stone balustrade. Directly ahead is the Luxembourg Palace. The east wing facade displays a unity of architectural style, although it was, in fact, built during two different centuries. To your right, the portion of the building between, including the first three pavilions, all topped with truncated pyramidal roofs, dates from the original 17th-century construction.

In 1610, when Henri IV was assassinated, his widow, Marie de Médicis, no longer wished to live in the royal residence, the Louvre. Instead, she preferred a lavish country estate, which would be reminiscent of her childhood home in Italy. To this end, she purchased land on the edge of Paris and commissioned Salomon de Brosse to build a grand palace with extensive gardens. A milestone in the development of classic French architecture, the Luxembourg Palace is, despite its original intentions, more French than Italian in style. Unfortunately for the Queen Mother, she was discovered plotting against Richelieu, her son's chief advisor, and was exiled in 1631; thus, Marie de Médicis lived in the palace for only six

3. FOUNTAIN OF THE MÉDICIS, PARIS

(1924)

GRANT WOOD

During Wood's second, more lengthy trip to France he enrolled for a time at the Julian school, a bastion of the art world for Americans and other foreign art students. He studied life drawing during his short stay there, but soon returned to outdoor painting.

Fountain of the Médicis, Paris (1924) witnesses an evolution of his impressionistic style. Moving beyond a basic understanding of architectural forms and compositional structure, he is now studying the dappled light created by the shady trees and woven iron fence. Movement has been added by means of odd-shaped red and yellow leaves floating in the running fountain.

Wood hasn't depicted any people in this quiet, secluded spot in the Luxembourg gardens, but the inclusion of the classicist sculptures of Polyphemus hovering over Acis and Galatea adds a figurative motif to the composition. One cannot help but think that its addition harks back to traditional, art school exercises for learning anatomy by copying plaster molds of classic sculptures; in effect he is still using the art student, learning technique.

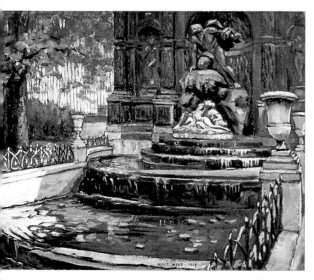

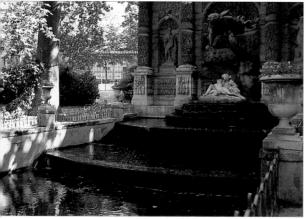

When Wood finally found his own direction, after returning in 1929 from yet another painting trip to Europe, he received praise and national recognition. His regionally-based, hard-edged, detailed scenes of Iowa were in harmony with his cultural background and temperament. In later years, Wood would reject his early impressionistic paintings as "wrist work," executed spontaneously without any thought or planning, and was angry that he had wasted his time on an elitist "foreign" style. He failed, however, to recognize or understand that each step of an artist's creative life has some relationship to what has come before. An action "against" is as important as an action "for."

years. Although minor external changes were made by the architect, Chalgrin, after the French Revolution, the major structural alteration occurred during the reign of Louis-Philippe. Architect Alphonse de Gisors extended the south wall, now facing the garden to your left, by about 100 feet (30 meters).

The square pavilion and the small inset to the left of the original structure dates from this 19th-century addition. Gisors, conscious of maintaining a harmonious design, matched his rooftop with the original 17th-century one by Salomon de Brosse.

Descend the steps, make two right turns, and proceed forward to the large, rectangular pool of the massive Medicis Fountain.

If Marie de Médicis, for whom the fountain was built in 1630, were alive today, she would be more than a little surprised. Firstly, her fountain, originally positioned closer to Boulevard Saint-Michel, was moved to this location in 1862 when Rue Soufflot, Rue de Médicis and Boulevard Saint-Michel were all constructed. Secondly, the steps and the rectangular pool were added by Gisors at the same time, and, thirdly, several aesthetic features were added to the facade. After the Revolution, Chalgrin added a sculpture of Venus to the central niche. But, in 1862, the central niche was again altered, this time to portray the mythological scene of Polyphemus, a jealous cyclops, about to assault Galatea, a sea nymph, and her sheperd-boy lover, Acis. In addition, two figures appeared on either side. A young huntress, modeled after Diana, is on the right, and a young faun is on your left.

Marie would, however, recognize her coat of arms near the top of the structure which dates from the original construction; also intact are the two oversized figures and stalactite-like formations circling the original three niches.

Backtrack on the same path as before, ascend the steps (don't miss the view of the Panthéon), and turn right onto the terrace. Ahead and to your left starts the procession of notable women who are sculpted in stone: "Illustrious Women and Queens." Commissioned by royal order during the reign of Louis-Philippe, many of these sculpted woman had been Queens of France or mothers of Kings. Each can be understood, in part, by her individually-portrayed nature; the work of twenty different sculptors is represented. At the statue of Bathilde (680), wife of Clovis II, turn right and move forward to the balustrade ahead; to your left is the "side" garden of Marie de Médicis' original garden. There was an entrance/exit on the south side of the palace to an oval, double terrace but there were no steps, no large basin and no balustrade. Her long and narrow "main" garden extended on the east side to beyond, where Boulevard Saint-Michel now exists; the fountain was the main attraction. On the west, next to the former residence of François de Luxembourg, her garden extended beyond the present-day Rue Guynemer.

From your present position, the building you see to the left of the palace is the Orangerie. Originally built by Gisors in the 1840's, it was remodeled in 1886 to become the new Luxembourg Museum. As early as 1620, Marie de Médicis' plan had been to decorate her palace with original works of art, and she had even commissioned Rubens to execute twenty-four paintings inspired by her life; these paintings, which now hang in the Louvre, were finished in 1625. One hundred and twenty-five years later, in 1750 during the reign of Louis XV, the east wing was opened to the public, and over one hundred of the King's paintings were put on permanent display. This marked the

4. AT THE LUXEMBOURG

HENRI CROSS

*A*t the Luxembourg by Cross is a superb sample of pure Impressionism. While painted directly from life, a candid moment is stopped only briefly as the artist quickly reduces the almost amusing scene to its basic essence. Three pleasure-seeking children, two of whom are awkwardly bending, are being watched by a formally seated woman. Her sober, dark dress serves to accentuate the bright, sunny light on the terrace, and a slightly darker, fuzzy blur of color represents the large garden beyond. In a typical Impressionist manner, Cross flattens the picture plane; no shadow is pure black and no line is ruler-straight. His loose application of paint is almost magical. Without denying the formal structure of the balustrade, Cross creates its solidity with odd-shaped globs of paint next to broad, uneven strokes. Cross, having already forsaken his given family name, Delacroix, for the English equivalent, demonstrates again in 1891 his unusual capacity to embrace change. He moved to the south of France for good and abandoned his loose brushstrokes for the more controlled dots and dashes of neo-Impressionism. Cross then went on to produce his most well-known and accomplished paintings in the Var.

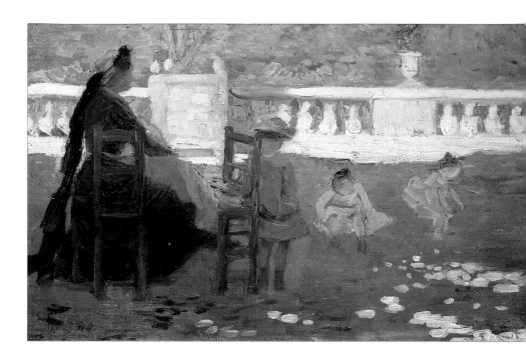

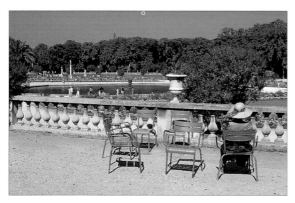

first public, painting museum in France. In 1814, after the Louvre (Palais des Arts) was partially emptied by the Allies (the English, Prussian, and Russian troops who defeated Napoléon's army) demanding the return of stolen works of art, most of the paintings from the Luxembourg Palace were transferred there. The Luxembourg Palace then became a museum for "living" artists, and honor was bestowed upon those chosen for exhibition (the works would be transferred posthumously to the Louvre). In this museum, Caillebotte hoped to exhibit his friends' works but Degas refused such an honor; the collection hangs today in the Orsay Museum. To make your next painting comparison, move away from the balustrade, taking about eight paces toward Mathilde, and turn back around to face the former "side" garden of Marie de Médicis. Diminish your viewpoint to include only the balustrade (which obviously did exist by the time the featured work was executed) and a small section of the garden beyond. The next featured painter was more than a little selective when painting in the garden.

5. TERRACE OF THE LUXEMBOURG GARDENS

(1886)

VINCENT VAN GOGH

To proceed to your next site, turn left, walk past the next two illustrious women of France, Berthe (783), wife of Pépin the Short, and Mathilde (1083), wife of William the Conqueror; turn left immediately after the second statue, and move into the tree-filled area ahead. Pass the café on your left, move just beyond the paved, dirt-covered path and turn around.

The planting of more trees in this area makes an exact location difficult to attain, but your present position is close enough to appreciate the eye of the next featured painter.

It is necessary to duck and shift your position a little in order to line up the terrace wall, the cylindrical sculpture of David and the spray of water from the fountain. People wandering about on a sunny day captured the imagination of the featured painter; the same sight is still common today.

When making your comparison of Van Gogh's *Terrace of the Luxembourg Gardens* (1886), be sure not to underestimate the importance of this painting. At first glance, Van Gogh's depiction is a rather pedestrian landscape. On a sunny day Parisians stroll amongst rows of trees in the popular public garden. Van Gogh demonstrates his knowledge of beginning painting "rules," and appropriately bathes the foreground in warm sunlight and the background in a cool, bluish white. The clear, blue sky becomes paler as it recedes to the horizon line, and the images in the distance are more difficult to discern, as is the case when you are observing the actual site. However, this painting marks a significant change in Van Gogh's palette. When he reaches for the green paint instead of the

earth-toned ochers, it is the first time he experiments
with a profusion of lighter and brighter colors in an
outdoor landscape painting. Later in the year, he
wrote to an English painter friend about his desire to
"render intense color and not a grey harmony."

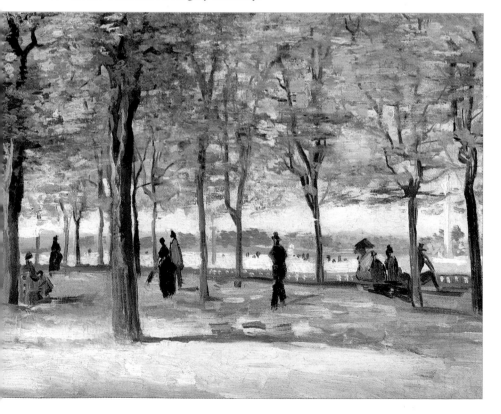

Move forward onto the paved path, turn left and continue forward on it. On your right is the sculpture of Sainte-Geneviève (420-512), the patron saint of Paris. Continue along the terrace, veering off the paved path, and pass, on your left, the following honored women of France: Mary Stuart of Scotland (1542-87), wife of Francis II, Queen of Scotland when she was 7 days old, until she was 25 years of age; after being widowed, she returned to Scotland and angered Elizabeth I, Queen of England, who finally put her to death. Jeanne d'Albret (1528-72), mother of Henri IV, wife of a Bourbon and Queen of Navarre; she practiced Calvinism as did those in her kingdom. Clémence Isaure, a figure in a well-known legend of Toulouse. Anne Marie Louise d'Orléans (1627-93), cousin of Louis XIV, Duchesse de Montpensier, wife of the Duke of Lauzun; she created a scandal for marrying beneath her station and is a former occupant of the Luxembourg Palace. Louise de Savoie (1476-1531) mother of François I; when he went to war in Italy she was Regent of France and made the Peace of Women with Marguerite of Austria. Pass on your left the most enigmatic, "illustrious" woman in the garden, Marguerite d'Anjou (1429-82), wife of Henry VI of England (who at 10 years of age was crowned King of France in Notre-Dame). When the English were finally ousted from France, problems followed her to England. When her side lost in the War of the Roses, she sought, with her son, refuge in France. Before circling to the other side, stop and turn left at the middle area in order to gain a better understanding of how the garden evolved. As early as the 13th century, a Carthusian monastery, complete with extensive kitchen gardens and a tree nursery, had stood on this location bordering the property of

6. THE LUXEMBOURG GARDENS

STANISLAS LEPINE

Interestingly, Marie de Médicis is prominently featured in Lépine's *The Luxembourg Gardens*. Lépine's inclusion of the exiled and disgraced Queen Mother was possibly a tribute to her; aside from the Médicis Fountain and this statue, her name does not appear in the garden which was originally her idea. Lepine's realistic depiction again focuses on the cloudy, color-filled sky and the majestic location. Tiny, refined brushstrokes define the local daytime population whose posture, with the exception of the

nurse and child on the left, mimics those of the "distinguished" Women of France. Starting from the 1850's, the well-dressed, neighborhood bourgeoisie promenaded daily in the garden after it was redesigned and then opened to the public. Lépine's painting, though not necessarily bearing the mark of a "genius," is still engaging. With care and respect, he has captured the garden's quiet, elegant ambiance which still exists today.

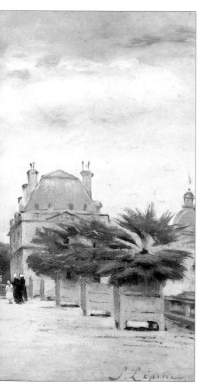

Marie de Médicis. Despite her numerous requests to extend her own garden to the south and improve her view of the domed Observatory ahead, the property remained under church control. It was, however, taken over by the state after the Revolution, and Chalgrin took the opportunity to design a formal French garden. In addition to the basin, the steps and the sloping, grassy areas just seen, alleys of trees and two grassy rectangular areas were planted on the incorporated, former church land.

For the first time the gardens' alignment went predominately north to south instead of east to west; Chalgrin's basin became the central motif, instead of the Médicis fountain located on the palace's eastern side. When Napoléon III and Haussmann decided to annex the land beyond the fence to construct a road connecting Rue de l'Abbé-de-l'Epée, on your left, to Rue d'Assas, on your right (and construct more housing), it created a furor in Paris. The left-bank residents strongly resented their garden being amputated, but despite the public outcry, this favored area shrunk to its present size.

Continue to Laure de Noves (1308-48), a woman from Provence whose beauty inspired the Renaissance poet, Petrarch. Line up the next three women, all of whom appear in the next featured painting:

Marie de Médicis (1573-1642), widowed second wife of Henri IV, Regent-Mother of Louis XIII, and, of course, the exiled Queen for whom the original gardens and palace were built; Marguerite d'Angoulême or de Valois (1492-1549), older sister of Francois I, and Queen of Navarre; Valentine de Milan (1366-1408), wife of Duc d'Orléans.

7. NURSEMAID IN THE LUXEMBOURG GARDENS (1872)

EDGAR DEGAS

To proceed to the next painting comparison site, walk forward and stop between the already depicted Marguerite of Angoulême (Valois) and Valentine de Milan. Move right to the top of the steps and turn around to make your on-site comparison. The featured painter did not execute his work at the site, but the ambiance of this location is close enough to the finished depiction to be adequate for your comparison. At the end of this alley is a miniature replica of the Statue of Liberty, sculpted by Bartholdi in 1905.

Undoubtedly based on sketches and then executed as an indoor studio work, Degas' *Nursemaid in the Luxembourg Gardens* (1872) is a lopsided, unusual composition. The depiction resembles a stage with a painted curtain on its back wall. A horizontal line crosses the lower half of the painting, separating the focal point – a nanny with a child on her lap – from the backdrop of greenery. Though it is not obvious when first viewing the painting, Degas is continuing his exploration of theater-like settings. In earlier works depicting the Peletier Opera House, a slightly descending line divides the performance in progress from the musicians playing in the orchestra pit. On the stage, fuzzy, greenish foliage makes up the background. This time, it seems that Degas catches act one, scene one of a modern play, set outdoors from the viewpoint of his unseen, elevated theater

seat. The action is about to begin. Half expecting
another person to fill the empty chair, we wait in
anticipation for the plot to unfold. Will the baby,
whose dangling feet we can barely make out, slip off
the nurse's lap, or will she adjust the precariously
perched child to rest more securely? Will the hazily
depicted people, walking along the tree-lined alley,
come forward, or are they only to provide a backdrop
for the action on the stage?

This painting provides an integral link for tracing
Degas' creative evolution. From historical paintings,
portraits and jockeys he jumps to the world of the
theater and the orchestra pit. (Examples of these
themes and motifs are viewable at the Orsay
Museum.) Although this painting does not feature the
gestures and movements of ballet dancers, for which
he is most famous, it is the first of his new genre to
exclude all action other than that on the decorated
stage. Degas, though decidedly not a landscape
painter, was, nevertheless, sufficiently inspired by the
Luxembourg gardens to use them in one of his
transitional paintings.

To continue to the next painting comparison site, continue along the terrace, passing: Anne de France (1462-1522), daughter of Louis XI, Blanche de Castille (1188-1252), wife of Louis VIII, mother of Louis IX (also known as Saint Louis), twice Regent of France, first after her husband died and then for her son during the seventh Crusade.

At this point, you have arrived at the steps that lead to the next site. If you are interested in seeing the remaining women, however, continue along the terrace past the last four sculptures: Anne d'Autriche (1601-66), wife of Louis XIII, mother of Louis XIV, and Regent during her son's minority; Anne de Bretagne (1477-1514), wife of Charles VIII (1491), wife of Louis XII (1499); she brought Brittany to France;

8. LUXEMBOURG GARDENS AT TWILIGHT
(1879)

JOHN SINGER SARGENT

S argent, a privileged American who was born in Italy and grew up in France, is more internationally renowned for his 600 oil portraits of upper-class society women than for his few Impressionist-influenced landscapes. Arriving in Paris the same year as the first Impressionist Exhibition, he entered the studio of Carolus-Duran to pursue his study of art. Fortunately for the young student, Duran placed more importance on making superlative paintings than on the tedious task of copying plaster molds. Under his tutelage, Sargent studied and imitated the vigorous brushwork of Velázquez, whom

his master teacher revered. Sargent flourished in the independent class, and soon developed a quick, loose brushstroke. Applied directly to the canvas, it was not to be altered or corrected.

Intrigued with the Impressionist painters, who at the time were creating scandals with their landscapes, Sargent decided to spend the summer of 1877 painting outdoors on the Brittany coast. One of these figurative landscapes earned him an honorable

mention in the Salon of 1878, and Sargent, who admittedly wanted to surpass his teacher in renown and skill, had already gained a reputation as an impressive, contemporary painter at the age of twenty-two.

Luxembourg Gardens at Twilight (1879) is one of a handful of landscape paintings Sargent did while continuing to develop his painting skills. Despite his tonal modeling, a practice which classic Impressionists abandoned and Sargent refused to give up, he skillfully depicts the changing light when day turns to night and images begin to appear less detailed. Fluid, diffused lines evoke form, but his overall emphasis is on the portrayal of the radiant quality of light in an expansive space. While also adopting the Impressionist concern with movement, Sargent depicts the couple gliding through the delicate atmosphere, as do the boats in the water-filled basin to their right.

Sargent's interest in portraiture precluded further investigation of his adapted, Impressionist technique until the mid 1880's. During his summer holidays between 1885-89, he reexplored outdoor painting with Monet at the older Impressionist's home in Giverny.

In the French art community, Sargent was most well-known for his scandal-producing

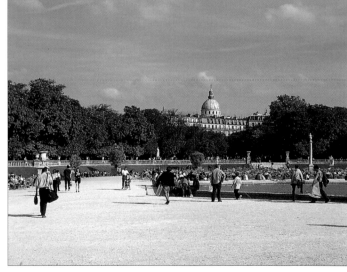

Marguerite de Provence (1221-95), wife of Saint Louis at the age of thirteen (bore him eleven children); and last but not least, Sainte Clothilde (475-545), wife of Clovis I.

Then backtrack to these steps, descend into the area of the central garden, and circle to the left until the Panthéon and central basin are to your right; to your left is the corner of the south side of the palace and to its left is the Petit-Luxembourg. Now the home of the President of the Senate, it was originally the domicile of the duke whose gardens were the birthplace of this once royal residence, now a public playground. Apart from the changes in clothing styles, the scene is the same as the one the featured painter saw here in this garden over one hundred years ago.

Portrait of Madame Gautreau, but to an entire generation of American artists, for whom Impressionism was a style to emulate, his dynamic, never tentative brush-work was consistently studied.

9. SKETCHES IN PARIS

(1893, DETAIL)

MAURICE B. PRENDERGAST

To go to the last featured painting comparison site, turn right and circle the basin in a counterclockwise direction. Once you are a quarter of the way around the basin, sit on one of the green benches to the right of the path, in front of the stand renting boats (15 francs for an hour).

At the conclusion of your tour, it is recommended to further explore the Luxembourg gardens. The southwestern area has free-flowing English gardens and an experimental horticulture area. In addition to the "Illustrious Women of France," sculptures of literary, artistic and political figures grace nearly every lawn or tree-shaded corner.

Marie de Médicis had wanted to build a road from her palace to the Louvre, but it was never realized. A street stretching to the Seine, though not connected to the Louvre, does nonetheless allow for an impressive view of the front facade of the palace. Exit the garden near the east wing of the palace, passing the Médicis fountain on your right. Turn left out of the gate, onto Rue de Vaugirard. Continue along this street until Rue de Tournon appears on your left. (If you wish to see an art exhibition at the Luxembourg Museum, continue forward

The popular Luxembourg Gardens was a favorite location for art students wanting to paint or sketch outdoors. Prendergast, during his student days at the Académie Julian on the nearby Rue du Dragon, was no exception, and frequently made the short trek to these gardens with his brushes and oils. Since he wanted to quickly capture the scene of the playing children and ever-present, observant mothers, Prendergast imposed on himself the exercise of rapidly completing small sketches without laboring over the final result. Purportedly, interested observers would buy his studies even before he had left the site. Predominately influenced by the Impressionists and Whistler, the most well-known American painter in Paris, *Sketches in Paris* (1893) is typical of Prendergast's student painting style. He borrows from Whistler a palette partially made up of blacks and subtle beiges, but employs the freer brushstrokes of the Impressionist painters. Further, Prendergast liberally dabs on strokes of color, some pure and some blended, to create the "impression" of images which the viewer translates as children and trees in the background. His "tricky" use of black in the foreground is to his credit. The non-modeled, flattened shape pops forward without overwhelming the harmony of the composition, but, at the same time, it draws attention away from the beige vase that appears to be floating in space.

This small painting is one of seven which were framed together by the artist's brother in 1939.

on Rue de Vaugirard to the museum's entrance situated past the west wing of the palace.)

Turn right on Rue de Tournon, proceed down the slight hill far enough to see the front of the Luxembourg Palace in its entirety when you turn back around. For a complete change of pace and a sample of wine, continue forward on Rue de Tournon (which changes names to Rue de Seine), cross Boulevard Saint-Germain and enter the Rue de Seine and Rue de Buci outdoor market area. Brouse in this lively area, and then for a unique and educational experience, turn left on Rue de Buci and immediately right on Rue Bourbon-le-Château. Stop at number 6, "La Dernière Goutte," an American-owned wine shop. Juan Sanchez, chef-trained but now the local French wine expert can readily answer your questions concerning France's most popular liquid (wine) and solids (food). Also, ask him for suggestions concerning restaurants in the area. He usually has wine tastings on Saturdays but don't hesitate to ask for a sample at any other time.

Montmartre

Tour 8 both starts and finishes on the southern boundary of the once-isolated rural village of Montmartre, and the bulk of your walk features motifs painted on the hill itself. Although the most familar visual images of this northern location of Paris were executed by two painters, Utrillo and Lautrec, who were not Impressionists, to consider only their depictions would give a false impression of the area. Populated by a variety of artists starting from the late 19th century, we are particularly fortunate, from an historical viewpoint, that both Van Gogh and Renoir lived and painted on the Montmartre hill.

Their work, along with that of the other featured artists included on this tour, can enhance your understanding of the abundance of inspiring motifs and the rich variety of lifestyles which coexisted here at the end of the 19th century.

Today, Montmartre is vastly different from the rural village depicted in the paintings to be compared on site; consequently your walk (mostly in a downhill direction) has been specifically designed to endear you to its modern, urbanized version; it avoids, wherever possible, the enclaves of tourists and the more unaesthetic, commercial aspects of modern living. Despite this careful planning, however, the best time of day to make this tour is early morning during the warm days of spring and summer, or late afternoons during the crisp, cool days of autumn and winter. Montmartre, even today, maintains an ambiance different from that of the rest of Paris, and, despite the tourists, its undeniable, small-town charm is sure to intrigue you.

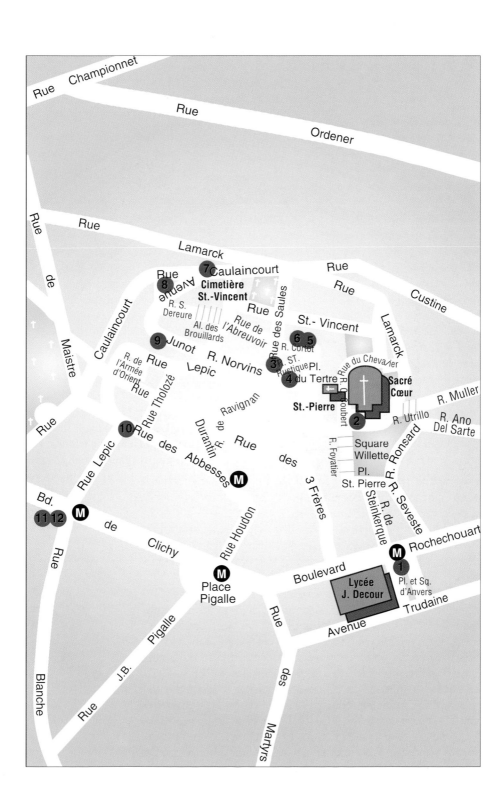

1. Place d'Anvers

(1880)

FEDERICO ZANDOMENEGHI

To arrive at the beginning of your next tour, take the metro to Anvers (Porte Dauphine-Nation line), and follow the signs exiting to the Funiculaire de Montmartre at street level. When you leave the metro station, stop momentarily on the middle island of Boulevard Rochechouart, opened by Haussmann in the 1860's. Glance straight ahead along the boulevard: Place Pigalle and Boulevard de Clichy, though not immediately visible, are beyond. Sex shows of a dubious nature now dot the area which, during the late 19th century, boasted some of the most well-known cabarets, taverns and night-time dancing spots in the city; typical is the Elysée-Montmartre on your right. Also gone are the artists who lived and painted here. The Medrano Circus, depicted by both Degas and Renoir, was located on the north side of the boulevard near Place Pigalle. Across the street to the south was the Nouvelle-Athènes, the gathering spot for Impressionists and other artists during the 1870's. Manet, following Degas' lead, painted interior scenes of café-concerts located on this boulevard (The Beer Waitress); The Plum, also by Manet, and The Absinthe Drinker, by Degas, portray the unhappier side of life for women drinking here in isolation.

To find the location of your first painting site, cross the boulevard to your left. Enter Place d'Anvers on the right, through the gate, and proceed forward on the park's path; stop about halfway. It was originally called Place Turgot when built in 1871, and the name changed to Place d'Anvers in 1877. Although it has been expanded and adorned with gazebos and more trees in modern times, its ambiance doesn't differ drastically from that in the first painter's view. Not known to have attracted the upper-class Parisians, who usually only came to this area at night, Place d'Anvers is an example of a

Zandomeneghi occupies a unique position among the Italian expatriates who came to Paris during the 1860's and 70's. Of all the Italians who aligned themselves with the Impressionist's philosophy of defying traditional methods of "picture making," he proved to be the most innovative and independent. Not only was he influenced by the creative commotion of the French avant-garde, but he, in turn, stirred the already heated coals by his interpretation of the movement's goals.

Place d'Anvers (1880) is perhaps Zandomeneghi's most daring urban landscape. Less a study of atmospheric light or real people in a modern urban setting – two themes which consistently appear in most Impressionists' works – his painting is more a synthesis of Impressionist principles applied in a methodically-controlled fashion. Embracing the use of clear colors to depict natural, outdoor light, he paints parallel patches of blue and softened orange in the shadowed, right corner, and appropriately positions green shrubs next to red flowers. The figures are minimally modeled and appear flattened on the picture plane, and his striking diagonal composition is derivative of Degas' explorations of innovative, compositional constructions. However, in his search for a modern style, befitting his own cultural background, he inadvertently touches upon major characteristics of the yet unborn neo-Impressionist movement. Zando's (his nickname) controlled stillness, use of color and placement of only slightly modeled figures were not lost on the young painter, Seurat, who would lead the new movement when it finally emerged six years later. Seurat's Sunday Afternoon on the Island of the Grande Jatte (1884-86), shown in the eight and last Impressionist Exhibition, has too many elements in

common with Zando's earlier landscape for them to be ignored.

Zandomeneghi never attained success in Paris' art market nor was he ever wholly accepted, with the exception of Degas, by the original group of Impressionist painters. Nevertheless, he participated in four of the eight Impressionist Exhibitions. He wrote letters to Italian friends about his isolation as a foreigner and his constant financial troubles.

typical neighborhood park. The building on the right, the Jacques Decour Lycée, is the same one depicted in the featured work. The lycée took over the premises of the Collège Rollins when it moved here in 1876. (Notice the numbers etched in the wall above the windows when you leave the park.)

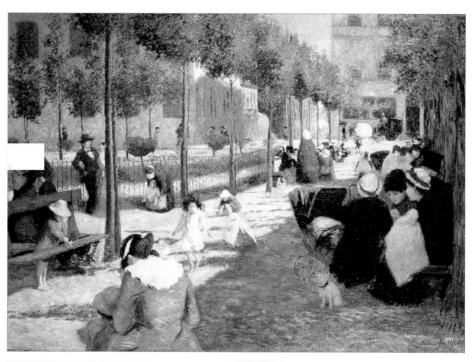

2. VIEW OF PARIS

(1886)

VINCENT VAN GOGH

To mount the Montmartre hill and continue your walk, retrace your steps to the metro station, Anvers, and continue across Boulevard Rochechouart. To the left is Elysée-Montmartre, and to the right is a building dating from 1885; walk straight ahead on Rue Steinkerque. When it dead-ends at Place Saint-Pierre, turn left and then right at Place Suzanne-Valadon. Use a metro ticket to take the funiculaire (or, if you are hearty, take the steps to its left) and upon exiting the outdoor transport, stop to observe Sacré-Coeur Basilica on the hill to the right. Built between 1876 and 1910, the basilica owes its conception to a group of French Catholics wishing to atone for France's humiliating defeat by the

V an Gogh's *View of Paris* (1886) is one of four canvases done from the Butte, or hill, of Montmartre. At the end of his first summer in the French capital, he continued to study the technical skills and the creative sensibilities of other artists. Although subdued browns, greys and red-ochers dominate his palette, abbreviated images give the painting a decidedly impressionistic quality. His moving clouds with bits of blue recall the painterly skies of Jongkind, a fellow Dutchman, and the subject, which includes an extended perspective of

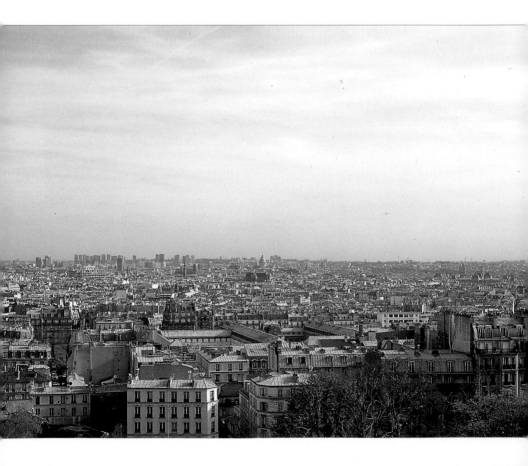

Prussians in 1871. Head to your right, and place yourself with Sacré-Coeur to your back. On a clear day, your position on the highest hill in Paris commands a spectacular 30-mile view. Conversely, the stark though decorative silhouette of domes and rectangles can be seen from almost every section of the city below. The featured painter's position was actually to the right of where you are now standing. To compare how he technically rendered existing motifs does not require a shift in your present position, although you will find it a little difficult to match monuments in the painting to those you can see below.

Before leaving this location, recommended is a tour inside Sacré-Coeur.

Paris from an elevated position, was probably inspired by Manet's well-known painting (seen in tour 4). However, contrary to both the Impressionist and neo-Impressionist painters, Van Gogh asserts his own sensibility when he juxtaposes a modern Paris with her historic roots. Clearly depicted in his painting, from left to right, are the Saint-Jacques Tower, Notre-Dame, the Garnier Opera building, the Panthéon and, at the far right, the double roofs of the Louvre. Suitably, an artist in transition is portraying a city in transition.

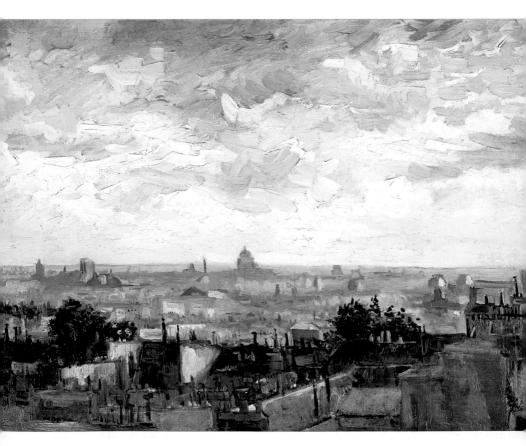

3. GUINGUETTE (1887)

VINCENT VAN GOGH

To continue your walk, turn right immediately after coming out of Sacré-Coeur and continue straight along Rue Azaïs (the street name is marked later). When the street dead-ends, turn right onto Rue Saint-Eleuthere, and then left onto Rue Norvins. Originally called Rue Traînée, it is one of the oldest remaining streets in the Montmartre village. Enter Place du Tertre. An organized, outdoor market, featuring street artists, gives a country-fair atmosphere to this former quiet meeting spot (some of the art work is very competent despite being painted expressly for the tourists). Browse, buy, people-watch or enjoy refreshments; however, to view your next site, keep to the right and continue along Rue Norvins to its intersection with Rue des Saules and Rue Saint-Rustique. Stop to see the connection of all three streets and position the remodeled Auberge de la Bonne Franquette, formerly called Billards en Bois (Billiards of Wood), on Rue Saint-Rustique, ahead and to your right. Purportedly Impressionist artists Sisley, Monet, Cézanne, Pissarro and Renoir gathered here in the evenings, and a plaque on the wall announces it to be a Van Gogh-painted location (another source locates his position next to the Moulin Radet, seen later on this tour). The restaurant is, nonetheless, the oldest in Montmartre; Henri IV dined here in 1590.

Whether Van Gogh actually painted *Guinguette* (1887) at this location is unimportant, as nothing remains, save a tree, of the outdoor site featured in his painting. What is known, however, is that the canvas was executed in the fall, as leaves were changing from green to brown, and the depiction clearly alludes to an important aspect of the former lifestyle on the Butte. As the 19th century was drawing to a close, artists and workers mingled at modest, outdoor areas to relax. Wooden benches and chairs were available for sitting alone or in groups, and the common beverage was a carafe of wine. Art historian's opinions are divided as regards Van Gogh's paintings in Paris. Some say their lack of intense color and emotion bears no relationship to his later paintings in the sun-drenched south of France. However, the rich tonal subtilities of this sober painting communicate a feeling of intense isolation, which can experienced as summer turns to fall. Life in Montmartre has its joys but also its pains.

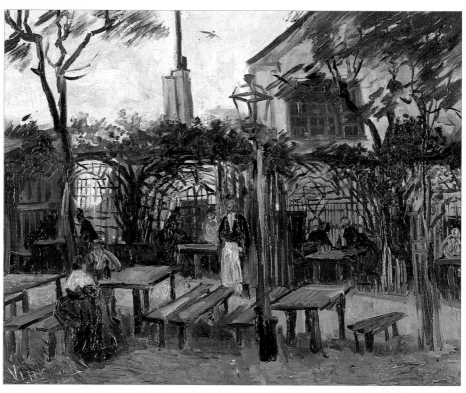

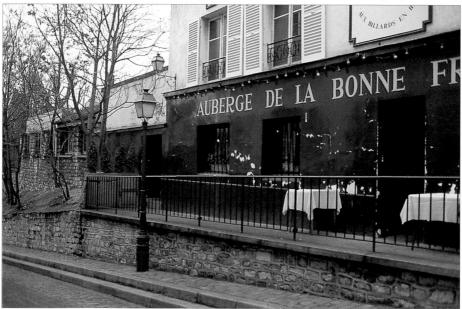

4. RUE SAINT-RUSTIQUE

(1944)

MAURICE UTRILLO

Although the next painter is not an Impressionist, his name, synonymous with cityscapes of the Montmartre village, simply cannot be ignored. He did more depictions of the isolated squares and deserted streets than any other well-known artist.

To make your next comparison, leave the usually crowded corner and enter Rue Saint-Rustique; stop when the view of Sacré-Coeur, rising between the buildings on this narrow street, is in the same position as in the painting to be

Rue Saint-Rustique (1944) is similar in mood to the Van Gogh depiction just seen. In fact, a sense of isolation and melancholy permeates most of Utrillo's paintings of Montmartre. The illegitimate son of artist and model, Suzanne Valadon, Utrillo was exposed early on to the bohemian lifestyle of the Butte. His mother introduced him to painting as a means of diverting his attention from over-drinking, and Utrillo, who had a visual, photographic memory, took to being an artist. He would amble the narrow streets, and then reproduce street scenes from memory in his dank, often dark, studio. Also working from postcards, Utrillo amazingly simplified the

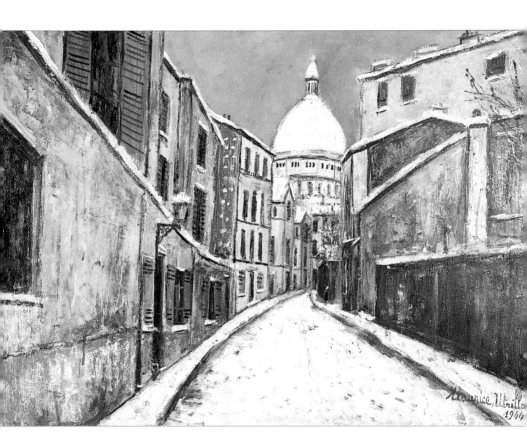

composition and, as seen in this painting, captured the natural color in a scruffy, uncomplicated manner. Despite numerous psychological problems, for which he was hospitalized several times, his Paris cityscapes appear fresh and direct. As early as the 1920's, his highly individualistic depictions were successfully received by Parisian galleries, and, by the time he died in 1955, he had already enjoyed a respectable international reputation.

compared. Originally, Rue Saint-Rustique was a pedestrian passageway, providing access to the gardens on the older Rue Norvins. The village ambiance of old Montmartre starts to emerge on this quiet, former footpath.

When Rue Saint-Rustique dead-ends, turn left onto Rue du Mont-Cenis and left again onto Rue Cortot. Stop at number 12 on the right. Formerly the studio and home of Utrillo and his mother Valadon — painter and model for Lautrec, Renoir, Degas and Zandomeneghi — it is now the Montmartre Museum. It houses a collection of paintings and memorabilia, and the building itself is one of the oldest in Montmartre. As you enter the quiet, enclosed garden from the museum's bookstore (admission charged), linger a few moments to notice how natural light filters through foliage. Although your next painting and location comparison is not of an exactly matched pair (the garden has since been reduced in size), contemplation of them will further your understanding of the featured painter's application of Impressionist principles.

For those unable to enter the museum's garden, look over the wooden gate to the left of the museum's door to make an approximate on-site painting comparison.

5. THE SWING (1876)

PIERRE AUGUSTE RENOIR

Renoir, when observing how naturally dazzling light filtered through foliage in this backyard garden of his rented studio, perceived opalescent blotches of both warm and cool colors splashing through odd-shaped leaves. His desire to record this physical phenomenon and his own enchantment with the female figure prompted him to combine two themes: the charm and innocence of sensual (as opposed to sexy) women, and the aesthetic nature of scattering light. Renoir poses his favorite model, Jeanne, below an open web of unseen foliage.

The Swing (1876) is a classic example of Renoir's matured Impressionist style. A delicate pattern of rosy, off-white daubs of paint, which one critic likened to "grease marks," gently caresses the front of the young woman's gown and idly rests on the man's darkly-clothed back. An overall bluish hue, with hints of yellows and lavenders, whispers throughout as Renoir harmonizes the pervading transparent light, and his brushwork — sometimes thick, sometimes thin — mimics the light's uneven flow.

At the height of Impressionism, Renoir was relatively unconcerned with anatomy. The young woman's ill-defined arms are hidden under fabric, and a hand with

indistinguishable fingers dissolves behind her head. However, her soft, peachy-toned skin attracts us to her beauty, and her posture indicates a shyness of character.

Renoir's attention to draftsmanship did not develop until the 1880's, so we cannot be sure if the little girl's naive, yet slightly coquettish stance was depicted by chance or was a purposeful depiction of her future charm.

The painting, shown in the third independent exhibition of 1877, did not attract any buyers. At the show's conclusion, it was purchased by Caillebotte; he wanted to offer both financial and moral support to his friend and fellow painter.

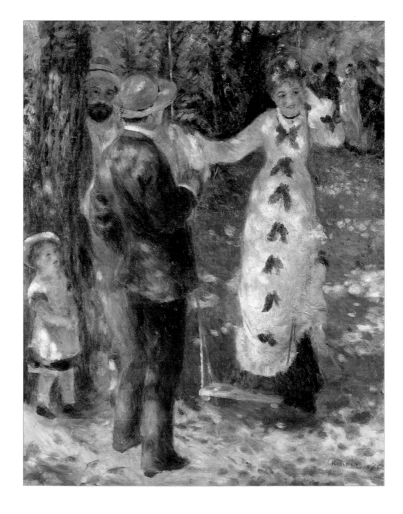

6. LANDSCAPE FROM MONTMARTRE

(1887)

MAXIMILIEN LUCE

To continue, position yourself on the museum's second floor and look out the north windows to the hills beyond. The featured painting was actually done from a studio next door (16 Rue Cortot). From this position, however, you have an approximate view of the painter's site, and can visually compare the difference between Impressionism and neo-Impressionism.

(For those of you who were unable or unwilling to enter the museum, read ahead to the next set of directions for an alternate location from which to make your on-site comparison.)

As you line up the distant hills in Luce's neo-Impressionist depiction, *Landscape from Montmartre* (1887), with today's partial view of the northern, suburban hills in the distance, keep in mind the Renoir Impressionist painting just seen. Although not immediately obvious, these schools are intrinsically linked. Before the neo-Impressionists retired to their studios to paint scientifically-derived dots of color, they too ventured outside to make sketches and observe how one color affected another in a natural setting. Luce's cityscape was probably painted from a sunlit window indoors, but his palette of glowing pinks and blues echoes the outdoor palette of Renoir.

Luce's brushstrokes are smaller and repetitively shaped, but they too echo the spots of sunlight depicted by Renoir. Both paintings have a luminescent pink-blue glow. When Seurat's *Grande Jatte* painting was shown in the eighth and final Impressionist Exhibition (1888), the critics made little mention of the division between the two movements. Only with time would the two techniques be perceived as separate schools of painting.

7. KITCHEN GARDENS AT MONTMARTRE: THE BUTTE MONTMARTRE (1887)

VINCENT VAN GOGH

Leave the museum, pass Luce's studio at number 16, and continue to the corner. Turn right onto Rue des Saules (stop here as an alternative to the museum comparison site of the industrialized north side of Paris and Saint-Denis beyond).

You cannot miss the Rose House, once a favorite café of Picasso and immortalized by Utrillo, on the left as you walk downhill. At the next corner, Rue des Saules and Rue Saint-Vincent, the vineyard on the right is the only one still remaining on the Butte; it was replanted in the 1930's. In early October, when the grapes are harvested, Montmartre is the scene of a festive celebration. Across from the vineyard, and again on your right, is an old artists' haunt, Le Lapin Agile. The name was derived from a sign done by A. Gill of a rabbit (*lapin*) jumping out of a cooking pot (thus being *agile*). Among the noteworthies who gathered here were Picasso (he painted *At the Lapin Agile* during his Rose period in exchange for food and drink), Gauguin and Utrillo. From the vineyard and the Lapin Agile on Rue Saint-Vincent, continue down Rue des Saules to its connection with Rue Caulaincourt and Rue Lamarck. Turn left; stay on Rue Caulaincourt. To enter the small Saint-Vincent cemetery — an interesting detour — turn left on Rue Lucien Gaulard. Artists' graves include Utrillo's, Valadon's (his mother) and Steinlen's — artists who cannot be ignored when walking the hills of Montmartre — and Boudin's (an

Van Gogh's *Kitchen Gardens at Montmartre: the Butte Montmartre* (1887), to all intents and purposes, is a realistic depiction of what he saw when looking south from his position on Rue Caulaincourt. From a photo taken in 1887, it is known that these same kitchen gardens and shack-like structures dotted the north side of the Butte and that two windmills could be seen on the horizon, but the fundamental likeness stops abruptly there. Firstly, Van Gogh drastically alters the proportions between the hill, the road and the windmill, and secondly, he sees and paints a rhapsody of vibrating color. Drab weeds become strokes of lemon-yellows mixed with pale blues and orange-ocher, and the shadow on the wide dirt road is alive with brilliant reds and cross-hatched blues. Straggly vegetation is made lush with rich aqua dabs, and the barn roof on the horizon is painted with every tint already used. Clearly, this painting and the one that follows are precursors to his distinctive brushstrokes and color sense which, in the south of France, would become swirls of emotional drama. His goal was to show in the 1888 Salon of the Independents (not to be confused with the independent Impressionist exhibitions, which ended in 1886), and this canvas is the largest Van Gogh had done to date. More importantly, however, it is an original statement of his own personalized creative investigations. After a year of absorbing, assimilating and painting interpretations of other artist's styles, Van Gogh demonstrates his own unique fashion of painting lines and perceiving color.

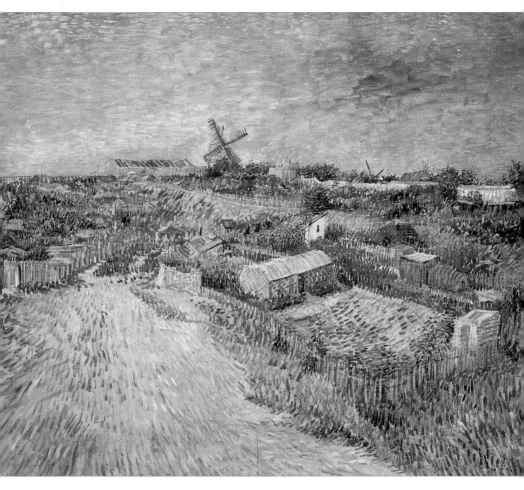

Impressionist who never painted in Montmartre). Return to Rue Caulaincourt, continue, and shortly, to your left, is Place Constantin-Pecqueur. The sculpture, near the rear, of a couple kissing is dedicated to the memory of Steinlen, who became well-known only after his death; his posters and paintings have helped to shape our impression of how dismal life could be in Montmartre during the early 20th century.

To arrive at your next destination, move just beyond the square and position yourself with your back to Rue Caulaincourt. Contemplate the painting and the site to understand both this artist's painting style and what Montmartre looked like in the late 19th century.

To continue, go along Rue Caulaincourt. Number 73, on your right, is the house in which Steinlen died; in 1910 it was occupied by Renoir, and was purportedly his last Paris studio. Continue to the square between 63 and 65 Rue Caulaincourt. Move to the top of the steps across the street on Rue Juste Métivier. You'll need a great deal of imagination to recreate what Van Gogh saw, as you look to the north toward the still existing industrial suburb Saint-Denis. This location, although not exact for the featured painting, is the highest on the hill and still allows for an unobstructed view of Saint-Denis. Before continuing, look around and blink several times to "see" both a rural Montmartre and the vastly different yet charming Montmartre as it exists today. Until the 20th-century urban renewal, what we call "rural poor" lived here in

8. VIEW OF MONTMARTRE, PARIS, BEHIND THE MOULIN DE LA GALETTE

(1887)

VINCENT VAN GOGH

V an Gogh's *View of Montmartre, Paris, behind the Moulin de la Galette* (1887) is yet another work expressly undertaken for the 1888 Salon of the Independents. It was painting slightly earlier, in the same month as the work just seen, and a few

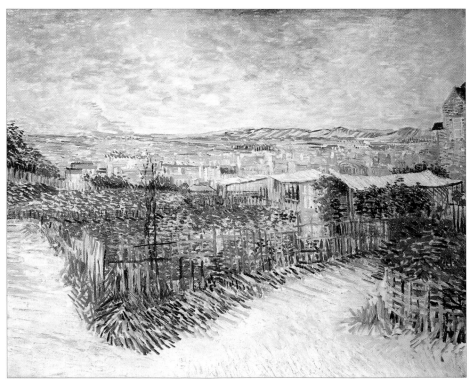

appalling conditions among unsavory
types and an assortment of artists.
To find the next painting comparison
site, which again is very different from
the modern site, continue from your
present position and proceed slightly
uphill, stopping just beyond 10 Avenue
Junot on the left. Look across the street
and up to see the windmill originally
known as Moulin Debray (after its
owner), but also called Moulin Blute-Fin
(the Fine Sieve).

By the middle of the 19th century, many
of the mills on the Montmartre hill had
become obsolete. The Debray family
converted two of theirs into outdoor
drinking establishments. After Mr Debray's
son began selling puff pastry cakes
(galettes) to his wine-drinking clients,
both mills became known as the Moulin
de la Galette. At first, the Blute-Fin
(Moulin Debray) was not officially given
this name; the official name, Moulin de
la Galette, was reserved for the nearby
Moulin Radet. At the Blute-Fin, however,
an area was eventually built for dancing,
and the modest open-air café and dance
hall became one of the most lively spots
on the Butte. This mill is the one
featured in the center of Van Gogh's
painting, *Kitchen Gardens at Montmartre:
the Butte Montmartre*, and it is from near
this mill that Van Gogh painted both
View of Paris (seen at the beginning of
the tour) and *View of Montmartre, Paris,
behind the Moulin de la Galette*. The
Debray family officially changed the name
of the Blute-Fin to Moulin de la Galette
only in the middle of the 1880's. Despite
this date, however, it is this mill that
represents the *galette*-selling dancing spot
which art historians and guidebooks
consider to be the place where the next
featured artist gathered with his friends.

remnants of an Impressionist influence are still
evident. Not yet committed to his personally-invented
way of looking, he devotes almost half of his canvas
to an atmospheric study. As in his Paris panorama
painted the year before (seen at the beginning of the
tour), light diffuses the hard edges of buildings and
the pale blue sky reflects onto the industrial plain and
hills beyond. In the shadowless foreground, however,
there are no patches of reflecting light, and the
vibrating colors have no temporal basis. Van Gogh
juxtaposes complementary colors, but it is his varied
strokes of vivid hues that define volume and
perspective and account for the overall dynamic flow
of this work.
Again, it is known from an historic photo that the
same sheds, the planted hillside, and even the barn on
the right, were exactly as you see them in his
painting. However, Van Gogh has altered the position
of the Saint-Denis hills, shifting them to the right on
his canvas. Van Gogh chose to retain a lesson learned
from his study of Impressionist painters: nature
should inspire an artist, not enslave him.

To continue your tour, turn left on Rue Girardon, the next street ahead, and left again on the small pedestrian Allée des Brouillards. Renoir's studio and home in 1895 is at number 6. The château facing it dates from 1772. It is a pleasant area now, but vastly different from that of Renoir's time. At the end of the alley you can again see part of the Moulin de la Galette (Moulin Debray-Blute-Fin). Return to Rue Girardon and continue to Rue Lepic. Cross the street, turn left and walk a few steps before turning around to face the reconstructed Moulin Radet. When the Blute-Fin proved to be more popular, the Moulin de la Galette at this location "lost" its name. Based on the date of Renoir's painting, it is possibly this site that Renoir featured in his painting (one Paris guide offered the suggestion that he painted in the garden between the two mills).

Moulin Radet and Moulin Blute-Fin are both depicted in Van Gogh's *Kitchen Gardens*.

9. DANCE AT THE MOULIN DE LA GALETTE

(1876)

PIERRE AUGUSTE RENOIR

O bviously, this location today bears no resemblance to the once lively, outdoor café and dance hall of the 19th century, but to ignore Renoir's *Dance at the Moulin de la Galette* (1876) would render you a disservice. No other single painting so directly illustrates both Impressionist goals, in general, and Renoir's application of them in particular. Renoir's unique expertise was in his integration of Impressionist landscape principles in his depictions of the human figure.

To observe and absorb this acknowledged masterpiece is to penetrate, almost in its totality, the visual perception which the Impressionists sought to achieve.

Two signed versions of *Dance at the Moulin de la Galette* exist, and art historians are divided as to whether Renoir actually completed both at the site. This dispute becomes immaterial, however, when looking at the immediacy of expression found in both works.

It was painted during the same year as *The Swing* (already seen), and Renoir is again depicting natural light as it cascades through a variety of thin foliage; but he has complicated his artistic goals by adding an animated crowd, dancing and general merry-making. Swirls of motion generate a splash of lavender on a golden hat, greens mixing with blues on a face, and a flash of scarlet on a hand, as color seems to bounce

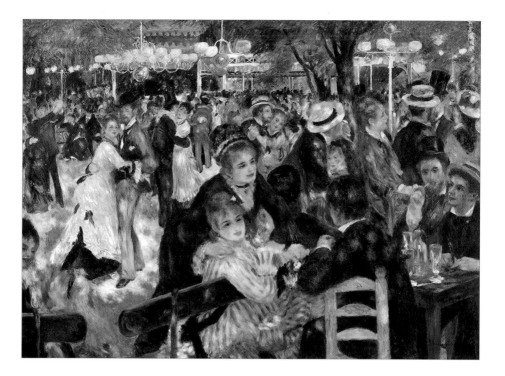

and skip back and forth on his dazzling, painted surface. A sense of life at its simplest, filled with joy and beauty, permeates the canvas. It is possibly this very sense, which prevails in many of the Impressionist paintings, that accounts for this movement becoming one of the most popular in the history of art.

Renoir believed a painting should be "happy and beautiful," and professed to paint for the pleasure it brought. He was the least likely to engage in conversations on art theory, and the most likely to suggest having a good time. Yet, it was Renoir who dragged his large canvas, albeit with the aid of his friends, from his studio on Rue Cortot to the Moulin Debray every weekend to render, under the dappled light, those same friends mingling with the vibrant working-class crowd. His result could only come from an intense direction and a profound knowledge of light and shadow, coupled with an ability to deftly handle a paintbrush.

Caillebotte bought *Dance at the Moulin de la Galette* at the same time as *The Swing*. Both had difficulty entering the French national collection, as Caillebotte's bequest was initially refused.

Continue downhill on Rue Lepic. Look up at the hill across from Rue Tholozé to see the Moulin de la Galette again through the trees. Turn left onto Rue de l'Armée-d'Orient, follow it around as it curves to the right, and turn left to find yourself once again on Rue Lepic. (To the right at 5 Rue Tourlaque is another former studio of Renoir's, and 21 and 27 Rue Caulaincourt are former studios of Lautrec's.) Stop at 54 Rue Lepic to see where Van Gogh lived with his brother during his stay in Paris. He executed several paintings from his bedroom window in a neo-Impressionist (pointillist) style. To view the next painting comparison site, continue along this street to the left and onto Rue des Abbesses, into which Rue Lepic runs. Stop just before the corner of Rue Aristide Bruant; it is still as bustling with people as it was when the next featured painter depicted it almost one hundred years ago.

10. RUE DES ABBESSES
(1896)
MAXIMILIEN LUCE

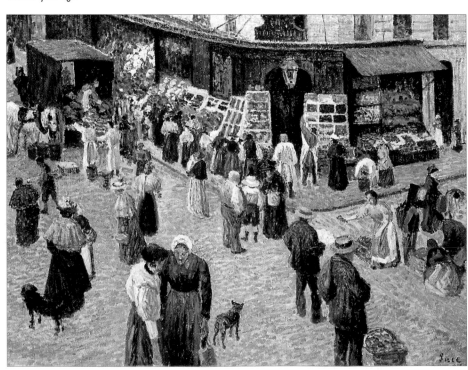

A n animated view of contemporary city life is the
subject of Luce's *Rue des Abbesses* (1896).
It was a familiar sight, not far from his studio, and
Luce was drawn to the lively spectacle on the street
below, wanting to record all the clamor which
accompanied even a small, outdoor market area.
While locals are chattering, food being unloaded and
merchandise being bought and sold, Luce logically
contemplates the technical "problems" of depicting
the scene. The unusual composition forces the
viewer's eye to scan the activity on the patterned
cobblestone streets in the foreground, although (at the
same time) the clear greens and reds of fruits and
vegetables in front of the store also attract one's
attention. Luce uses a structured approach to render a
humanistic view of his own neighborhood in
Montmartre.

11. BOULEVARD DE CLICHY (1887)

VINCENT VAN GOGH

For an interesting detour, continue along Rue des Abbesses to the metro station. For the price of one metro ticket, you can descend, on foot, into the deepest metro in Paris and take the elevator back to street level; paintings by Montmartre artists adorn the spiraling stairway. This metro station is the only one left in Paris with its original art nouveau entryway still intact.

To reach your final destination and make the next two painting comparisons, backtrack to Rue Lepic, turn left and continue downhill to Place Blanche on Boulevard de Clichy. Situate yourself on the south side of Place Blanche, with the Moulin Rouge diagonally across the Place to your left, to compare the first painting to site.

The desire to explore a classic Impressionist theme impelled Van Gogh to take his brush and paint and descend Rue Lepic during his second winter in Paris. The result, *Boulevard de Clichy* (1887), depicts, under a specific temporal condition, ordinary, daily activity at an identifiable location. Still standing today are both the balconied building on the left, and the studio (104 Boulevard de Clichy) of his former teacher, Cormon, which is almost centered in his composition. The tree on the right is now the site of the Moulin Rouge; it had not yet been constructed when Van Gogh picked the location.

True to Impressionist sensibility, fragments of paint become figures wrapped up in winter coats, and the crisp cold of winter permeates the scene. Lines in the buildings dissolve, as do those on the wide boulevard, and the bare trees are equally Impressionist in handling.

In this work, however, instead of using the complementary colors so extensively explored by Impressionists, Van Gogh positions red next to blue with only a very pale purple and yellow being seen in the building on the left. His interpretation of the properties of light is also rather unique. Van Gogh paints short, obvious strokes of red in the pale blue sky next to the building on the left. Perhaps he was trying to indicate how color and light react on a windy day; the breeze hits the building, and it's red color is bounced back into the sky.

Despite his "fleeting moment" being lighter in feeling than in his prior works, Van Gogh's ever-present interest in the contour of a shape and its solidity prevents this painting from being a successful impressionistic painting.

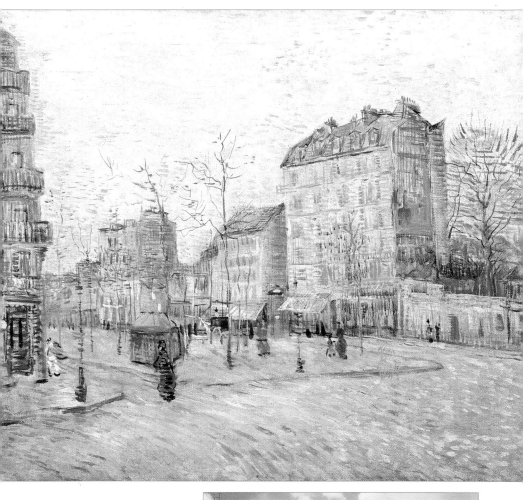

To make your second comparison, stay where you are and look to the right. Place Blanche has been remodeled but some of the buildings featured in the painting, on the far side of Boulevard de Clichy, still exist. Although a little difficult to distinguish, even with bare trees, 62 Boulevard Clichy is the former location of the Café Tambourin, and this is where, in 1887, Van Gogh exhibited his work and painted a portrait of the owner, Agostina Segatori, in 1887; some historians say their relationship involved more than business.

For the most part, it's not worth the trouble to explore the studio locations south of Boulevard de Clichy. If you have the inclination, you could search out the Nouvelle-Athènes café in Place Pigalle to your right. Located on the corners of Rues Pigalle and Frochot, it bears no resemblance today to the once popular gathering spot of the Impressionist painters.

12. BOULEVARD DE CLICHY (1886)

PAUL SIGNAC

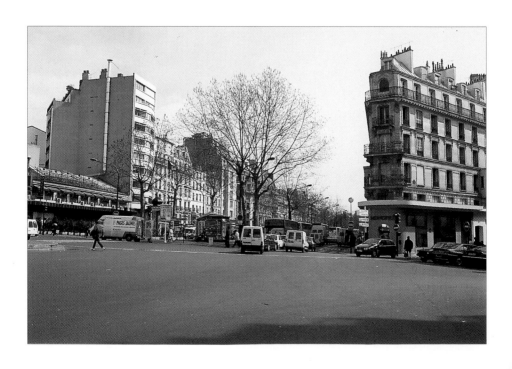

Signac's *Boulevard de Clichy* (1886), shown in the eighth and final Impressionist Exhibition, is typical of his early painting style. A moment of time is slowed down as people drudge along the boulevard. Under an illuminated "grey" sky, the "white" snow sparkles with bits of blue and orange, and bare tree branches seem to shimmer and disappear. Predominately self-taught, Signac applies the lessons learned from studying Impressionist masters, Sisley and Monet, while adopting the heightened color sense of Guillaumin. After meeting and becoming friends with Seurat two years previously, his brushstrokes, particularly in the buildings, are a variation of the other artist's pointillist dots. Ultimately, it is Seurat who proved to have the strongest influence on Signac's more mature works.

Perhaps as important as Signac the painter is Signac the leader. During his 26 years as president of the Society of Independent Artists, his personal belief in artistic freedom set the standards for the society's yearly Salons. Younger, more avant-garde painters were given ample exhibition space and encouraged to show, despite his own and others' bias toward the figurative art of the 19th century.

TOUR 9
Saint-Martin Canal

Your last tour takes you to an area of northeastern Paris not usually explored by *flâneurs*. However, if you are not already familiar with the Bassin de la Villette and the Canal Saint-Martin, this area (complete with locks in the city proper) is a delightfully surprising "must-visit." Strolling along the canal you will usually see only locals; reading the newspaper, fishing or just sitting are the activities of choice. Yet, when a boat passes by, the footbridges are suddenly crowded with curious folks wanting to witness the remnants of river operations of an older era. Interestingly, when the canal's activities waned in the 1960's, developers wanted to build a north-south access road in its place. As it would have completely altered this quiet area, energetic debates ensued all over the city; the then Minister of Culture, André Malraux, listened to passionate pleas from both sides, and, in the end, the canal was saved.

This short walk, during which you will make only four comparisons of paintings by three artists, starts in a charming location depicted by Sisley, a charter member of the Impressionists' first show and a painter not yet featured in this book. The second featured artist, neo-Impressionist Signac, chose to depict perhaps the most picturesque spot along the canal. You are highly encouraged to complete the walking tour by taking the canal trip suggested at the end. In addition to gaining a different perspective on the painting comparisons, you will also have the unusual experience of traveling the canal via the locks. The boat trip starts at the new marina (which opened in 1983 and has berthing for 230 private boats) near the Bastille Opera House. At the end of the trip, you can disembark at either the Bassin de la Villette or the Ourcq canal; the latter position is conveniently located near Paris' new City of Science and Industry. To complete your tours following in the steps of the Impressionists and neo-Impressionists in Paris, this final walk, although still in the city, is almost like having a day in the country.

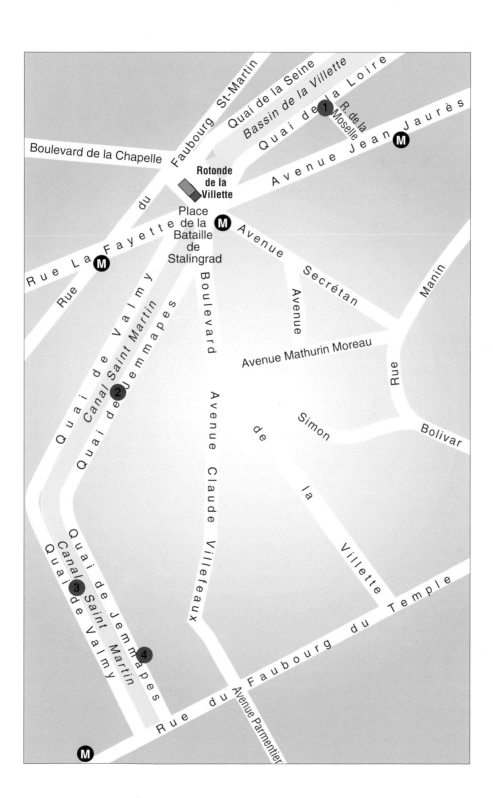

To start your final tour, take the metro (Bobigny-Place d'Italie line) to the station Laumière. There are two different instructions for exiting, depending on the direction in which you were traveling on the metro. If you were going toward Bobigny, take the escalator at the sign *sortie* to arrive at street level, make a U-turn on Avenue Laumière, cross Avenue Jean-Jaurès to the right, and immediately turn left. If you were going toward Place d'Italie, follow the exit to Avenue Jean-Jaurès, côté des numéros impairs, and at street level make a U-turn. From your position on Avenue Jean-Jaurès, proceed forward to the second street on your right, Rue de la Moselle (where a sign points to Quai de la Loire), and turn right. Continue ahead to reach a footbridge and the Bassin de la Villette. In front of you is the Bassin de la Villette; enormous in size (700 meters by 70 meters), it was dug by 1,500 Russian and Austrian prisoners of war between 1806 and 1809. In the 19th century, this area became a gathering spot for pleasure-seeking Parisians. The country village atmosphere, complete with *guinguettes* outside the city limits, made for a day of gaiety and outdoor activities. To your left (but not yet in view) is the Canal Saint-Martin, and to your right but blocked by the bridge is the Canal de l'Ourcq. This canal is linked further along to Canal Saint-Denis. Accessing enough unpolluted water for the capital city's population had always been a problem, and transporting goods — mainly building materials from Rouen and other northern cities — along the Seine to the heart of the city and beyond, was a time-consuming activity. In the early 19th century, the raw materials coming from the north arrived via the Saint-Denis canal at the basin, and then continued via the Saint-Martin

1. SAINT-MARTIN CANAL

(1872)

ALFRED SISLEY

S isley, a charter member who played an integral part in the initial 1874 Impressionist Exhibition, enjoyed the company of his close friends, Monet, Bazille and Renoir, while painting in the Fontainebleau forest during the 1860's. In the early 1870's, however, he went with his paintbrush to the well-known Saint-Martin canal and Bassin de la Villette to experiment alone. There, both before the Franco-Prussian war (see next site) and afterwards, he depicted those pictorial motifs his friends had discovered earlier in the Paris suburb of Bougival. Shimmering water, bouncing light, and a seemingly countrylike setting, not often found in the city, are all essential elements of his first Impressionist painting, (mistitled), *Saint-Martin Canal* (1872). Mimicking his fellow Impressionists, Sisley studies the reflecting quality of the sky's light, and a bluish hue permeates the delicately executed work. Contrary to his friends, however, Sisley is not drawn to the animated form here; without careful scrutiny, the two figures near the basin could be missed. Sisley's future fascination with the sky is only slightly apparent in this painting, but his notably perceptive depiction of what he called the "white wandering clouds" set him apart, even then. In mature works, not undertaken in Paris, he investigated the depth of field of the heavens; as he expressed it, "the sky has planes just like the ground." Although Caillebotte bought his works, Durand-Ruel was his dealer, and Pissarro described him as "a great and beautiful artist... who is a master equal to the greatest," financial rewards and international acclaim eluded Sisley during his lifetime. Only after his death were his expertly-realized paintings awarded the price equal to their admirable quality.

canal, through the city's east side, to finally arrive at the port created in the moat of the former Bastille. In total, 30 kilometers of the Seine, through the city's center, would be bypassed.

To make your first on-site painting comparison, turn and face right. Although the area has drastically changed since the first featured painter stood here — most notably, the bridge in the painting linking the basin to the Ourcq canal beyond, is not the same — the shimmering water is still inspiring in this delightful setting in northeastern Paris. (The drawbridge featured in the painting was replaced in 1885 with the modern one you see today.)

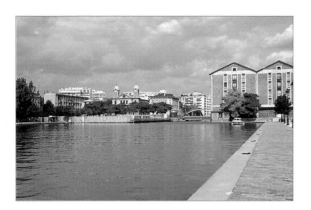

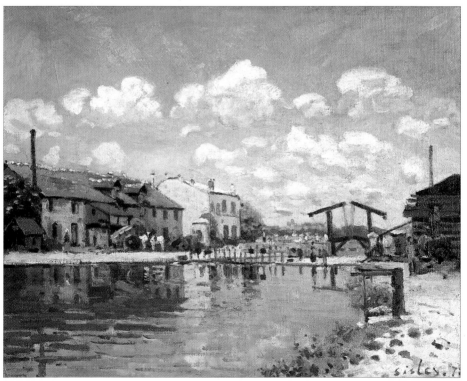

To continue, turn around and proceed forward, with the basin to your right. Today, the primary function of the Ourcq canal is still to bring water into Paris. Despite the water from the Ourcq not being drinkable since 1894 the city of Paris still consumes 380,000 m³ of nondrinkable water, daily, to maintain the plants and trees adorning the city and to clean buildings and streets; 180,000 m³ comes from the Ourcq and 200,000 m³ from the Seine. Today, the Saint-Martin canal is used for commercial pleasure boats. Notice ahead the impressive round building on the horizon. Built by Ledoux (1785-89), it was the central building in a three-part complex on the Farmers-General Wall; this wall had been constructed to prevent products coming into Paris without being taxed. Constructed by Louis XVI, just prior to the Revolution, it was hated by the populace. Continue forward until the first lock and footbridge of the Saint-Martin canal are on your right. The bridge is new, designed to complement the other bridges, similar in design and to be seen later.

Ahead at the light, turn left to cross Quai de la Loire and continue around the curve to also cross Avenue Jean-Jaurès. Once across, turn right and walk forward to Place Stalingrad. To reach your destination, the bank of the Saint-Martin canal which is under the metro tracks and beyond Place Stalingrad, circle clockwise crossing Avenue Secrétan, turn right to cross under the tracks, and continue forward across the next street (the street on both sides of the metro is Boulevard de la Villette, but it is not clearly marked). To continue, turn left, proceed in a forward direction to the driveway on the right and descend to the banks of the canal.

Continue forward under the first bridge,

2. BARGES ON THE SAINT-MARTIN CANAL

(1870)

ALFRED SISLEY

When tracing Sisley's evolution as a painter, it is necessary to look at *Barges on the Saint-Martin Canal* (1870), as well as the painting just seen. Both contain elements of his mature style, and to consider one without the other gives a deceptive idea of his progress as an Impressionist. Many painters do not follow a consistent path when beginning (some never do), and Sisley is no exception. When you look at both works, however, most elements of his more mature work are, here, in their rudimentary stages.

This painting more visibly demonstrates his experimentation with a variety of differing brushstrokes and the integration of the human form as a pictorial motif. Again, following the lead of Renoir and Monet, fragmented brushwork, rich in color, defines the rippling water, and short wisps tell of bare winter trees. Ribbon-like strokes show the flexibility of the loosely-hanging ropes while broader, longer strokes give the barges a stable sturdiness. Movement, an important Impressionist concern, also interests Sisley. It is clear here that he, unlike his friends, is creating a quiet animation of drifting clouds and working men. As Sisley matures, his palette will completely lose the toned-down hues of the Barbizon painters, still seen in this painting, and his later canvases will become suffused with sunlight.

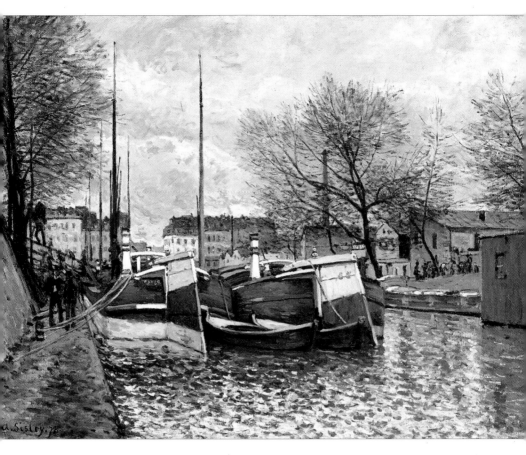

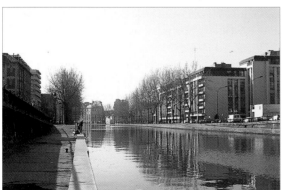

and stop. Not featured in this book, but available for viewing at the Orsay museum is a Sisley painting, *View of Saint-Martin Canal* (1870), executed at this location. Ahead on the horizon line, and featured in the Sisley painting, is the second lock to the canal. Continue walking forward along the Bassin du Combat and pass the lock; follow the sidewalk, not the brick path. On your left is Quai de Jemmapes. At the traffic light, cross Rue des Ecluses Saint-Martin ahead, and continue downhill. Turn right at the bottom, backtrack along the brick road next to the water; about halfway to the hand railing, turn around. Notice especially the break in the buildings on the distant quay when you make this on-site comparison.

To continue your walk, return to the quay and proceed forward. At the footbridge, stay on the sidewalk. On the left, past 108 Quai de Jemmapes (down Rue Bichat), you can see the handsome brick and stone building of the Saint-Louis Hospital. Founded by Henri IV, built between 1607 and 1612, the style of architecture is similar to that on Place des Vosges. At number 102 is the Hôtel du Nord, made famous by Marcel Carné's movie of the same title; Arletty and Louis Jouvet starred in it. Cross the next pedestrian bridge, seconds from the Hôtel du Nord or, to avoid the steps (even though the view is worth the exercise), continue forward, turn right on Rue de la Grange-aux-Belles (use the sidewalk on the left side of this automobile bridge) to cross the canal, and continue left on Quai de Valmy. You have just crossed the canal at a particularly seductive spot, often seen in both French films and television productions.

Note the lacy Eiffel-designed, pedestrian bridge. It became the model around the turn of the century when all the original footbridges were redesigned. Obviously, those along the canal not reflecting this pattern, are newer.

While staying on the water side of the quay, stop in front of 79 Quai de Valmy, and turn back around to see the next featured site. If the traffic swing bridge is closed (the green structure in the middle), imagine it to be open when making your next featured comparison.

3. THE SAINT-MARTIN CANAL (1933)

PAUL SIGNAC

The Saint-Martin Canal (1933) was painted near the end of Signac's life and renews a theme he had investigated in his youth: the encroachment of industrialization in suburban Paris. When looking at the painting, however, it is difficult to believe that this canal was ever anything other than a quiet waterway, located within the city. Other painters, Boggs among them (see next painting), depicted the chimney smoke emanating from the factories lining its banks, whereas both Sisley and Signac concentrated on the quiet, nearly countrylike atmosphere of the canal. Yes, the formally-constructed composition does pull your eye to the iron pedestrian bridge, almost centered on the canvas, and yet the figures resting leisurely on it, though small, belie the notion that the bridge is an intruding structure. In his younger days, Signac painted factories and motifs of "progress" with care and sensitivity, although the people appeared dwarfed and despondent during the era of industrialization. Half a century later, Signac painted a strikingly beautiful cityscape in muted pastel colors, an unreserved tribute to man's ingenuity. Although the area is industrial, the city dweller can still enjoy the reflecting water, swaying trees, and statuesque buildings in this urban environment.

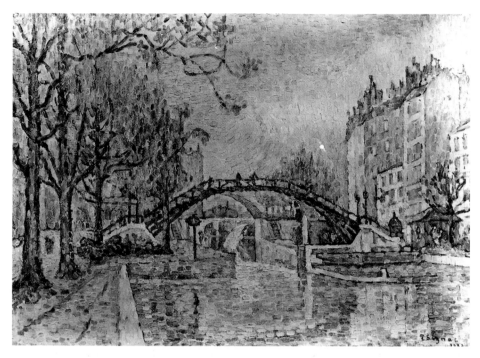

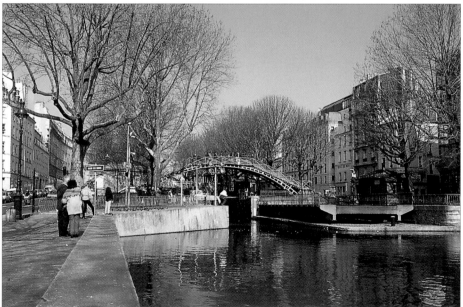

To find the last featured painting site on this short tour, continue forward, pass the bridge, turn left at the traffic light, Rue Dieu, and cross the car bridge to its end at Quai de Jemmapes. Turn toward the canal in the direction from which you have just come to see the same view as the featured painter.

To continue your tour, which does not include more painting comparison sites, turn left on Quai de Valmy and continue to its conclusion at Rue du Faubourg du Temple. The canal Saint-Martin goes underground at this point and emerges at its other end, near the landscaped marina next to the new Bastille Opera House.

At Place de la République, take the

4. THE VALMY QUAY

(1905)

FRANK MYERS BOGGS

B oggs, an American, who painted in both the 19th and 20th centuries, was originally trained by Gérôme, a notable in the Academy. When making his mark as a contemporary painter, however, he adhered more closely to Impressionist intentions and priorities. Typical of his mature style, *The Valmy Quay* (1905) proves to be a professionally executed, "safe" rendition of the industrial area in northeastern Paris. Considered to be a "second-generation" Impressionist painter, Boggs, who became a naturalized French citizen, enjoyed commercial success in his adopted

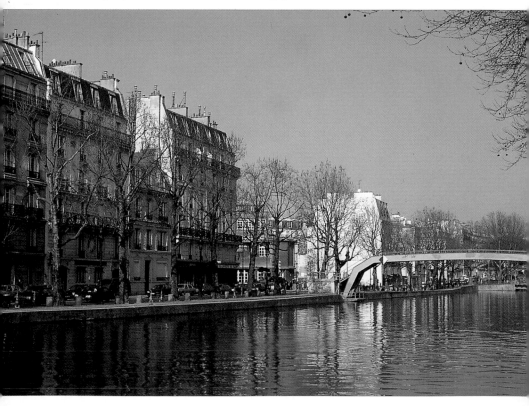

country. By the late 1890's, the Parisian public had accepted, as sad yet charming accounts of their city, his atmospheric studies of turbulent clouds and polluting smoke in well-known locations.

Boggs was also embraced by the Salon as early as 1889. This bastion of conservatism could no longer ignore a style and manner of painting which the public had grown to appreciate over time.

Caillebotte was right in his original 1876 will, when he predicted it would take the public "twenty years or more... to accept this painting" (Impressionism). Similarly, Manet, in the catalogue for his one-man show mounted concurrently with the World Exposition of 1867, had perceptively stated, "To exhibit is the vital issue... for after several viewings, people soon get used to what may have surprised and even shocked them. Little by little, they understand and accept it."

metro Bobigny-Place d'Italie to Bastille. Highly recommended is the Canauxrama canal trip. Its departure point is on Boulevard de la Bastille, at the marina. Traveling on the canal is vastly different from walking on its banks. You can exit at the modernistic Parc de la Villette and visit the City of Science and Industry at the other end.

To walk the approximate one-mile, landscaped, covered area of the canal, circle to Boulevard Richard-Lenoir on the other side of the Place. Don't miss the view from the middle of Boulevard Henri-IV, a "perfect" example of Haussmann's ideas regarding perspective with the visual connection between Panthéon and Place de la Bastille.

Patty Lurie is a painter and a writer. Her first book, *A Guide to the Impressionist Landscape* (Bulfinch Press; Little Brown and Co., 1990) met with considerable success. Currently, she is living and painting in Paris.

Pavillon de Flore, Pont Royal.
Patty Lurie.

As I put the finishing touches on this my second book and I clear out old notes and irrelevant slides, I have a serene sense of calm, knowing that this project has finally been completed. Admittedly, it took much longer to research and write than I had anticipated, and I thank my friends both here in France and in the States for putting up with my ever-changing moods. I am very excited about sharing the end result.

Aside from a few paintings for which no color reproductions could be found, this walking tour guide to Impressionist painting sites in Paris more than meets my expectations. I invite your comments and look forward to meeting and/or corresponding with any of those readers who so desire.

First of all, I sincerely thank the following people who, without being asked, generously sent or gave me books which facilitated my research for this enormous project:

Anne Bader, Martha Bardach, Sylvie Bernard, François Besse, Rachel Boynton, Laurel Burns, Serena Campbell, Mary Christo, Ginger Danto, Andrea Dombrowski, Anne Devere, Dottie Diggs, George Dolese, Maria Ecks, Mim Elkan, Dallas Ernst, Darryl Evans, Laure Flamand de Lestapis, Sheila and Steve Finch, Grace Gallant, Judy and Sam Hellinger, Roberta Kramer, Stéfan de Lestapis, Mitch Martin, Howard Meyers, Marelle McMillan, Dottie Morey, Emilia Nuccio, Fred and Maria Olivier, Sylvie Osorio-Robin, Rick and Pam Perlman, Barbara and Larry Pitsch, Sonia Prox, Bill Rapaport, Nicholas Reed, Claire Robson, Ted and June Rose, Susan Rosenberg, Juan Sanchez, Susan Schneider, Bob and Arlette Swanson, Laura Sattler, Jim Tangersly, Josette Tavera and Stéphane Thonat.

For helping to track down the necessary resource information I wish to thank the following people in Paris: Martine Ferretti, Bernadette Buiret and Serge Morozov from the research library at the Orsay Museum; Tony Stone, head librarian at the American University; and Anita Dalmas, Jean-Louis Oudin and Mr. Fournier, all from the Fournier Gallery.

Thanks should also be made to Isabelle Chemin and Fabienne Vaslet, at éditions Parigramme; to Solange Schnall, who translated the text for French edition; to Patricia Abbou, proofreader.

My photographer, Darryl Evans, deserves special thanks for his technical expertise and positive attitude. Despite unpredictable weather and difficult lighting conditions, his persistence and diligence insured admirable results. Additionally to be acknowledged are the many people who willingly allowed us to disrupt their usual schedule when making these on-site comparison photographs.

Gratitude is expressed to the following museum curators, trustees and private collectors who graciously permitted color transparencies to be used free of charge: Belgrade Museum, Hiroshima Museum of Art, University of Illinois (Krannert Art Museum), musée des Beaux-Arts de Lyon, musée du Petit Palais, Genève, MSC Forsyth Center Galleries. In this day and age when "the bottom line" seems so important, their generosity cannot go unnoted.

Next, special thanks go to Rachel Boynton, who read and commented on the text regarding the paintings, and Serena Campbell, who read and edited the entire manuscript and also walked every tour; both offered invaluable criticism which undoubtedly improved the quality of this book.

Guide to Impressionist Paris owes its birth to my mother, Claire Robson, who encouraged me to follow my heart, and to my French publisher, François Besse, who originally bought this project for éditions Parigramme. His unequivocal support sustained me in my doubtful moments. Had it not been for the two of them, this book would have stayed forever in my head.

A final note, I wish to thank Virgilio Sanchez Jr. who bought the first copy of this book even before it was printed, Dick Pelletier for the ample amount of paper he supplied, Carol Pelletier for her neverending encouragement, and Juan Sanchez, the owner of "La Dernière Goutte", the wine shop noted at the end of chapter 7; his wines got me through my struggles at 3 in the morning.

CREDITS

Photogravure Euresys (Baisieux, France)
Flashage Leyre (Paris, France)
Printed in Italy